Moshe Katz
Into Creativity

Into Creativity

Choose To Re-Design Your Life

Moshe Katz

moshe' katz Architect

Moshe Katz
Into Creativity
Choose To Re-Design Your Life

Photos / Sketches / Illustrations
Moshe Katz

www.moshekatz.net
moshekatzarch@gmail.com

Contents

Preface...................9

Chapter 1- Biographical Background11

Chapter 2- Creativity...................21

Chapter 3- Creativity & Doubt...................25

Chapter 4- Creativity & Curiosity...................29

Chapter 5- Creativity & Language...................35

Chapter 6- Creativity, Architecture & Design...................45

Chapter 7- Creativity & Intuition...................61

Chapter 8- Creativity & Spirituality...................69

Chapter 9- Creativity & Awareness...................81

Chapter 10- Creativity & The Child in Me...................93

Chapter 11- Creativity & Extremes...................99

Chapter 12- Creativity & Fears, Ego, Perfectionism & Blocks...................105

Chapter 13- Creativity & The Reaction to Life...................121

Chapter 14- Creativity & The Role of Society...................131

Chapter 15- Creativity & Motion...................141

Chapter 16- Creativity & Nomadism...................155

Chapter 17- Creativity & The Question of HOME............................161

Chapter 18- Creativity & The Interior Poet...................................183

Chapter 19- Creativity & The Absurd...193

Chapter 20- Creativity & Improvisation, the Courage to Dare............199

Chapter 21- Creativity & Teaching and Learning.......................205

Chapter 22- Creativity & Multidisciplinary Approaches....................213

Chapter 23- Creativity & The Process ..221

Chapter 24- Creativity & The 5 Questions...................................229

Chapter 25- Creativity & What All Things Dream to Be.....................235

Chapter 26- Creativity & Abstraction...239

Chapter 27- Creativity & Freedom..243

Chapter 28- Creativity & Daydreaming...251

Chapter 29 - Creativity & Inspiration..257

Chapter 30- Creativity & Reality as a Recommendation....................269

Chapter 31- Creativity & HUTZPA – The Rebel, the Anarchist............275

To Dora Feldman, love of my soul

Thanks to my parents, who uncon-
ditionally loved and supported me
throughout my life, took me on journeys
worldwide, and taught me the essence
of boundless giving, freedom, and wan-
dering. To all who believed in me and
recognized sparks of good. To all those
who have crossed my path and were
an integral part of my creative develop-
ment and skillfully sculpted me to be-
come and love the person, I am today.

Reality is just a recommendation

Moshe Katz

Preface

This book is a collection of my reflections as an architect and a multidisciplinary artist during my search for a place to call home. These texts directly result from my artistic and professional activities centered around my quest to define the origin of creativity. Creativity has been a cornerstone of my personal and professional life. I write to illuminate my discoveries and identify the tools that helped me successfully practice as an architect and an artist. I do this hoping to capture and describe the creative energy that flows through me, pass it on to you and positively influence you in your journeys.

This book is a direct result of my memories that lingered all these years and events that served as breeding grounds for my insights on creativity. I intentionally choose to wander between the artists, books, and characters I have learned about, places I have visited, the experiences I have had, and the works I created in this world —all of which have influenced me and shaped my worldview as a creator. Together, they have led me to develop unique methods for understanding, re-discovery, and applying this magnificent force that is bursting from within each one of us — our creativity.

- Moshe Katz

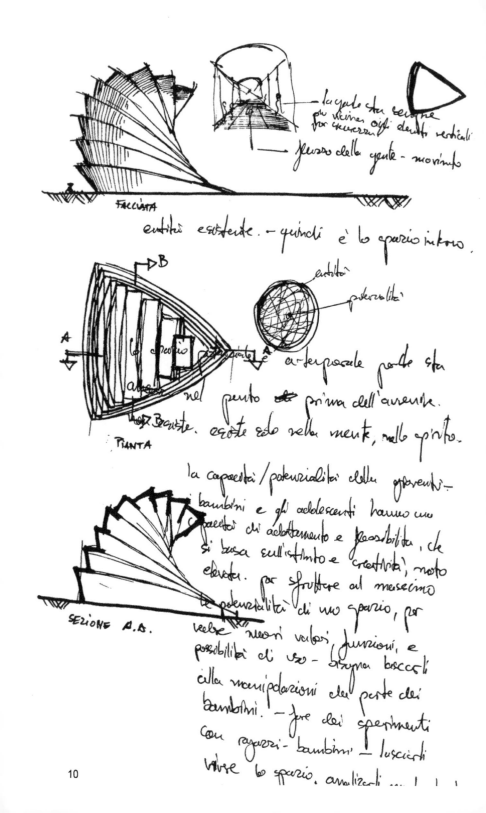

FACCIATA

— la gente sta seduta
più vicino agli oggetti verticali

— flusso della gente - movimento

entità esistente. — quindi è lo spazio interno.

entità
potenzialità

A

B

TIANTA

la quale... parte sta nel punto prima dell'avvento.
esiste solo nella mente, nello spirito.

la capacità/potenzialità delle persone:
bambini e gli adolescenti hanno una
capacità di adattamento e flessibilità, che
si basa sull'istinto e creatività, molto
elevata. per sfruttare al massimo
le potenzialità di uno spazio, per
vedere nuovi valori, funzioni, e
possibilità di uso - bisogna lasciarli
alla manipolazioni da parte dei
bambini. — fare dei esperimenti
con ragazzi - bambini — lasciarli
vivere lo spazio. analizzarli ...

SEZIONE A.B.

Chapter 1 - Biographical Background

I was a child in motion, an offspring of a family of modern nomads (wanderers). Every couple of years, my parents moved to a different country. I learned new languages and had new environments to adapt to. I loved to wander around each new place we went to.

Back then, children spent most of their time outside. We were like curious little cats. I remember running away to the beach every day, standing in front of sand dunes that changed their shape in the wind, and spending hours with my "friends" - clouds and furious waves. I made up stories and games and liked to take apart things I found outside to create something practical or imaginative. When you live outside, your senses become sharpened like those of a wild animal; you become sensitive and learn to observe the details, vegetation, people, and buildings — it all becomes a part of this vast playground that ultimately becomes engraved within you.

When I didn't spend my time outside, I played for hours and days with my Lego. I built futuristic buildings on the moon or some other planet with different rules from what we knew on Earth. I would make up endless stories about myself, my envi-

ronment, and the world and check which one of my childhood friends would believe them and be as enthusiastic about them as I was about daydreaming.

In 1989, my family moved to Berlin, only a few months before the government took down the wall. I was just ten years old and still didn't understand the local language. One day at school, I just heard the commotion, and we followed the other kids as we all gathered around the teacher and received a small hammer as a strange present. As little construction workers, we got on the bus and went directly to this large, long, high wall filled with colored paintings, words, and signs. "Now, try to break it!" we were told.

Each one of us found a small crack in the concrete wall. We hit on it using all our strength, picked up the small pieces, and put them in our pockets, but the wall still stood. All around, television cameras captured excited crowds and masses yelling, singing, and crying at the sight of a wall falling. It was only a few hours until the actual "workers" came to the site and tore down the Berlin Wall using heavy tools, leaving nothing but dust. When I got home, my parents asked me how I liked my first day at school.

I said, "Everyone here is weird. The teacher took us on a strange class trip to break down big walls filled with beautiful pictures, but we couldn't do anything with our small hammers. People were yelling and crying, so they took us back." But little did I know that the world had changed on that day. The city became the world's biggest construction site, and our playground grew exponentially overnight— Berlin was united. My first months were harsh. I painted to survive socially. You make friends immediately in a foreign country if you know how to decorate their notebooks or walls with "Bugs Bunny" or "Raphael's Angels"

paintings. Children are easily impressed with such talents.

I was also "blessed" with a unique sense of humor. I used it as a creative tool that allowed me to bring people together or, at least, closer to me. Humor is an alternative way of looking at reality: a vision of discovering things that are not visible to others. It is another way to look at reality, stretching it to the absurd while softening the encounter with the foreign and unfamiliar. As a child, I developed these abilities: drawing, painting, and a sense of humor. By then, I understood that my survival in the world depended on these particular talents combined with my ability to speak the local language, even better than the locals.

Graffiti and skating defined my teenage years. My friends and I were obsessed with finding smooth surfaces to ride on. There were just a few of those in Berlin, but one place became our skating "home." It was an all-glass building with a large, smooth, paved platform around it. The friction with our skateboard wheels was as low as possible and allowed us a flow of constant motion as if we were surfing a wave.

Like every teenager, there came a time when I needed to go to the restroom, and all I wanted was a hidden corner. I had my constant corner near the southern wall and a lower garden. Many years later, I sat in the full classroom as a passionate, curious student. The professor showed us slides: "...and here you can see the most important monument of the modern architecture — the new National Museum by Mies van der Rohe in Berlin...." I looked at the wall in awe and shock, realizing that this was the same place I used to pee on all my childhood - the southern wall of the modernist temple!

Once I even fell, my skateboard virtually flew toward the glass façade of the building and almost smashed it. Imagine, if that had happened, I would have been accused of destroying

the "holy of holiest." At 16, I found myself back in Israel at high school, finishing my matriculation. On my first day, I had to choose a field of expertise to study. "You can choose psychology, biology, physics...." The teacher said. "I like to draw and paint," I said. "Well, we have no arts, but the closest to that is architecture. There are some parts where you need to use the pencil...."I thought I couldn't lose anything by trying, so I agreed to architecture. How could I go wrong?

During our first week, the class went on a trip to Jerusalem – the Supreme Court building complex. The tour focused on the stories behind the meaning of every detail of the building. Each part had its story, social significance, and poetic symbolism. The light, for example, played an active role in the views and shapes it created. It inspired a fairytale sensation – a ray of light hitting the wall, the windows, and floors, creating a magical interplay between the space and the natural light.

The stairs led upward within an enclosed space toward an unexpected panoramic hall, opening up with an all-glass façade toward the city, introducing that effect of revelation and surprise. That transparency of the hall and the opening towards the city symbolized the justice that was available to all.

The symbols, shapes, small halls, and arches kissed by light with magic connected the whole place to the local history. All these together and each precise detail separately were a part of a fascinating story within a building. But what struck me the most was that there was a person in this world whose profession was to make stories into buildings. Even though I have lived in buildings all my life, this was when I fell in love with architecture. It became my companion, comforting mother, partner, religion, and infinite god, which I would never fully understand. She (architecture) became my biggest passion and the love of

my life, the dream I have been fulfilling each day until this very moment.

I used to sit at the old drawing table for hours at night and draw with pencils, special new pens and rulers. Back then, people didn't have access to a computer, which today saves valuable working time. I was the last generation to draw by hand. It had its charm and a strong identity recognizable only in free-hand sketches today.

Something in that hand shivers, the angle of the pen, the strength you hold it with, and the touch of the pen with the paper you would produce that unique touch that no longer exists in digital materials, where everything is characterless, uniform, and homogeneous. Already then, in high school, architecture became the center of my life. She was above anything else. I sacrificed quality time with friends, girlfriends, and family to be more connected to her. She became a genuine reason for my existence.

On the same day of my architecture matriculation, an external architect who came to evaluate our work asked permission to put my idea into practice in one of her projects. In time, it became a great building – the first Japanese restaurant in Israel to make sushi as a show, a restaurant planned as a theater.

The main stage was an open kitchen in the center of the space; the main actors - the cooks, juggled and played with food while the guests sat around on various levels facing the center event. I thought to myself, if a professional asks a seventeen-year-old kid for his ideas, I must be in the right place. Still, it would take me many years to discover the source of my inspiration and the methodology of my creative process, which gave me proper security and serenity.

The next step was university studies. When I came to Flor-

ence (Italy), that long flaming volcano erupted inside me after many years of craving. Each moment of my life was connected directly or indirectly to architecture. Each passing day was another day I was still not an architect. I took a five-year calendar with thousands of days and put an x mark for each day passing, reminding myself how "soon" I would enter the real world and be reborn as an architect.

I was a stubborn student filled with passion and curiosity; I discovered much knowledge before I could understand or digest it. This provoked endless questions inside me, which remained open, and took me down this long, lonely, and fascinating journey.

At university, I decided to question everything and everyone, and I would not be 'served' the content. The architecture was much more than mere functionality. I believed it could not be reduced to its uses, such as a kitchen, bedroom, technology, or design recreating past tendencies. I wanted to be an artist and "write poetry" with the architectural spaces.

I wanted to excite people, and above all, I wanted to create architecture that responds to their emotional, spiritual, and psychological needs. I understood that my professor's way of doing or seeing things was not my way, and I would have to find my path. So, I started wandering in that infinite desert of knowledge and sensations to find my voice of expression and my purpose in the architecture world. I was searching for a living architecture: dynamic architecture like a living creature.

In 2003, when I talked about architecture that meets people's spiritual, emotional, and psychological needs before its functional ones, I was considered crazy. I felt the need for architecture to be seen as an event, an experience meant to make your spirit dance with joy. Everyone was too practical and technical; for me,

the main goal was how to implement these needs into a physical structure and find a methodology that would lead to an innovative and different outcome, project, or solution each time.

My intuition led me towards the dynamic architecture. I felt the need to find my creative process and become my artist. To be free. I wanted to become an artist who expresses his intimate world through architecture. The projects I planned were unique and stood out from the rest. They were published in exhibitions such as The Biennale di Venezia, magazines, and galleries because of their innovative approach. Back then, I didn't quite understand what made them unique; I could not explain it yet. I felt I was a vessel allowing them to come through me.

My intuition always guided me. When things felt right, I knew that I had found the way. I knew that was the design that asked to be expressed through me – I insisted on it and fought until the end. Like a samurai with a dying wish, I was willing to sacrifice my life in the name of art. I fought for my ideas many times, even at the risk of being expelled from the university. It was sexy and romantic, and I was young, faithful, and confident. In one pocket, I held Dante, and in the other, Frank Lloyd Wright. They gave me the moral strength I needed.

Before finishing my studies, I was just a twenty-six year-old student taking a six months. I sent some of my work to different architecture practices. One of them returned my message, and I found myself planning and designing a project – a whole new city for 30,000 people in Azerbaijan. That was my first professional experience – to dream of a new city and plan most of its significant buildings and environment, a detailed master plan of a futuristic vision of how people should live in 20 years. I was still just a kid, and maybe because of that, I dared to dream of a new city in this world.

I finished my studies with honors, even though it didn't matter. No one in the real world looks at your grades, just the quality of your projects and your creativity level. However, graduating with honors did help on some occasions. I wandered between eight different practices, accumulating experience while working on various projects of different scales until I decided to return to Berlin. Why did I go back to Berlin? To get a short break and meet some childhood friends. I went there with a small laptop and carry-on bag for a week and ended up working as an architect for several years. The reunion with the city of my childhood was magical and intense. A Jewish, Israeli architect comes back to the once home of his youth and works to heal the scars and cracks left by the Second World War. Using his imagination and dreams for unique and creative living environments and buildings.

I felt I belonged there. The city and I were connected by the most extraordinary human tragedy, each holding a different side of the rope but still strongly connected. After several fruitful years, I left again with nothing but the same laptop and carry-on bag. This time I moved to Portugal, where I learned lessons about the beauty of modesty and pureness of simplicity. At that time, my creative process was already strong and defined. I felt that I couldn't and shouldn't keep it to myself. I felt I must share it with others and give it away as a gift. That's when I decided to return to Israel, to the same sand dunes of my childhood, where I am working as an independent architect to this day. My clients are asking me to dream extraordinary dreams for them. I teach creativity to students and young professionals in different fields, giving them tools and techniques to become their own artists.

This helps them immensely in designing their future and gives them a considerable advantage. I still teach in colleges and privately mentor architecture and design students. I give

lectures worldwide about dynamic architecture, creativity, and multidisciplinary arts. I keep researching and working as an artist, dreaming of a better, more beautiful world and making people's souls sing. What started as a daydream twenty-five years ago became a way of life, filled with the same passion and childish, limitless love!

Chapter 2 - Creativity

Creativity is our responsibility towards the world and ourselves. It is an ability, an approach, an action — an existential motion within the world; the experience of things and the ability to pass it through different dimensions — from the void or nothingness to a tangible existence.

Creativity is a motion because it seeks to express whatever desires to come out of the creator —their feelings, sensibilities, thoughts, and imagination — through them as a bridge toward reality. Creativity is the awareness that shifts between different points of view through our attention and how we act in the world in search of the new — for the original. Creativity is the essence of every human being; it is integrated within every little bit that makes us who we are and affects each moment of our lives. Creativity is the primary and fundamental role we were born to fulfill. Thus, we need to practice it to learn how it works and become artists, deliberate creators of our lives.

Creativity is:

1. A way of thinking that breaks through the familiar, the safe, and the rational: a way of thinking that allows you to develop unique ideas and conclusions, original or absurd, visionary and innovative.

2. A way of looking at the world, a view that recognizes beauty everywhere and in everything, even in hidden places. A view into an alternative world where reality, as it presents itself to our eyes, is just a recommendation.

3. Sensitivity and attention, a deep mental and sensual connection that allows the creator to recognize signs and principles, the DNA of what surrounds him.

4. An awareness, the child in me – free, curious, and open to playfulness and constant experimentations. It's a genuine awareness that does not rely on conventions and practiced knowledge but on what things dream to be.

5. The expression of intuition and instinct. Creativity is a vehicle for my intuition, a voice that brings higher knowledge inside me.

Creativity is a unique and original way I observe, analyze and understand the world. It's how I uncover secrets about it and connect all parts into something new and exciting. Creativity is an action, an actual practice. It's not only the observation and way to reach conclusions; it's also how I feel and experience the world.

It's letting go, giving the interior voice in me the needed freedom to express itself with a tangible language. It's also the ability to daydream, envision solutions to problems, give new expressions to ideas and see beyond the obvious.

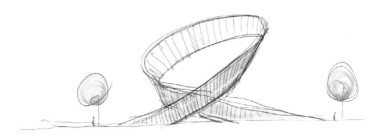

*"The Environmental Knot" An open space concept
sketch for a land sculpture*

prospettiva ①

- grano accostato
- grano visivo (percettivo)
- grano tattile
- grano dell'odore

Chapter 3 - Creativity & Doubt

Doubt is an enormous source of power for any creation. It elevates an internal tension after things cease to be too precise or too defined. The doubt opens the door to a new and deeper understanding. For a moment, it seems there might be a layer we haven't discovered yet.

"The positive doubt" is the one that brings us closer to the hidden beauty in everything that surrounds us - the doubts, in reality, the doubt in the finiteness of things. To understand that there is always something waiting to be explored beyond the commonly known limits or their known shapes or materials.

Doubt comes before curiosity. The action, the motion toward new knowledge, comes because we doubt a known thing or idea. If we already know everything, there is nothing else to discover; there is no point in searching. Doubt encourages curiosity through observation, research, and analysis. In the creative process, doubt helps us get closer to our imagination. If I doubt the sea as the sea, what else can it be? Maybe the wavy motion is just its way of hiding something, and basically, the sea is a giant living creature? A living blanket hiding its true nature in the abyss where we would discover the true face or essence underneath? Maybe the sea is more than what meets the eye? That's doubt.

So, from this moment on, we begin with a process of investigation, observation, and reaching a hypothesis through imagination so that we can see or prove if our doubts have helped us gain new insight, or is it all exactly as we thought before?

Creativity that is based on doubt is dynamic and living. It has an existential tension in searching for new laws or secure knowledge that brings us to a more complex and accurate understanding of our reality. The doubtful creator always stays on alert and is ready to be surprised, open, and sensitive to discover new truths.

The doubt is questioning all truths and existing mental fixations. It's the needed earthquake, the invisible force that moves the subtle tectonic plates of our lives. Things start to move, crack, fall apart, break and then disintegrate into the abyss until a new alternative topography is built, and our world changes shape and form.

Doubt is a powerful motivation to create a new order through momentary chaos. It's a much-needed confusion and chaotic motion that eventually leads toward an alternative interior logic. Still, the creator can't live only in doubt. Because each creation or work seeks a manifestation in real life, it needs certainties and securities to validate the truth of its work and justification. Therefore, there is no other choice than to create new truths, certainties and bring the to life in the matter. But the doubtful creator knows that these truths are only temporary; they are not eternal. They belong to the exact time, place, and knowledge limitations of the moment. After a process of casting doubt, discoveries, and the appearance of new truths, the creator enjoys the result of his current work. He wants the new reality, gives it a place in the world, and analyzes how it reacts and develops. After some time, a new force rises again, the same skepticism and

doubt with which he examines if the fundamentals of his work are still strong or if the earth beneath is shaking again, seeking transformation. That's why it's good for the doubtful mind to be temporary. It allows the creation to grow and fulfill its existence until it's put to the test before it reaches chaos again and returns to the void of nothingness.

Doubt creates a void that demands to be filled. In that tension lies every creation and every creative thought. For me, doubt has led to the discovery of dynamic architecture. When my whole environment dealt with and taught architecture as one-dimensional, mainly technical or technological, I started to develop my parallel world, which caused enormous doubt from all around me. Such a substantial doubt canceled the mere existence of all the principles I had learned.

It was a lengthy process of research and wandering until I understood what architecture is to me and my place in it. I was sure there was an alternative truth that suited me and the world better. I called it "dynamic architecture."

Forse la chiave che ci fa
entrare nella porta della 'creatività'
è il regalo migliore che uno
può trovare
bisogna provare, cambiare-
noi stessi. Solo allora può
iniziare un viaggio di colori,
suoni ed immagini
incantevoli.

trascinarti dal corrente,
dalla forza della curiosità
come in un fiume, solo
se ci lasciamo anche
col corrente - questa
armonia ci fa sentire ...
l'inizio di ...
...

Chapter 4 - Creativity & Curiosity

Curiosity is the engine of the creative man. It's the internal force for motivation and research. Curiosity is an inherent motion, dispersing in all directions by the desire to understand and experience new things. Curiosity needs space and a great sense of freedom. It remains connected to our emotions and brings us closer to moments of revelation and amazement. It grows continuously from the void or nothingness into real existence, and each time we feel that revelation of the new, it strengthens and encourages us to keep pursuing our research with even more extraordinary dedication. Curiosity has no end or limits, and it knows no rest. The happiest person is the one who keeps their curiosity alive, vivid and active all their lives.

The curious child acts with a sense of survival. Without a free curiosity, their life would be in danger. It drives them to learn about their world, understands how it works and how to best act inside their environment. Curiosity is the first fundamental principle for any motion or action in the creative process. An artist who is not curious acts only from the known and familiar, the safe, limited knowledge he already attained. Thus, they won't be able to create anything new but will continually repeat the same variations they did in the past.

However, the curiosity of the adult can prompt insecurity

while facing uncertainties and the need to accept our "ignorance" and the lack of security. Not knowing where the process leads, where we might end up, and what we might find is scary for most people. That's why it is necessary to accept curiosity with a positive, joyful spirit, without any fear of the consequences, with a free, childish, innocent playfulness, because curiosity leads us towards discovery and enlightenment. Being curious is a fantastic feeling. It is something we should aspire to, love, and wish ourselves to act on each time.

Curiosity is a quality we recognize as "childish," an ancient quality that asks us to peel off all our layers and return to some primal state of the unknown concerning the world: to return to a state of raising questions, to find our place in that infinite space around us. The more we grow up, our egos, fears, and rational minds become obstacles to curiosity and prevent its implementation. A person not connected to the child in them would find it too challenging to allow curiosity its full expression and, as a result, will not be able to create or feel active creativity inside.

In the beginning, there was curiosity. There was a need. From emptiness, from the darkness, everything existing came to light. The beginning is a moment of the birth of a need, a curious search inside the chaos just a moment before the creation. Man is a curious creature; it's an inherited quality, and it's always possible to return, activate, and strengthen it each time. Curiosity is there, always ready. You can't lose it but instead, only move away from it or not give it enough space to have it expressed in your life. However, it's always there, waiting patiently for us to act through it.

Curiosity requires the release of any omnipotent position we might take. It requires a temporary forgetfulness, that void that asks to be filled again with new insight and knowledge. How

do we reconnect to creativity? We start by returning to childish innocence, giving up on status, position, or a role we have taken on.

We begin by willingly losing the security in things around us so we can discover them as new through a different perspective. Every day, we take small steps toward paying attention to intricate details and allow ourselves to analyze them for more prolonged periods of time and in more profound ways. The wheels of curiosity must be moved slowly and lightly at first, gradually, until they start to rotate naturally by themselves, stronger and faster each time because being going back to curiosity is the return to the creators we were meant to be.

Curious people are better people because they can put themselves in the "shoes" of others and are willing to see the world through their eyes with the need and the will to understand them. They are better people, better spouses, friends, or even lovers, and their contribution to humanity is more profound than those who maintain a single, constant vision of reality without ever challenging it. Curiosity is the driving force behind all of the questions. Without it, man would not grow, be aware, discover the world or even try anything new.

The motion of life is based on curiosity, which motivates a question and a research process: a process leading to moments of discovery, new understandings, enthusiasm, and so on. A single person in his world is usually more curious than society. As opposed to that, the rest of people, being a part of society or a developed group, blindly accept other people's answers to problems, which were tested and proved, agreed upon, and accepted as the ultimate reality. This may be a time-saver: the single man usually trusts those common truths. He doesn't question them or directs his curiosity to each detail of the world. At the same time,

imposed society's values, opinions, and ideas lead to diminished curiosity among most of its participants. By this logic, only a few are allowed to take on this 'exclusive' role of the curious and discoverers.

In science, with each discovery opens infinite new doors simultaneously. Curiosity is a force that prompts us to take that first step inside, to get lost in the new world so we can learn its new rules and principles. Without curiosity, the human creature, being a rational and intelligent creature, which survives through learning and experimenting, would not be able to find any solutions or grow through understanding. Instead, they would rely solely on an instinctive reaction to life, which can only be successful sometimes.

Curiosity is the key to intelligence, and because of that, the famous "apple" of the tree of knowledge (Genesis) was nothing but a symbol of the key which opens the door to our curiosity. The knowledge between good and bad, knowing how to create your reality through understanding the existential tools man has in his hands, allows us to become deliberate creators of our reality. To be our own gods. Suppose it wasn't for the curiosity of Adam and Eve. In that case, the whole of human history could be summed up by eternal life and one chapter of a short, boring book.

In current times, curiosity will be able to heal the masses. As more people today feel a lack of curiosity and creativity in their lives, they start asking new questions; they want to make discoveries and gain new insights. They instinctively know that this will help them develop creative solutions to contemporary and future challenges faced by the people, society, and the environment.

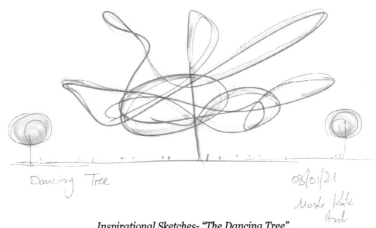

Dancing Tree

08/01/21
Moste Kafk
Arch

Inspirational Sketches- "The Dancing Tree"
A Dynamic Space / Sculpture

Chapter 5 - Creativity & Language

Man creates through words. Thoughts and emotions are being communicated through language, through words that resonate and make a motion. In the "Book of Genesis," God said a word 'so he says' each time before creating the universe and its infinite parts. This saying implies that the WORD already incorporates all creation and its realization if spoken or thought in silence. It contains the vision, the dream, and it's the first mediator of our ideas to the world.

A spoken word with its sound adds another level of reality — a vibration, a resonating frequency, a sound, and a tremble with its dimensions — height, depth, intensity, and so on. A word spoken out loud is already the creation of its meaning, the same as singing, which has the power to awaken our emotions and stir new worlds in our imagination.

The creative person considers words as sources: a source of inspiration, knowledge, or a feeling, a source as the beginning of the creative process. There is tremendous security in words since they already deliver a clear root, a recognizable sound, a law, and a meaning. The description of the word already brings us closer to understanding the theme our creative work is concerned with.

In the creative process, the word is the first translation of inspiration, of an experience into reality. It's the foundation upon which our entire work is built. It is the main principle of our creation. We are obligated to find its roots, origin — its etymology — including where it was born and its original meaning before putting more layers of content upon itself. The creator always demands the source, the genesis, the pure state of the beginning of things — that's where the DNA is, with its power to develop itself, through us, into a new, innovative concept, by an alternative evolution we put the word through. This evolution brings you to new frontiers but remains connected to the same root.

The further we go to the source, the more accurate the word allows us to be about our intentions. How far do we take the word back? Back until it's about to go back to silence, to a soundless meaning, to the moment of its birth before it disappears again to the void it came from. This is where the creator finds the secret and considers it as a building stone for his new creation.

(So, he says) It's the sound that incorporates the emotion and the frequency of the word's meaning. "When we bring the sound of the word, it already comes without our connection to it, our will, our wishes, and our hopes. It is combined with the spiritual and emotional expression we wish to bring to the world. To be aware of the word is to be mindful of what we are trying to create through it. That's why a prayer spoken out loud has the potential to create and change the world. Once all parts are synchronized and blended with a firm intention, the vibration, that's when the creation is already happening.

And suppose "God" created with words, so can we, creatures of his image. In that case, we use the word as part of our creative process, sometimes unaware of how powerfully a word expressed within us or out loud can affect our reality. (Life or death is in the

hand of the word), so it was said, reality and nothingness, the end, are both created through the word. Language allows us to be deliberate creators who choose to influence and build something out of a dream, out of a will, instead of simply reacting to life. To be the designers and shape our reality using words. That's the ultimate goal.

Each creation starts with the spirit, the soul that gives it life. That soul lies in the word, the idea, the concept with all its principles. It acts as a seed with its DNA of the potential result that grows at the end of the creative process, allowing different ways of expression. If we hold to that original truth, we are asked to provide another, new, innovative solution. The same DNA can bring us infinite results, thanks to a slight change of details or forces we apply along the way; in this case, we will certainly reach a different evolution than ever before.

The word brings life to the project and exposes its soul. A combination of words, their inter-connection, contrast, or comparison evokes different emotions. A field of words and intentions creates the perfect relationship between all parts. Creativity exists in the abstraction, the ability to strap the known meaning of a word down, look at it as a child, and as if, for the first time, discover its secrets and possibilities.

The writing, the language, and the fluent expression of what's inside us are essential habits in the process. The intuitive writing in the creative process shows us valuable knowledge, for the most part—higher wisdom. At the same time, our soul learns to express whatever is flowing through written words.

Sometimes, the creative process begins without words, even without a thought or any language. It's like trying to capture and experience a moment without any concepts or notions, in its pure state, with silence, as if in a void, where the thought is

not a part of it. When there are no thoughts, the pure existence comes to the surface, a pure moment of sensational experience of the world before words were even introduced to man, an understanding of the universe without any rules or language to describe it.

People have tried and still are trying to "clean" themselves gradually from all words, and languages through meditation, breathing, and attention or constant focus on things so that they can experience the simplicity of the moment through dimensions other than the mind — thought, reason, languages or meanings, without analysis or conclusions. Just observe and stay attuned. If the language is "turned off," parts of our human characteristics are also shut down. Some say it's a moment where the divine in us comes into play. The lack of words brings us closer to the infinite part within ourselves, the ones that are not limited or based only on the limits of reason.

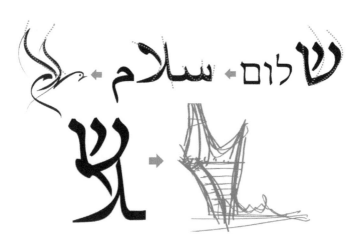

The Peace Hotel" project in Eilat/Jordan/Egypt
Conceptual morphology- From a word to symbol to space

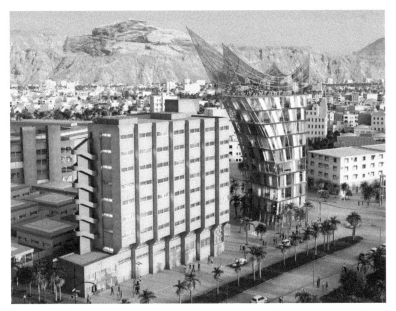

Rendering- "The Peace Hotel" in downtown Eilat, Israel

For us to reach a state of no words, we sometimes use repetition of just one word, which has the power to cancel all of the others from arising from within us, like the word "OM." Any other mantra that has the role in directing the flow of thoughts, the words, back to the nothingness, and turning our attention towards a different understanding of our environment or ourselves will do. The word "attention" in Hebrew means "put your heart." That's where the authentic experiences without words lie.

After such experience, derived from silence, comes a thought, a word translated through the sound and into the light. A different need for expression arises to communicate the past in a human language, as a social creature to others with a common language, or sometimes just to ourselves through silent thought. The awareness is translating itself into words which become the creator's essential working tool that he uses to connect and

develops his work into a tangible material state.

A creative person knows many words. The richer and more complex his expression, the greater the variety of creative languages he speaks with a final purpose of creating a story. The story of his creation is the new world he is developing for all the creatures in it. That world is a sequence of words. Multiple words enable him to reach deeper, understand, and be as precise as possible to translate his experience to others. In the creative process

Skill in dealing with words is one of the basic requirements of creation: a skill acquired through writing in unique styles and daily reading. The prominent Italian Renaissance artists understood it quite well. Many were also poets who wrote and expressed themselves through the written word. They showed us that the creator must control his spoken language in the same way as his artistic language (music, movement, dance, paint or any other).

The Word Switch: In some exercises, I ask my students to write a long text explaining their personal connection to the subject they choose. It can describe an emotion or any other concept. Still, the text must explain its relationship to that feeling or thing. After the text is ready, I take it, cancel the word "me" or "I" and change it to the word "space" or "building" or "cake" or "dance," depending on the student and what they study, architecture, pastry or dance.

Using this method, my students learn through the texts a new potential and a new perspective of the project, which is revealed surprisingly without even knowing about it beforehand. For example, a student wrote: "**Love** makes me dissolve into my primary state. I feel pure and free, and my motion is gentle, round, and harmonious...."

"Language Identity"- Two opposite worlds (Hebrew and Latin).
Building the new language with a new set of rule s(the letter-the symbol)
Connecting tensions, conecting worlds to one. Exhibited in Berlin, Germany

I changed the sentence to: "Love makes the building dissolve into its primary state. The building feels pure and free, and the motion is gentle, round, and harmonious..." By changing only a single word representing the main subject, we reveal the quality of the space they would like to design. Even though I was speaking about myself and my connection to love, it was just an exercise to understand what the building wants to become through us.

At this point, I need to use my imagination and see this text forming shapes in my mind so it shows the hidden potential of the building. The exposing tool of the creative design was the word switch. Then it transformed itself into the subject of my creativity.

A wordplay shows another creative dimension. We can easily take a common word and play with it, give it a different

relation or direction or change our point of view towards the subject. We rephrase the sentence, add a question mark, and ask if it can work differently or what the world dreams to be. The word is a flexible organism and requests experiment, playfulness, and a constant inquiry about its existence to discover if there is a new, unique meaning in the original word.

The word is a living thing. It develops and grows. It creates images in your imagination, a new world, a space. The word can bring forward our spiritual-mental freedom into full expression. It can move, change or start processes, but it can also imprison us.

The creator needs words. The child doesn't. Before a child learns a language, they are perfect. Children don't need words and are not limiting their reality to framed meanings or notions. They have everything — sounds, intentions, all the options are lying in front of the child before any limit is created by words. The word reduces and confines the experience, but the nonverbal child is free and is a limitless creator.

Our challenge as adults is to return to that state and relearn to work with the basics. The role given to words in the first place is a confining and limiting one. Out of infinity, a choice is made. This choice is then further narrowed down to a more clear and precise choices. All that enters a category with an exact definition.

This is how the world enters into boxes of meanings. I try to take the word and reverse the process. I seek to use it to liberate me from the chains of the common, agreed notions. Using the word to reach the infinite again, where its meanings are multiple and flexible again. In that space, I strive to discover added information or insight, with which I return to my process and use them in my creation.

The human creator is a storyteller, a dream creator who narrates it back to the world in a new language. Contrary to the baby, who has no words, the adult creator thinks, dreams, analyzes, explains, narrates, and creates a whole story of his being in the world or the dream he wishes to realize. Each creation demands a story, and each story begins with one word. As an architect and artist, I find that the word is the key to my work. It starts even before the idea turns into a concept. There is a subtle process. Before I use a common word, I allow myself to experience or understand the word in its infinity, not through its enclosed frame of understanding. That's the pre-word phase. As a result of the liberating experience, I begin to work with the word itself. I put it to the tests and look at it from different points of view. I build ideas, concepts, and short stories with it until their true potential emerges and is ready to be translated into the world.

The word starts the creative process by connecting to the origin of its meaning once it takes you to its genesis. It points out the beginning from which I must grow in new ways and unknown directions. It shows the essence of what needs to be created and manifested along the way — engraved into the soul of the project, which is the only and true home it has.

HOME — that's where it all starts.

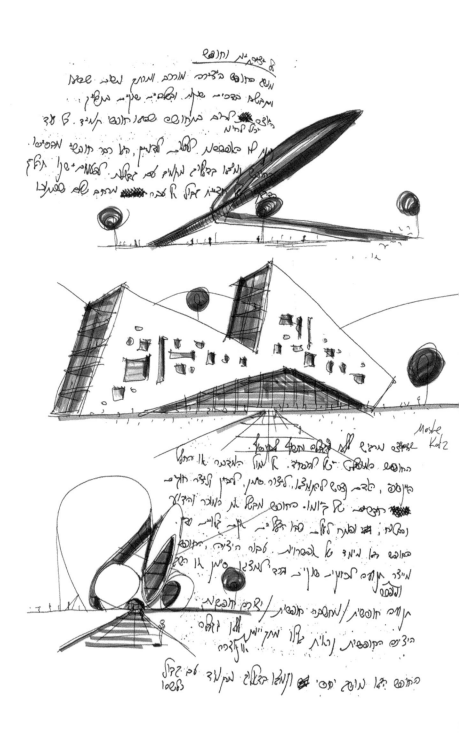

Chapter 6 - Creativity, Architecture & Design

I started my path in architecture at sixteen. Then I chose the profession I would love to have for the rest of my life. Until then, as a child, I invested most of my time in creative activities, allowing my imagination the freedom to invent funny, absurd stories. At those times, the cellular phone was not designed yet. The only escape I had was into myself instead of digital worlds (which were actually in development somewhere in the basement of an American teenager who would one day become a billionaire).

Out of love and passion, I looked for my place in that new infinite world that opened up within me. Of course, creativity remained an integral part of my life, very intuitively, unaware that I was mainly trying to express myself. My environment encouraged my freedom. I received only positive feedback from my family, friends, and schoolteachers, all repeating and emphasizing that I had something special inside of me. All I had to do was keep on going my way. All of them helped me believe in myself, and through their love and appreciation, I learned to love and value myself.

Everything works through voices. Children grow through the voices they hear on the outside: the voices of their parents, friends, other children, or significant figures. The more repetitive the voices are, the deeper they are engraved within them. With time, those exterior voices become their own repeating

themselves inside their minds. Even when the environment stops repeating them, the person embraces the messages and replays them almost unconsciously in different tunes and situations. These messages can be positive or negative. Both are crucial for their future. This is why children need to receive an abundance of positive, reinforcing messages and hear loving and encouraging voices in each situation, no matter what, even if this praise is not objectively justified. To this day, the exterior voices I remember are loving messages transmitted to me clearly — You are incredible! You are talented. Keep on going without fear! Keep on trying! You are safe! Everyone wanted my well-being and stood behind me, next to me, with the reassurance that only I knew what was best and encouraged me not to be afraid of trying, regardless of the outcome; All that's important is to enjoy the process and learning. These "freedom" voices became mine in time. Against all evil or limitation, and anything I have heard in my adult life from insecure people. These interior voices were always stronger and pushed me to unique, exciting places and paths. These voices of self-belief and bravery led me to peaks I would have never reached if I had accepted the negative messages that came from around me. My creative awareness was forged at a very early age. Thanks to those positive voices, it kept its place and was nurtured, improved, and remained an integral part of everything I did.

After realizing that the creative language I wanted to use to communicate with the world was architecture, my passion for it grew tremendously. All my sensitivity, curiosity, and abilities were directed at it. I chose to study at the University of Florence in the Faculty of Architecture. I was surrounded by the city's creativity and its' frozen beauty. The city became my best teacher, an intimate companion, and awoke within me that infinite inspiration. Thanks to all those gifts she received from the cre-

ative-artistic geniuses who left their marks in matter and space. I felt I was walking among them, immersed in their creations, and all that was left for me was to learn from the secret they passed on.

From the first moment on, I have read as many books as I could; they all, and not by chance, pointed to where my path is, a journey still ongoing today. Frank Lloyd Wright talked about the well of infinite inspiration from which he acquired his ideas. I was amazed and curious at the same time to find mine as well. Louis Kahn described space and light as spiritual and abstract raw materials and related architecture for me to a controlled yet transcendent experience. I loved Michelangelo, for he dealt with dynamism and tension in his work, expressing it beautifully; Dante Alighieri wrote about courage and passion for entering new worlds. Thanks to the divine comedy, I grew as an architect by looking at this book through a set of different eyes. I read the phenomenologists, existentialists, and surrealists, Salvador Dali and Breton, who reminded me again about the centrality of the dream dimension in my life. There were many others I have been exposed to, and they all became my teachers and guides. Time passed, but their words and works spoke to me and screamed ever stronger and clearer than any other living being I had met then.

At a certain point, I realized, just as an inner feeling, in some unique, non-logical place, that the most important thing I should learn to master is the creative process. That is, I put myself through a particular path each time I wished to plan or design a project, with the certainty that at the end of the process, I would find a new, original and innovative solution each time better than the previous one.

Still, no one was able to help me with that. Each professor

I spoke to and asked for assistance told me that I had chosen a very challenging, intimate, and complex path, making it impossible for others to help. Except for one, most professors didn't understand what I was talking about. Others dismissed or laughed about the concept of creativity or claimed that creativity if you are lucky to experience it, is nothing but the ability to repeat the same things that great people before you have said and done.

It was indeed a personal and a very lonely journey. I put myself into that infinite desert, where I couldn't find any orientation at first. I was left to wander, looking for clues or a direction to follow. On the other hand, this journey was full of incredible discoveries that were uplifting and unique, moments of fear, anxiety, sadness, confusion, and hope. I walked through this path for four years until I finally felt I acquired the tools to work with and was empowered to start experimenting with and improve upon for the years to come until I felt like my own artist.

The biggest responsibility of an architect towards the world is creativity. The architect is supposed to do everything within their powers to be as creative as possible for the benefit and well-being of the environment he is creating and inspiring the souls of others. In each moment of our lives, we are "wrapped" with architecture. It provides the background of our existence: the places where we live, work, and recreate, where we create our memories and express our most intimate feelings. That's why there is a tremendous responsibility to the one who is designing the backdrop of our lives. My firm belief and practice are that before a designed place answers to a practical and technical purpose, it must first answer to the needs of our souls and fill it with inspiration and amazement. That place must make your spirit dance with joy, even if it's just a design of a small bus station or a bathroom. The world already has computer software that provides reasonable, technical, and practical solutions for any space

design. Man is almost unnecessary for these tasks, while he is still very needed to revive spaces with a living spirit. Creativity was and will be the most valuable resource for our future.

Places without inspiration and creativity are being built constantly at a heavy price. Such sites don't "invite" the contemporary man to come, visit, stay and live inside, creating new beautiful memories, be impressed and surprised by them, appreciate and look after them. Although most people today have access to images and inspiration from worldwide, they travel and visit other countries and know that it's possible to create alternative and inspirational living spaces. Architecture, as a real estate business, architecture has taken the practice towards a capital-technical work of numbers and tables to calculate the maximum gain and profit with the minimum work, material, and "waste" of space for "crazy dreaming."

The guardians — the authorities and the representatives of the so-called public interest, whose role is to demand creativity and inspiration for the city's quality and its citizens — are not executing their most important duty. Creativity today is not a necessary condition in architecture and urban planning, and there is no demand to manifest it in a project. Only regulations, and planning limitations, which deal exclusively with the technical and logistic aspects of a city, become the crucial factor in defining the future image of the city. Senseless parking regulations, together with the absence of effective public mobility solutions by the city or government, force the investors of housing projects (for example) to supply the necessary parking spaces inside the lot, usually at the ground level, thus "stealing" our right for a street, for a city. The city is being experienced on the ground level only; that's where the public space lies and life takes place; the quality of life is created and where people interact and communicate. The vibrant street is the ancient institute we love

so much when we travel to old European cities; each walk is a beautiful and fulfilling experience for both – our hearts and eyes. And all of this usually occurs between the pavement and the 1st floor. This is where the city is happening. That's the floor that belongs to everybody, the ground floor, which provides the quality and well-being of human interaction, the potential for intuitive living, and creates the dynamics of a city. The ground floor is the engine of experiences with its continuous flow and development of a street as an urban connecting tool. The magic of a street is where life is being created and learned with everyday magic and surprises. It becomes the main principle of our identity and connectivity to a place, in an emotional, spiritual or physical way.

Once we are obliged to plan the parking spots at the ground level of our plot (if for economic or regulative reasons), the municipality says: "We don't want a street in our city! We don't want any life in it." That's how a city is developed with voids and spaces of no public interest or quality, useless most of the hours of the day: a city of parking lots or private garden apartments, detached from the public space – all robbing our rights for a livable city that emits positive energy and allows for greater standards of community living.

The result of such regulations and laws are voted on and decided by the representatives of the public interests themselves. There is no room left for creativity on any level. The number of limitations is too high and lacks flexibility for any innovative or flexible suggestions for solutions, especially for places, quarters, or zones that need it the most. They need a sense of community and public life more than any parking solution, and that's the tragedy and paradox of contemporary cities. Once the individual citizen becomes aware of being "robbed" of his street, it's already too late. The newly built shoe box structure is already built and standing.

Creativity is a responsibility and an obligation, not a privilege. **It's the moral obligation of the architect towards the world.** It is supposed to enrich our lives and reveal the hidden secrets of the place, its culture, history, dreams of the future, and relations to the environment. Architectural creativity creates spaces that are exciting and emotional. It elevates our spiritual or intellectual experiences. For it to become such, the architect is called upon for a creative process that helps him bring to light the maximum potential of a place.

Creativity in architecture transforms architecture from a simple instruction manual into poetry; into a place you want to visit and each time discover yourself as new or understand more of the profound, rich message it communicates: into an architecture capable of a dialogue with your senses and emotions and transferring you from the ordinary and the everyday experiences into a living dream. Such architecture grows out of a creative process, which seeks to express the dream of people to live and co-exist together. What does such a dream look like? What does a city dream of? How do you translate such a dream into reality? Look around you. Does that look like that dream?

The house, the apartment, represents a man's dream to live either by himself or with the first nucleus, the first institution he created: his family. The apartment or a house is his dream space, the environment. Look around your apartment. Try to look at it through this filter of your dream. Does it genuinely manifest your deepest dream of what home is, or is it mainly a means to satisfy your practical-technical needs?

Architecture that grows out of creativity aims to produce spaces that are, first and foremost, the expression of their mutual dream. That's the first objective before all regulations or applicable laws come into place. It's the architecture that seeks to an-

swer to the soul and spirit of a man. It grows out of love for them, together with the deep understanding of human complexity and all its triggers and layers for which we design our solutions. All are a part of the design for our integral, holistic well-being.

The creativity in architecture paves its way through each of those aspects and layers of the space, from the exterior to the interiors, to the details and furniture and lighting, up to the handle of the door and the choice of glasses or forks. Its concept moves freely inside each detail, the same as the soul moving and influencing each cell or part of our body. Creativity in architecture and design does not limit itself to furniture choices or the paint color for the walls, but the whole space and its environment, the shape and volume, the materials and textures, the light, the roof and floors, the open areas around it, the open and the enclosed ones as well. These openings, the stairs, and each one separately is part of a conscious, creative expression of the architect with the aim of surprising, unique, and exciting the user or visitor.

Creative architecture directly impacts the man and his mental and physical state. In contrast to sculptures or paintings you can take off the wall if you don't like them, architecture remains. It stays there for years and decades in its immense size and scale, dramatically affecting the environment. Otherwise, it is torn down. That's why the lack of creativity has a heavy price. For such a building to remain after a century, it would need immense efforts to heal. Maybe it's time architecture adapts the same pledge that medicine has taken: "Primum Non-Nocere: "First, not harm!" In that case, the responsibility of architectural creativity for our sake and the future's sake is high. The architect must prove and demonstrate his intention and solutions for all those complex human and environmental needs that transcend the practical component. In precise opposition to all architects who are sure that this profession is meant to cater to their own

needs and glorify their name, creativity in architecture intends to fix, cure, enlighten, surprise, teach and excite. The creativity in architecture derives from empathy. It's an act of loving the world and others. You are supposed to stand in or next to a building, and the first thing you should say to yourself is: "There was someone here who truly loved me! Someone who dreamed for me."

The House of Curiosity

As I entered the design process of an elementary school project in Impruneta, Tuscany, Italy, I immediately understood that I was not interested in repeating or planning a prison-like building that most schools look like today. My instinct told me that school is a much deeper and more significant component in a child's life than what meets the eye. I turned to a local school near my house. I asked the principal for permission to conduct research with 200 children in his school to get their perspective on what a school dreams to be: what are the deepest needs and wishes children have for their school

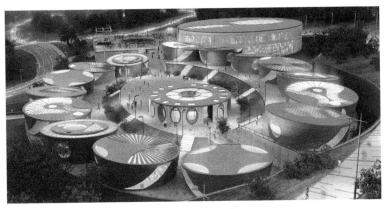

Rendering - Exterior view "The House of Curiosity"
Elementary ementary school project in Impruneta, Toscany

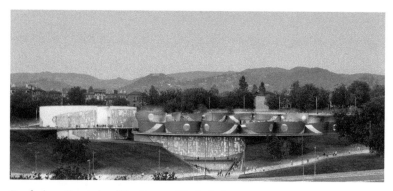

Rendering - Front view "The House of Curiosity"
Elementary ementary school project in Impruneta, Toscany

The whole inspirational research process with the children lasted six months. I gave them instructions to draw the "school of their dreams." Focusing on their dream was a strategical thought for two primary purposes: One - to reveal their current relationship to their existing school and, thus, understand what does or doesn't work for them, and two - to discover where their spirit asks to take them in their free imagination, where there are no limits of reality, what the environment they would love to stay in for most of their day, and what are the triggers that arouse their interest or amazement. I studied children's and adolescent psychology as a parallel process, focusing eventually on deciphering children's drawings. I discovered through them some insights I could never have reached by myself. These kids, through their dreams, became not only an inspiration but were the mere planning and designing principles and the final expression of the whole building complex in practice. I called it "the house of curiosity" because, according to my interpretation of the research, that's the school's central purpose: curiosity! The place where they learn to be and practice curiosity is directed towards the world and themselves.

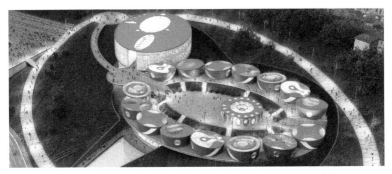

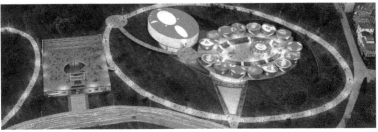

Rendering - Bird's view "The House of Curiosity"
Elementary ementary school project in Impruneta, Toscany

In my opinion, school is not intended to teach simple knowledge that can be acquired with a simple, fast touch of a finger on a phone or to learn more than what's already written in a book. Instead, first and foremost, school is there to teach children to be actively curious, to discover the passion for gaining new knowledge, and the desire for learning about the world and themselves. It's where they develop a thirst for knowledge. A place where they learn how to observe the world and look at it differently, a place that adds a filer of amazement towards life, the universe, and to themselves as unique, amazing creatures. It is a special place, personalized and built out of different singular spaces, beautiful and exciting in themselves. A school is a place where you learn about the unique, original quality each space is made of and recognize the hidden and visible beauty in each of

its details. Through them, I have learned about all the solutions I must introduce in the building, so eventually, the children were my primary guides while I was developing this project.

The school is built complexly. It is a world of different isolates, singular buildings, and a community of buildings living together. Each classroom is a world with another opening toward the sky and the landscape. It is framed in a way that emphasizes or provokes a question about the view we see or, on the other hand, how we know this space from the outside and ask ourselves, "What happened in there?" The eyes, the filter through which you look at the world, are different in each small class and encourage curiosity by showing us the world differently than we're used to. Small public squares complement the complex and other "meeting spots" connected with nature. The facades of the main building are designed with a screen that had children's drawings carved inside the materials, creating a unique language out of the voids that bring a magical light inside the space or letting the light outside at night and becoming an exceptional, uniquely expressive, cathedral-like sensation from afar. All of this was made possible thanks to the language of the children expressed through their signs and drawings that I have translated into the matter.

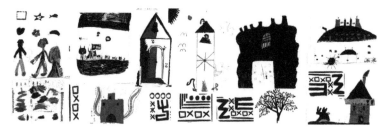

"The House of Curiosity", Elementary school project - The graphcal elaborations of the children's drawings to form the shading structure geometry and design as a customed light screen

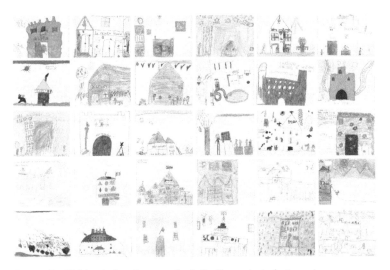

Research - Children's drawings as a basis for the projects design principles. "The House of Curiosity", Elementary school project

The connection to the natural landscape is direct or made possible through peripheral walkways, which are used at all hours, especially in the evening by all visitors. The school sports hall is built inside the hillside and integrates into the topography. Still, half of it becomes a glass wall toward nature, opening itself up toward the beautiful Tuscan panoramic landscape. The area has become a weekend park, perfect for sports activities or just a walk with the dog. At night, the sports hall is a mixed-use space for cultural and public events by all.

The "House of Curiosity" school was born out of the children themselves; I was nothing but a mediator, a translator of their dreams, and an interpreter of the profound original principles they revealed to me into space. When I met an older architect, who planned and executed many school buildings and told him about my project and process, he didn't understand why we put in the effort. "There are already strict rules and regulations by

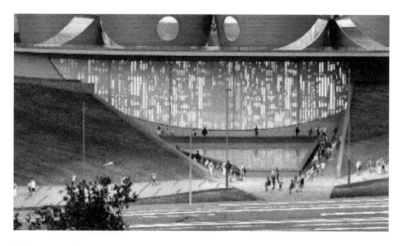

"The House of Curiosity", *Elementary School Project*
Light Screen Wall applied based on children's drawings

the Board of Education, and there is only one way to plan schools today...." I told him that after seeing his buildings, it was clear he had spent his time planning jail houses, not schools.

He did so without ever considering his main clients' needs — the children, their imagination, and their dreams! It was clear he never searched for the true needs of children: emotional, spiritual, intellectual, but instead only concentrated on the functional ones. " You don't love children!" I told him. "If you only had a bit of empathy, you would dedicate all your life or even just one hour to understanding your clients and their true needs. You would have understood how to design the right place for them where they spend most of their days." There was a long hard silence afterward, and we both parted, each one sure of his justice.

I have no children and probably won't have any; that's what life chose for me. One thing is certain, the project and the journey I went through were for one purpose only — so that one day, someone might say, "Here worked someone who truly loved me! Someone who dreamed for me."

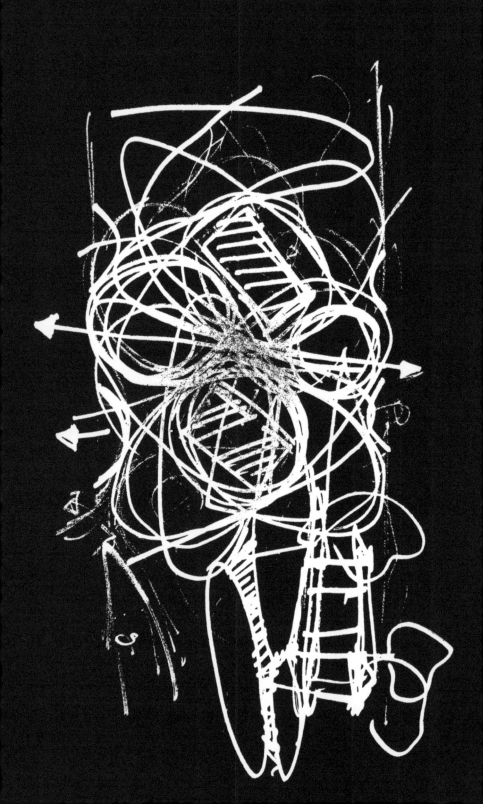

Chapter 7 - Creativity & Intuition

An artist without intuition, without the inner voice that tells him where to go inside the uncertainties of creation, can't work freely. Any creation is directly influenced by intuition, which helps the creator unveil the precious knowledge or a research direction he needs to take to create something new and original.

Intuition is our "radio device," connected to the universe, the world, nature, the people, and everything surrounding us. Intuition is the knowledge that is not logical. It can't be perceived through a tangible sensation. Instead, it is the wisdom that comes to us through our senses. Without proof or a logical explanation, the intense feeling of something being right and our positive sensation towards it grows out of a thoughtful process.

Through it, we receive energy and information from our senses after being liberated with our decision and confidence that our "radio" indeed can transmit and receive signs and signals that contain valuable information. We perfect that skill by letting ourselves be guided by it; we check and try to act through it. The more we try and succeed the bigger our confidence in ourselves, in our intuition and in the universe. At that time we are coming into silent dialogue with the universe, understanding that everything works in our favor. Always.

The creative process comprises many phases of uncertainty, of discovering edges and limits, of staying in the unknown while wandering inside the infinite desert of knowledge and all that's still hidden from our eyes and senses. The only guide that helps our orientation – helps us find our place, know the right direction and what details to trust, and when to pay attention, is our intuition. In the creative process, from the research until the execution of the work itself, the creator is required to answer or choose unexpected paths that lead to discoveries. The more we are skilled to listen to our intuitive voice and trust it, the stronger it becomes. More often it calls us. This is where our intuition enters the game.

An intuitive creation's advantage is receiving higher knowledge and unique and extraordinary wisdom. I can say about myself and significant parts of my works that whenever I open up and listen to my inner voice, allowing it to guide me towards a direction or choice, I always receive remarkable answers. To my amazement, they come from a different place than growing out of my interior complexity or rational thoughts. This added value and allowed me to discover a secret I could not do by myself.

With intuition, there is higher freedom; a particular way or form does not limit us. Knowledge comes from any possible direction. Sometimes at surprising speeds we don't expect. Therefore, we must remain observant and constantly expect a beautiful surprise. For the man who works through intuition, a higher sensitivity is recommended with more profound attention to detail, the ability to observe, and especially the ability to be absorbed in the moment. All these alone are qualities that enhance our creativity.

Creativity born out of intuition has a more substantial influence than any other creation and perseveres in time. Such

creativity exposes the deepest secrets. Even after many years, we will still be able to learn new insights about its beauty because of its vast knowledge and complexity and its connection to infinity. Such a creation becomes infinite as intuition is part of an aware, creative process when we take the role of a partner upon ourselves. We are partners in creation with the whole universe, which has its part and brings its intention into expression through us. The ability to increasingly let go of control of things is an immense privilege and gives us great satisfaction. It's a powerful sensation we can't feel in a merely technical or practical, rational process.

The inner voice is the most important one, not only for creativity but for life in general which is a creation in itself. Once synchronized with our actions, this voice creates a connection of an existential meaning until our inner core, inner source, works with it in a perfect match as all our layers. Creativity is at its peak, the potential for success is the highest, and the feeling that arises is that of perfection, satisfaction, and happiness.

For most of our lives, we learn NOT to listen to our inner voice, not to use it or trust our intuition. We were taught to trust our rational thoughts only, the ones that prove and analyze the reality and the logical making of our decisions, things we can "control."

That's why people detach slowly since their childhood from the deepest, most intimate connection with themselves or their surroundings. That's why it is crucial to find our inner voice and the connection to the universe as creators, so we can find authenticity in our work, to feel that we can create from within ourselves as artists, perfect as we are and connected to the deepest roots within us. Thus, an ideal creation is in synchronicity between our interior source and the source of the universe.

The feelings, and sensations, that imply our active connection to intuition are the feelings of satisfaction, uplifting, enhanced curiosity, a passion that emerges once we follow a particular path, acquire a higher motivation than the ordinary, and develop positive confidence that we were doing the right thing. We have a deep understanding and reassurance about the path we follow, even though we can't explain why. Each negative feeling or sensation implies distance; it is vital to observe and pay attention to the positive or negative waves we face and always choose the extreme positive ones! Fears are not intuition; on the contrary, fear expresses our distance from intuition and detachment from it. Fear is demonstrative of how far away we have moved from our source.

For those searching their way back to intuition after many years of blockage or detachment or not following its signs consciously, it's a constant practice of trying again and again. Whenever there is a problem to solve or a question, not escape toward the secure ways of logic. Instead, we must observe the answer that is coming from within. Without explanations or a concrete conclusion, look for the extreme positive feeling that arises from one option. Ask yourself, "What feels the most exciting and positively overwhelming? What feels right or fascinating to me? What fills me up with passion and curiosity?" Whatever the first answer comes up within your body and mind, that's how you know you are right. It's a process of practice and tryouts, what worked, what didn't work, trying to figure out if fear was a part of your decision, observing the mind and spiritual state you were in when you made the right intuitive decision that turned out to be perfect for you. That's how you build, step by step, the renewed relationship with your intuition. You should not be too hard on yourself if you are not accurate at times. It's all an essential part of your growth.

I teach my students the same technique and habit of listening to their inner voice. Whenever they ask me what I think about their work and how I think they should solve a problem, I instinctively respond, "Come look at what you did. What is the thing that most excites you? What is the first thing that pops into your mind, takes your attention, and makes you scream, "Wow! OMG!" And that's the direction we must follow and develop. It's a direction that always proves itself correct. I trust them and their inner voice that knows what's right for them and will lead them to their path of growth; it just needs a reawakening to connect them back to their intuition, so they learn to listen to themselves again. So, they can trust themselves and the path it leads them to, which starts with the unknown and uncertain, but always yields a magnificent result in the end.

In the first stages of a project, my students often ask what theme or subject to research and which direction to follow for inspiration. To these questions, I always say that there is no other way but through yourself into the infinite sea of knowledge. The current will take you in a different direction by itself. As a child, I nearly drowned three times in the ocean, carried by the sea's currents to intense swirls. Two times I have been rescued, the first time by my brother and the second time by a stranger, but the third time, I let go and didn't even try to get out by myself. Instead, I let the sea do the job. The current took me out by itself; something in me had to trust it for survival. Today's research is a similar process. Each finger that clicks on a mouse or a smartphone takes you to a swirl of millions of new pages, each one taking you to others and so on and on. What needs to guide you in that motion is not a rational thought but an awareness of the question, "What feels wow to me! What particularly catches my attention?" Even if we don't understand why this is what happens. Give yourself the freedom to flow with the current, right

through the positive feeling that arises. Explore the new directions; follow the trails. Excitement will guide you through your decisions, and curiosity will help you discover the complexity and depths of the process.

Imagine entering a coffee shop. Look around you. Just observe, and then, a person catches your attention in some positive way until something within you says, "Wow!" Now, what do I do with this wow? It's a sign. We should walk toward that person, meet them and try to get to know them, if possible. We should be active based on our intuitive curiosity and get to see the world through it. The wow is always right. It's the start of our journey toward a secret: to a sign which becomes your project's starting point. At each crossroad, let your inner voice decide. Still, most important is to document the revealing of those signs you discover along the way and bring them back to the creative process as building stones.

In the beginning, the first steps of your intuition's path need guidance. Someone you can trust to walk with you and show you, even if it's just once, how amazing it feels to reach your highest potential through an intuitive process. After you see the fantastic things intuition can do for you, you learn to trust it as a partner in life that always brings out your best.

There are some instances where our connection to intuition is easier. It depends on the environment we create or the conditions we face, like silence, music, being inside or out in the open. Sitting in front of the sea and the waves does the work for me. When I concentrate on a question or finding the starting point for a project, the hook, I try to feel what it is that seeks my attention to be researched further. There, it always happens by the sea, as if the waves bring it to me from some distant source. For me, the sea is my home. The closeness to it comforts me and strengthens

my sensation of identity. Each coastal place I ever visited made me immediately feel like I belong there. The ocean captivated me. I visited it, I dove into it. I know its depths. I surfed it. I know the feeling of synchronicity with that powerful force of nature of an ocean wave, and I understand how fragile the human is in front of it. I am attached to its endless motion and dynamics, and I embraced it and took it inside of me into my world.

I took it into my life as a nomad moving in a constant motion, outside or within, and as an architect who researches and produces dynamic architecture and employs motion in his works. The sea is where my inner source identifies and feels most comfortable. Each one of us knows those places where our identity and freedom surface with ease. It would help if you started reconnecting to intuition in those places that make you willingly let go and relinquish control.

Intuition starts transmitting information like a radio station when you release the need to control situations with your logical thinking. Your inner voice as a skilled DJ brings the messages through you until everything is clear. That flow of knowledge can last a long time, or some hours, or sometimes maybe just a few minutes or seconds as long as we maintain the balance and don't fall into logical thinking. The flow in this critical stage will continue if you can surrender, trust it, and observe and document everything that comes to you without judgment or rational processing. Just be in the moment and enjoy the discoveries.

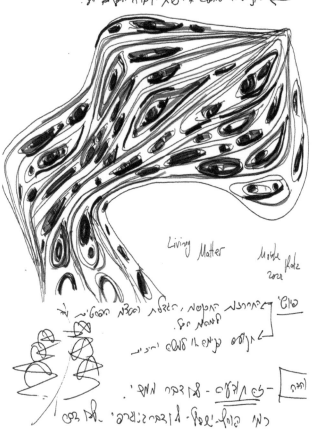

Living Matter

Moshe Katz
2022

Chapter 8 - Creativity & Spirituality
Love, the Dimension of Now: Synchronicity

Creativity contains and works with all the layers of our existence. The spirit, for those who believe in it, also contributes to our creation process. We will see its dominant effect on our work if we give it the freedom to express itself. That's why we need to be aware of how the spirit works.

Spirituality is the network of relationships and influences inside us, which are integral parts to creative process even for those less acquainted with the specific language and the terms. The word "spirituality" has in these times different meanings and interpretations. Some of them underestimate the spirit, the soul, and their importance. Some revolve around religious or New Age practices such as yoga. Today, more than ever, we are experiencing a time of growing awakening, where people are increasingly committed to their spiritual search. This special force unites and becomes a common language between people from all over the world.

Many artists of all times, when describing the peak of their creative work, described it as coming to them from nowhere, almost as a surprise. They "just knew" what to do, and the creation just came out in a constant flow into the world. All that was left for them to be in that moment was being a mediator, a

channel. Beethoven, Dali, Michelangelo, writers, poets, painters, and scientists from all times wrote about it as they described their creative experiences. And today, as an architect, I wish to add my profession and say that **spirituality is an integral part of architecture**.

The phenomena of releasing a creation, as if it comes out of nowhere, is in reality our spirit which elevates and tunes itself as a radio. Its purpose is to receive the chosen messages passing into reality through us, in the language of our choice. This approach considers that there is another dimension in which everything is bubbling and exploding with events and potentials – the creative dimension, where all intersects and comes together with the urge to become a reality.

It resembles the raging sun, creating explosions of atoms spreading all over the galaxy. Electromagnetic waves and energy make their way through the infinite void in search of a match or a meaning. Light rays pass through the stars, planets, moons, and black matter, crossing systems until they reach our Earth. Then, making their way through the sky, passing between clouds, through accidental holes made between them, in a tiny crack the size of a finger, past buildings, next to windows, trees, and through the infinite leaves – precisely in that small space created by the wind, and then – sharp as a razor, from all the possible things in all the universe, the light meets the tip of my finger. A handshake of peace between infinity and me is happening in this quiet moment, awakening my spirit because it reminds me of its source. It's a moment of inspiration. That inspiration becomes a sign on paper. That sign develops and grows into an entire creation manifesting in the world as space and light in motion, as a meeting place between people and the setting sun in its daily dance. I called it: **Sunsetarium**.

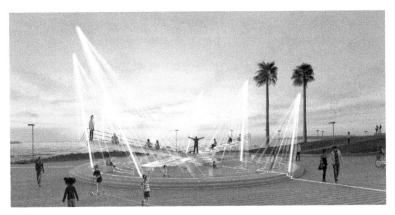

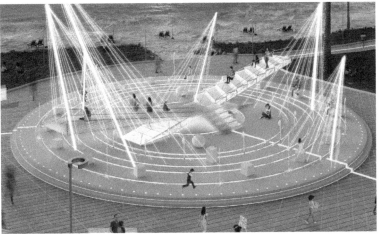

Rendering - Sunsetarium Project, a cultural/social meeting space for sunset lovers to celebrate the ritual of the setting sun

And so, from the dimension where all things already exist, still as a potential, they look for the "sucker" (as the poet said) who knows how to take them and bring them into reality, into the world. In that sense, we are letting go of the primary right of the creation. We acknowledge and understand that our role in the process is the mediator between two worlds. It happens

through us, as chosen by our open spirit, through our sensitivity to receive the message and bring it into existence.

The spirit knows how to identify that process, a motion of the creation passing through it, which demands quieting our ego. Most "artists" have a developed an ego because they think they are the beginning and the end of the creation. Nevertheless, the creator who operates through the spirit renounces control and judgment of his creation by putting his ego aside, accepts anything that decides to pass through him, and uses his sensitivity to be as accurate as possible in the translation of the message he is inspired with. This is the most crucial preliminary phase – temporary cancellation of the ego and acceptance of your role as a mediator: a partner in the creation but not its origin or exclusive owner.

During the second phase of the spiritually-based creative process, an emotional element comes into play. Love. Love is the emotion that opens and sharpens our senses. I am not referring to romantic love but a pure, empathic love that sees as its goal the wellbeing of others, the wellbeing of the environment, and the world. The people who will experience the creation will witness the improvement of their lives, find the solution to their problems, or even "just" make their spirits elevate with amazement and happiness.

Through the love for the other, the voices become clearer in us. They are more beautiful and stronger than ever before. I see in my creative process in architecture that love is my powerful motivation. It brings a responsibility with it, a charge for the happiness of others. It shows us how to help others and contribute to the quality of their lives through the creation that makes a better living environment, not just for their bodies or to satisfy practical needs, but mainly for their spiritual and emotional

wellbeing (which will strongly affect their physical needs as well). When designing, I always ensure that my emotions emerge from loving the place and the people who will live here. I love them so much that it makes me work harder and never allow myself to compromise. I learn where the right moral decision is. When encountering morally wrong considerations, I know I must keep my distance.

Love is what makes me inquire about all viable options and never rely simply on the familiar and common solutions, because the only way for me to help the world is to innovate. A love of that kind is a powerful motivation. It puts me in a constant state of inspiration, the same as loving someone and seeing only what's beautiful and magical in them. Only this type of love is aware and more controlled. I choose to put myself in that position, to fill myself with that emotion. It's a choice, almost meditative, which leads me to a total commitment and surrendering to that feeling. When I get to a project site and fill myself with love, it is that feeling that makes me see the hidden potentials and beauty of the place and reveals its secrets, the magic of each element or connection I discover. I start dreaming on behalf of that site and wishing for its happiness. I connect and communicate with it in a dialogue of lovers. Otherwise, in a different situation, I would only see the ugly and worst of its letdown conditions, the apparent problems and limitations, and the lack of opportunities the site presents in its raw state. I would do a cold, rational analysis, almost a medical one, which would lead to an announcement of a 'death of the site.' I choose to be in the first state of mind, as loving a person focusing on the strengths instead of the weaknesses. This is how you develop new relations and possibilities with the object of your love.

In the creative sense, love transforms itself into the right moral decisions and elevates motivation. It sharpens your sens-

es and allows the new energy to flow through us, almost as an act of love that creates a new being. This is the same as a creative process; it has the same motion and quality of the spirit that leads all efforts toward an entirely new existence.

Another connection I find between spirituality and creativity is the "now" — dimension. The most appropriate time dimension for spirituality and creativity is the now—the present moment. Our giving in to the instant allows the flow of things without judgment or interruptions, without the heavy burden of the past with its traumas, or the expectations of the future with the feelings of uncertainty. The only thing we can be sure of is now. In the perfect instant, the present perfect time, everything is happening through an intuitive and spontaneous, thoughtless flow. Just like that, we let things happen from observation and synchronize our movements with our emotions. Our ability to give in to the instant is the space from which creativity emerges.

In the spiritual-creative process, everything comes through a synchronized motion. Synchronicity is "forces which operate in consideration to each other to reach a mutual and harmonious motion forward and one that is in a constant flow." As opposed to balance, synchronicity does produce motion. That's why when a spirit brings its higher knowledge, all our existential layers, the physical, mental, emotional, and spiritual, synchronize themselves to it and emerge into the world through us. Everything is supposed to be a part of that motion. The spirit is the beat of the drums, leading it all. On top of that, we put the strings of our emotions, the singing sounds of thought, and so it goes layer after layer, we build our creation's "music" structure.

Creativity that comes from the spirit takes its knowledge from a higher source. The information it provides is powerful,

valuable, and rooted in the mystery of infinity. We receive glimpses into parts of that knowledge as we recognize and acknowledge a principle or a law, almost as a small hidden pearl that inspires us. It's a unique knowledge that connects different insights and extreme complexities, so each one who receives it immediately understands and feels that he is dealing with something bigger than himself or his abilities. When the creator believes in that assumption and allows things to happen without resistance, judgment, or fears, that knowledge passes through in the fastest and purest way. After one such successful process, a "frequency" is finally opened, and more knowledge comes through each time we wish for it to happen. That "frequency" is our precise radio station in constant transmission. Once we cue that station, we can stay tuned to it as much as we wish. All that's left is to listen to its messages through our intuition and give it some form of expression in a language of our choice.

Spiritual creativity always tries to forge new relationships and connections with the universe in its developing process and final manifestation. Louis I. Kahn, in collaboration with Louis Barragan in their Salk Lake Institute project, designed a water channel that crossed the main square, dividing it into halves, straight toward the ocean, connecting it almost with a direct line and direct touch. One day, at a particular moment, during one specific sunset, the light will enter the space as if it were only made for that purpose alone. At that moment, an almost mathematical connection will be created between the man standing in the square and the water channel, creating an expansive sensation of the man directly toward the ocean, the sun, and the stars. And so, in one moment, a synchronized connection has been achieved through all.

That creation has immense power because it is expressed willingly and in a controlled, conscious act connecting to the

universe and all its parts, thanks to an understanding of a hidden law: an existential law we are exposed to through this project. That's spiritual architecture. It comes from the universe through us. Afterward, it connects us back to the universe, back to the source through concrete work and matter so that we can complete the circle. It unites us and reveals its primary secrets—that I, the space, the water, the sun, and the whole universe are all a part of the same system and constantly connected as one.

One of the beautiful examples of spiritual architecture is the Pantheon in Rome. The Pantheon exists thanks to one opening at the dome's peak, precisely in the place that is supposed to symbolize the maximum stability of the arched structure; that's where you find the void instead. The universe enters through that particular void: the wind, the rain, and especially the sun. It is considered a space created as a light container for the sun. With its constant motion, light enters the building through different angles, moving inside and emphasizing the hidden principles of the space and the changing time. In each moment of the day, the sunlight falls on a different statue of another god so that all of the principles of creation are shown in a cycle of one day.

The Pantheon is an architectural space created mainly for its connection to the infinite, the universe, and its laws. Its symbols, but primarily it is the light that takes us back to the universe. The Pantheon excites me each time I visit it. Who can remain indifferent to a moment where you and the sun are entering into direct dialogue, and she is telling you her secrets? Each place developed out of the understanding of the laws of the universe, their expression, and the dialogue we create with them in reality - all these make us eventually return to our infinite source. That spiritual experience uplifts our soul thanks to its renewed connection. My source and the source of the universe are one again.

In the connection between creativity and spirituality, there also lies the element of faith of trust. The faith that there will exist an extraordinary creation at the end of the process, even though during the first steps, we have no certainty or a clear direction in which the project will develop. That faith helps us cross all of the insecure stages of creativity, each demanding to see a result and one filled with the fear of "getting lost." In the beginning, most creators are afraid of getting lost and not finding the proper focus for the absolute expression of their creation, but there is nothing to fear. You can never get lost. It's just wandering nomadism designed to find signs, knowledge, and information, the inner voice that shows us the right path to follow.

With each project, I start as new, as if I forgot everything and needed to learn all the basics again. I enter the dimension of the concept or the location where the project is supposed to be built and let myself walk freely and get lost inside it, as I usually do in new cities I visit. I walk in its streets without an intention or goal. I get lost in its small corners and pathways without knowing where they lead. This wandering sharpens my instincts and senses. I experience many moments of discovery and amazement that stay with me as inspirations. Then, at the time when everything is unknown and awaits an answer, this knowledge or information comes to me because of the survival instinct we all have. Each thing is lived and experienced intensely until we are again surprised by the discovery. Each detail enters inside of us and becomes a part of us. Even after all these years, I still remember the shape of the stones, their cracks and color, and the light that penetrates their voids from the times I got lost in the streets of Florence; each new detail is still exciting and fresh through my eyes. Same with the creative process. I allow myself to be a wanderer by choice, like a nomad with the same attitude as Baudelaire or Walter Benjamin. The only difference is that in

the creative process, the wandering is also inside the infinite spaces within me.

The only security I have is the trust in the universe and intuition, which knows how to take me towards the knowledge I search for. I am confident in each process; even if its beginning shows uncertainty, I know it will eventually lead me to an original and innovative solution. I enjoy the process with playfulness, knowing I will produce incredible creative work. My spiritual strength is the force that allows me to stay in such a beautiful condition. I am yearning and looking for it with the excitement to discover where the roads will lead me. The spiritual creator designs his reality consciously and deliberately without being a reactor to life only, but as someone who changes and shapes their life. Living is not a passive but an active role.

The spiritual creator bases their knowledge on understanding the spiritual laws and principles and their connection to the universe. He understands the deep hidden relationships between everything around him and the laws of creative gravity, the laws of attraction: when our emotion, or emotional intention, sends its signals out to the world through vibrations and resonance to what we are wishing for or need. The laws of creative gravity applied by the universe bring the results back to us in different forms. Once it's out of us, the creation, our "design," is already made. It's done and on its way back to us until it manifests in reality or through our senses.

The time gap between sending out the requests for knowledge or signs until we receive them can be seconds to days or even years. It all depends on how "open" we are to allowing ourselves to receive them. It mostly depends on our trust in the universe and how much or little fear we put into our experience. Once we feel those contrasting feelings, instead of excitement or

joy, we feel fear or doubt, which only serves to block the flow.

We are asked to trust the universe and enjoy the process as if a child who ordered a great toy awaits the mail to come with his package. We wait with excitement and positive expectations, imagining how it's wrapped and sailing on the ship in the ocean on its way to me. We imagine how much fun it will be to open the package, how magical and exciting the moment of playing with the new toy, and all the beautiful things we can do with it. There is no fear or doubt involved. Even though the universe has its time, things happen in different rhythms because of life's complexity and the vast network that connects everything and requires synchronization.

Architects frequently find a gap of years between their dream and their project vision until its actual on-site execution. In that gap, the architect's role is to keep the dream alive and maintain the enthusiasm and beauty of the project in his mind. In that sense, he is the deliberate creator instead of a reactive one. The architect dreams a reality down to its smallest details a long time before it's even realized, manifests itself within matter, and proves to all that his dream was worth dreaming.

Here as well, in architecture, the path is complex and made of infinite parts which need to be synchronized so that the dream can become a real space, a place that manifests his vision. Holding the flag of the vision, the creator is responsible for believing in the dream and convincing the world of its value and beauty to excite others about its arrival; he makes the whole universe work together solely in favor of the project.

dalla striscia di cielo - con passare
del tempo - verso il tramonto il cielo
si apre per assorbire tutta la luce.

movimento ciclico - pieno - uguale al momento
del est.

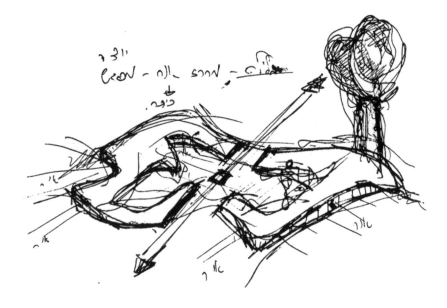

Chapter 9 - Creativity & Awareness

The creator has a flexible awareness that can change quickly at any time. For example, unlike an ordinary person who looks at a tree, he can change his awareness and see a different thing than a tree, a new being, together with its environment from a distinct perspective. The awareness allows a man to have different points of view, far from the ordinary. Once his awareness changes, so do his senses and understanding of reality. An awareness change in the creative process allows you to expose new dimensions within the subject. This becomes a valuable tool in the inspirational research phase.

The creator's awareness is changing through the connection to distinct roles or the acceptance of reality and laws that are different from what we know. For example, the child's or the poet's awareness completely differs from the common one. Accepting a certain truth, even if temporary or integrated throughout the process, creates a new and unique vision. Some of those truths imply that one, the reality is just a recommendation and two, the time perception changes. Instead of going from the past through the present towards the future, it goes in different directions, opposite or parallel, perhaps. Another possible truth is that we are a part of a much more complex process where we have other partners in our creation with whom we can create a new reality, still hidden and unknown to the visible eye.

Beauty is everywhere, and it's not only our responsibility but also an obligation to find it. In this sense, we accept the belief that behind everything lies a secret. Something which hasn't been discovered yet, some new beauty awaits exposure. If we haven't seen it yet, it's our "fault" because our awareness wasn't elevated yet to that extent, and we failed to open our eyes to the new. Rainer Rilke: from the letters to a young poet succeeds in describing that awareness change:

"If your daily life seems poor, do not blame it; blame yourself, tell yourself that you are not poet enough to call forth its riches; for to the creator there is no poverty and no poor indifferent place."

The more flexible the creator is with different types of awareness, the more hidden secrets and original insights he will find. The awareness changes as we take a new truth upon ourselves and try to experience life through it and act based on it. For example, in one room, dozens of people are standing and living by the same objective truth: a table is a table. They all agree on its details and its purpose within our reality. Nonetheless, it takes only one to change his awareness and look at the table differently so that he can discover an entirely different object or its purpose. He won't see a simple table but a process of becoming something else. A table is just a table in its first steps of development, but what if it's just a step toward a different object altogether? Thanks to its material, texture, or the complexity of parts and joints, there might be hints showing where it might lead using nothing but our imagination.

Sometimes creators are looking for a new awareness from different angles or points of view. For example, they start observing the world through the height of an ant or looking at things from a zoomed-in microscope perspective or, on the other hand,

from a bird's view. Another option might be to look at everything backward or upside down; For instance, the Lilliput awareness looks at a rock as a whole house or a city, whereas a tree's log looks like a mountain or a complex topography that might be colonized and made into a home right in between the cracks. Changing our awareness is essential because it allows us to be in a constant state of inspiration and awe of our discoveries of secrets and signs. Those signs are vital for the creator because they become working tools inside our creative process and the expression of the final "product" or project we are planning.

As I look at the world from an ant's perspective and its life awareness, I can momentarily experience what it means to live as an ant and imagine its life conditions. Once I enter that world, that "me," the person in me, is immersed in that new environment and lives by its laws. The new relationship between me and the new reality allows me to discover new insights into this unique perspective.

I can take this view back with me to the "old world" and understand through it an original principle or a way of being. Can I adopt some of the new rules and details I have discovered from my "ant-being" and change the reality of the "human being"? Is it possible because I was part human and partially ant for a moment? I do it sometimes and think to myself, what would it be like if I had the job of being the architect in the world of ants? What kind of space would I design?

The changing awareness delivers infinite possibilities and original identifications. It's the creator's responsibility to translate those identifications into signs, document them, and adapt them to the conditions of my working process. That's the actual translation. The translation process is already a creation in itself; it has the inspiration, then comes the choice of what to

concentrate on. Then we create a hierarchy of importance and meaning. Finally, the creator chooses how to abstract and clean all the less needed elements until he reaches the purest form of expression as a sign – a drawing, a model, a sound, a movement, or any other language he uses for his creation.

The creator's awareness is always free; it has many faces and motions, enabling him to wander between different perspectives of sight or thought. It even allows him to be in another person's shoes and imagine or live their existence for a moment. It will enable him to be the whole universe or a small, tiny grain of sand on the beach. In the "grain-awareness," he asks questions, checks, or experiences, trying to understand what it means to be a grain. He analyzes the new relationships with its environment, the ones with the wind that can change its position, and how you would exist with other infinite small grains right next to you. You create a notable, dense structure that moves and changes constantly. Once he is equipped with the new awareness, he starts examining himself – now that I am a grain of sand, a "grain architect" who got the job to design a house for my "people," what would it look like based on my new knowledge of the 'grain world'?

When walking barefoot on the beach, do you ever think about a house for a grain of sand? Most people don't change their awareness to that extent. Still, the artist uses this tool as a working process, with intentional playfulness and the purpose of training their mind daily to change and open up new worlds. Alternatively, they do it only for the great fun and enthusiasm in discovering small secrets that can only be seen once you shift the perspective. It's creating an intimate relationship with ourselves by having our special "glasses" only we can use to see the world differently while no one knows about it. Imagine I had purple glasses, and now the whole world looks purple to me.

That's a new law. How do you live in a purple world? What's new or unique about it? How do things change for me, and what are the new needs I discover? Do I understand something about my old world through this filter or limitation?

Such a shift of awareness sometimes demands a physical transformation, changing our position, height, or place, like entering a tunnel. It works with different rules, similar to the worlds of Alice in Wonderland or Peter Pan. On the other end, everything is different.

The Child's Awareness

A child's reality is not constant, fixed, or certain like one of the adults who place too many layers of truths and objective ideas on the child's perception. For the child, everything is always possible (except for the limitations and boundaries he receives from his parents or teachers, who gradually limit their freedom). The child is still flexible in his awareness. We look at a glass of water; for us, it's just a drinking tool. But for the child, it can be a car, a truck, a superhero who saves the world, his best friend he talks to at night and tells him his secrets before falling asleep. The glass as glass is just a recommendation for him. In his awareness, the child can make anything out of the glass according to the level of flexibility, safety, security, and freedom he feels. The child's awareness still hasn't been fixed, limited, or closed, as will happen in the coming years if he doesn't make sure to keep that part in him active and alive. The more you fill the child with reality, his free awareness will shrink. He will cease to wander and discover the world through different perspectives and come to conclusions that the masses do not objectively agree upon or understand.

By learning not to activate that awareness, the child reaches

adulthood and suddenly awakens and understands how creativity is a significant, necessary advantage and essential for his survival and success. He might also know that he or she would like to be a man or a woman who innovates and develops unique solutions. Still, at that point, he would have to work very hard to unpeel layers after layers of resistance, blocks, and mental fixations he has accumulated all his life. Layers that make his mental, spiritual and imaginative motion so challenging prevent him from developing his unique creative potential.

The child's awareness is perfect. Maybe that's the role of children — to remind us of the real purpose of our lives. Never forget or run away from creativity; instead, learn from it and understand how to return to your own source. Any child can teach us more than we can teach him. Look at the children. Observe them. Try to understand them, adopt their instincts and intuitions, and imitate them, for they are the best teachers!

The Poet's Awareness

The poet's awareness takes upon itself the truth that beauty and inspiration are everywhere and in everything. If we can't see them, it's a sign that we lack sensitivity to recognize these characteristics, or we are not looking from the right perspective, depth, or interior freedom, all of which are blocked by our judgments or habits. The poet can access the depths of all extreme experiences, but can also look at things outside and be a spectator of life. From the inside out or the outside in, the poet's awareness works through strong intuition and sharpened sensitivity in search of signs, symbols, and images representing their world. Sometimes it's a process of abstraction; sometimes, it's a concretization. The poet can recognize life's meaning in a single ray of light falling on a leaf. In that eternal moment, he

discovers the secret of his own life, inside a tiny, temporary detail that becomes eternal. He recognizes the temporary element in the infinite and eternity inside the passing moment giving it an expression, a sign, a symbol. He looks for the complex new relations in the things he observes that present themselves to his senses; he imagines the whole story connecting everything and appreciates its symbolism.

A single ray of light on a leaf reveals the relation to the dark environment void of light; in contrast, as a divine sign, a precise finger of God is sent from the skies to point out the most important thing of all — one leaf moving slowly on the ground. That perishable faded leaf in the wind, weak and helpless, unaware of its faith. How does it act in its environment? Does it change itself or its surrounding? Does it maybe symbolize something thing we haven't seen yet?

These relations of opposition, completion, subtraction (absence), and amplification allow the poet's awareness to recognize some hidden secrets and signs behind the things he observes or experiences. In that sense, awareness is a working tool at the hand of the creator. Artists use their awareness to recognize signs and symbols that become, in their time, the building stones of their work, the beginning of their research and analysis, and the unveiling of the potential of their creation.

There are two main opposite motions the poet's awareness has:

1. Toward the infinite smallest detail — understanding the universe through a grain of sand.

2. Toward the expansion to the whole universe — understanding the grain of sand through its connection to the infinite.

This awareness shift brings us infinite pieces of a puzzle about the subjects we examine and redesign. Once we collect as many as possible, we ensure our creative work is richer and more interesting.

To become aware, the creator must expend his attention to details and notice relations around him. He becomes "aware" of them, aware of the infinite details they're made of along with the infinite connections they manifest within the world as a network. The conscious creator feels the grass moving in the wind, the feet of a dog playing on the grass, and the fur of his leg rubbing against it. He feels the body's motion, the traces his body leaves through his existence, the tail moving fast and displaying the dog's mood, and so on, until he can see the connection between the grass, the dog, the moon, and the rest of the stars.

The more we expand our attention, the more details we absorb. Each piece has a purpose, a meaning, and need to receive a place within himself. The perfect exercise starts with observing, experiencing, and paying attention to this moment. Then describe as many details as possible and their connections, patterns we recognize, and ways through which we let our imagination run free and maintain the flow of describing the unique and extraordinary things we find about this very instant.

The awareness comes with heightened sensitivity. It makes you grow as a person, connects you to yourself and the environment which is filled with its hidden forces - such as energy, which is constantly present. We all feel it, especially nowadays, as this subject is commonly discussed. More and more people are receptive to these new perspectives. Each awareness practice only strengthens the quality of our creativity and allows us to bring in more original, interesting layers of knowledge into our work. The more a creation is filled with different elements

that grew based on our awareness change, the stronger our personal connection to our creation is. When this happens, we will feel ourselves inside of it, as if it was our own expression of our interior world that received a real form and shape in real life.

The Spiritual Awareness

The spiritual awareness takes upon itself the truth that we are not the beginning or an end of the process but only a tiny piece of a bigger fabric - of many "players" and forces of creation. When we interpret, mediate, and pass the things that go through us into the world, without any connection to a religious belief, our spiritual awareness accepts the constant connection to the universe and all that surrounds us as an invisible net of influences. These intersections ultimately shape the fabric of life. Such awareness seeks the direct connection to those forces, with close or distant characters such as the people, nature, stars, the sun, the light, and the sky that opens up at night and shows us our real place in the world, and the most precise scale of us in reference to the infinite. As creativity forms a dialogue with all of these, it commits to the rules of the soul which has a motion of its own. It influences, and expands towards forces and places that cross our body and connect with them.

The spiritual awareness of the creator will strive for harmony and synchronization. Synchronicity in the understanding of the principles, the adaptation and change toward it so that both can continue in harmonious and considerate motion, responding to each other and the environment to allow mutual growth and development. In silence or halt, there is no motion. There is no need for synchronicity. It is created only when two parallel different movements are happening so that the creator, understanding the principles of both movements, tries to adapt

to them and gives them an expression - a dance, an invisible choreography, so it teaches us something new. About the way this principle works and the effects it has.

The awareness of the spiritual creator aspires to know infinity and have a dialogue with it as a friend or advisor. It tries to be attentive to what infinity has to teach us. The subject of curiosity and his constant research is the awareness of different time perspectives, alternative spatial dimensions, or an alternative existence. The spiritual creator always strives to find an existential secret and express it in his work. Mostly, it will be an abstract one. In my practice, I often ask myself, "What's the soul's movement? What would her movements be if it was a dancer?" If it moved towards its source? Is it moving in the tension between the ultimate nonexistence, and on the other hand towards all the possible options that ask to become real? What are her horizons? What happens between them? Which motion is created between the two of them?

In spirituality, the creator deals with interpretations of signs, expressing his approach as there is no absolute, singular knowledge. That's the beauty of it. Everything is changing and developing, is open for observation, and is prone to original discoveries. We must be in peace with not knowing everything all the time. Spiritual awareness is open to accepting and receiving the unknown and uncertain as a possible state. Such openness challenges the creator with his belief and trust in the universe, for he is always surrounded by partners in the creation and ready to receive guidance at any moment.

He receives his messages through intuition: a clear language he uses to communicate with the world. Through this language (intuition), he feels and knows what's right. Spiritual creation is not based on consciousness or intelligence, but on a higher

knowledge received by the intuition that brings new directions and layers to the whole experience. Only along the way will the creator understand how strong his intuition was. Such a process allows us the learn new things even years later. How many times did we look back on something we did or wrote intuitively years ago, and today, when our awareness is more developed, we reminisce and say, "How deep and innovative was I?! How much did I know without understanding it to the fullest?

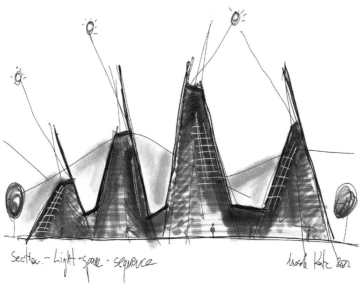

Conceptual Sketch - A study of space as a result of light sequences

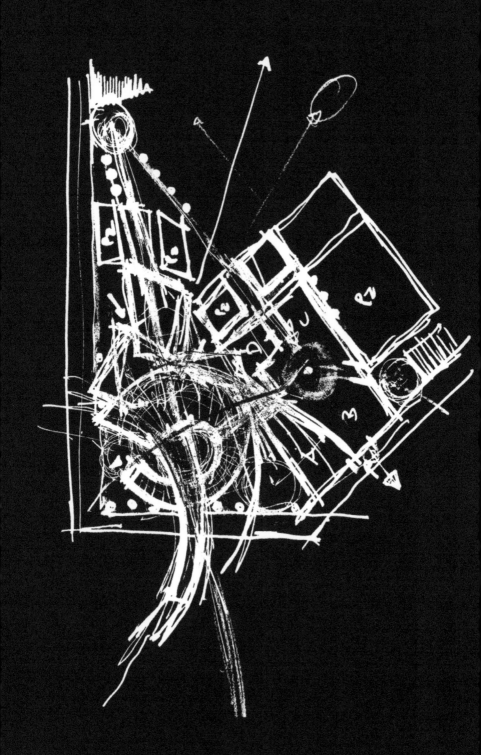

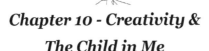

Chapter 10 - Creativity & The Child in Me

the world, and I did everything I could to allow that freedom to myself. Such a way of life is made of everyday habits and practices where imagination plays an important role, together with the expression of thoughts and emotions in unique ways. I would create situations and stories in which I was the "hero" who decided on the outcome. Once I decided to walk around the neighborhood as a cat. I picked up the qualities and movements of a cat to feel what it means to be one.

I used to go to the sandy dunes on the beach, lie down, and for hours watching the clouds changing shapes and imagine the characters created by the wind and cloudy masses. At those moments, I felt like a cloud myself. I felt like the painter of those characters. Those days were filled with humor and foolish behavior. Each situation was an opportunity to identify something interesting or funny and see how I could express myself in new ways.

When I was twelve, I wrote my first biography. It was called "Berlin-Israel, My Life as a Human". It was a sixty-page description of my everyday life until that time, through memories and events I lived, explaining to the reader what it meant to be a hu-

man in this world. I imagined I wasn't human but an alien of some sort, reporting on life on Earth as a man, explaining what's is it that's beautiful, hard, interesting, or strange in this life. Because of all the wandering and constantly moving from one country to another, I had many moments of alone time filled with creativity and imaginary worlds. I loved and still do love to invent stories and tell them to others, invent or take old objects I find in my closet, take them apart, and put them together differently.

As I write these words, I understand I am still doing the same things, only on a larger "playground" as a professional with influence and responsibility. I stayed with the exact needs, expressed in the same powerful ways that become stronger with each passing day. Instead of writing my biography as an "alien," I write about my life here so others can understand or learn what it means to be a creative creature.

I always tell my students about my choice to teach. I decided to teach because I want to have more friends to play with in the playground of creativity. I teach them what I know so that we develop a common language and enjoy the playfulness of creative planning as if we were just children. I guess I am tired of being alone and I am looking for partners on my journey, the ones who come from the similar world as mine, and speak the same language of creativity. As someone who lives creativity as a way of life, it doesn't only manifest itself in my profession but as the purpose and meaning of my whole life. It is an integral part of my everyday routines without any separation. I create; therefore, I exist!

Creativity is a free expression of the childish soul in me. Once I live and work through this source, synchronized in harmony, security, and peace, I feel that this is my true calling and purpose in life. It is then that I feel at home.

Creativity is the expression of everything that wishes to get out into the world, and life is where it happens; and manifests in the most precise way, similar to my inner source. In my life, I came across many people who tried to convince me otherwise, to limit me or make me change directions or attitude. Each time it happened, I became more convinced that creativity was the only way to go. It's the inner voice, the intuition, which constantly directs me toward the right path.

The creator's path is filled with tensions, changing motions, changes in harmony, casting doubts, entering into imaginary worlds, and returning to reality. It takes him out of the ordinary and safe into the original. In his journey, he collects signs and insights expressed in his life through everyday practice. These exercises teach him to observe things from a different perspective, from a more extreme point of view. They make him experience these moments with extra sensitivity and connect to the child in him, where reality is just a recommendation while searching for the hidden beauty behind all things.

These exercises are just a part of each creator's life's habits. Everyone who seeks to develop their creativity uses these attention exercises and becomes more focused. In this path of a creative journey, there are moments of solitude, moments of insecurity and uncertainty, moments of the void, and moments of chaos. In all of them, the more firmly your inner security is rooted, the more you trust your intuition. These moments, which are an integral part of each journey, are then experienced with more enthusiasm and happiness and overpower the fears. Even though fear is part of the story, the power to overcome it is integral to the process and growth. This is where we discover the courage within us. That is your personal and creative development.

Creativity, in reference to your way of life, is the process that moves from fear to love, from uncertainty to knowledge. There is a small battle between daydreaming and reality in the creator's life (same as a child's). Both worlds fight for time and attention within him. Each side wants to be expressed more than the other and achieve more influence. As we grow up and reality knocks on our door with the request for a change, it makes a living in daydreaming more challenging. The key lies in spending as much time as possible inside the daydream. Make it more complex and allow it to flow as much as we can each time, with little breaks we have from reality's problems. Unless we make a brave decision by creating a life that is free and that lacks as many commitments as possible, we cannot dedicate our every day to the life of a skilled creator.

Until today, while writing these words, I have been living without a family or children, without commitments to mortgages or loans. The longest contract I have is with the cellular company for the next six months, with the option to leave in 30 days. Maintaining flexibility and freedom is a part of my process. At a certain age, tension arises between the need for security and stability and the need for creativity and freedom. How do you combine both?

Such life of a creator is very dynamic. The secret lies in synchronizing your life so accurately that you have stability and existential safety (economic or emotional, etc.) and, on the other hand, freedom and a limitless life. The creative person, even as an adult, is constantly connected to the child in him with an intimate experience and dialogue. He is required to give it its maximum expression. He draws from the child, its connection to his source, to the universe, to the well of creativity and uses its help to detach or break from the known in his reality to enter an imaginary world where everything is possible and where the

original materials required for his work are to be sourced from.

The child in us is an active partner in the process and life. A partner, a friend, or a counselor who gives advice, observes, and excites us. It has the purity and ability to recognize the truth, the innocence that knows to trust our intuition, the courage and playfulness to try new things or paths, the infinite curiosity, and the phenomenal ability to learn new things. The child is the perfect creation, but there is only one thing more powerful – the adult who is connected to the child in himself and can influence the world using that awareness and the tools, the resources he has as a grown man to affect and change the world for the better and positively impacts the wellbeing of masses.

Even today, I still wear unmatched socks and look at things from different directions. I still love surprise eggs and can't help the need for the amazement effect of revealing a secret. I keep creating alone moments for myself to "play" with my imagination. Today it's also a professional habit. I drive to the beach daily and look at the clouds, trying to figure out the characters by their shapes made by wind and air.

Still, I don't know what home is. I still look for new friends with whom I can play and enjoy the time instead of fearing the complexities of life. I want the freedom to envision, invent and witness what comes out of me. I think it's the same with every creator. "I wish they would just let the child in me play and at the end of the day receive a loving hug that says, 'Everything is alright. You are safe. You are always wanted and loved!'

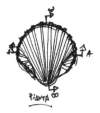

Chapter 11 - Creativity & Extremes

In a creative process, the extreme is a powerful and needed quality, unveiling the limits, boundaries, and requests from us to stretch towards new and unknown territories. Such extreme comes from courage. It is a conscious, rational choice that has a clear purpose. It brings us close to the realms of the absurd, illogical, insecure, and sometimes fear. The courage lies in handling it and coming to peace with the uncertainty of the whole process as a standard, welcomed situation.

The extreme is a sort of a parallel world. In this temporary reality, everything that is happening is influenced by different laws. Living permanently in that extreme reality is not the goal, but visiting it from time to time, exploring and experiencing the potential of things through the extreme, reaching new insights, and returning to our creative-working process with all our discoveries and try them out. The extreme, which is kept for the creative process, is a positive, fascinating characteristic. It is held in a dimension of infinite possibilities — in our imagination or a daydream, with constant mental, emotional, and spiritual experiments we put ourselves through as we search for unique discoveries.

The extreme is a complex motion. Sometimes it's sharp and one-directional; sometimes, it's chaotic and moves in different

directions. There is always an inherent need to break the order of things, undermine their laws, and check their nonexistence (nothingness), where things disrupt and fall apart until they reach their "zero" state of being. Where they are empty, that's where the original and innovative are at. The extreme helps us push ourselves farther — more than we ever could if we had gone through a comfortable, safe, predetermined everyday life. This type of process must reach an extreme point, a feeling where ideas or objects become fragile. You feel they are about to crack and break and then be built as new. The feeling is powerful and clear. You know for certain when you reach that unfamiliar state and when we are about to break into the infinite in a moment.

The creator sees in being extreme an essential quality to master, necessary for the outlining of boundaries and limits we were not aware of before. After reaching that boundary, he doesn't stay there but returns to reality and his process. However, now, with the insights he collected, he can integrate them and improve his work. Being extreme is vital throughout the entire creative process and the development of the project (controlled and aware extremes). Through the extreme, we leave our comfort zone for a moment and ask to find an extraordinary, out-of-the-box solution. Such a solution needs an extreme gesture. Only an extreme motion enables us to break out of a box and its limits.

The creative-extreme person can't allow a solution where its rules or limits are common and clear to all. He breaks ground for any reason or using any logic. He is willing to dismantle and reassemble everything into irrationality. There, he will find the root of his authentic, unique work in that experiment of his ideas and different expressions, signs, sounds, and other elements.

I always remind my students that they are not extreme enough and give them the wind in their back to help them dis-

cover their limits. This can only be done through learning to play with the extreme. They usually fear that their work will seem "too crazy" or exaggerated, or they will be laughed at or not taken seriously as the project looks impractical when they are asked to design something that answers to people's needs in the concrete world. Nonetheless, the creative person who can reach the extreme and comes back with new insights, with the memories and the secrets he found there that become the principles of his work, ensures an original and innovative work or solution for today's and future problems. It's all about a quick journey into a different world, a quick visit to a new dimension where all is possible even though it seems like chaos.

The extreme brings chaos to life, so we can start with our search for a new order and new rules and the light that shines immediately after. The temporary motion of chaos works as a storm, swirling all the elements known to us. All common knowledge becomes mixed, intersects, explodes within each other, and maybe through that Big Bang, the new and original is born out of that supernova.

The extreme is the particle accelerator of our thoughts and images. After the explosion, the secret is uncovered. Creativity needs those moments in their different stages. It checks how far we dared to go, how courageous we were in crossing our limits, and how original we were in drifting into new worlds. It also examines how skilled we were in breaking and reassembling things as new or putting everything under a question mark – even God.

Extreme creativity becomes lawless until the moment it forms a new law of its own, which we can't recognize immediately. It shows how free we were and the risk we were ready to take for the discovery of the new. Once we reach it and come

back with new findings, we have an overwhelming sensation of amazement and happiness. Such extreme creativity brings an unexpected motion of life to our work. As an architect and an artist, I find that the extreme is expressed by forming a new experience and its translation into a spatial design. A line becomes a sign in unexpected motions. A roof becomes a tower. Each thing grows, breaks, and changes its dimensions or shape. A flower becomes a theater on a rock. The outside becomes the interior. What was at the bottom starts flying, and everything reaches its illogical and lawless state. The next step would be staying in the new state and observing the new conditions and relations.

What will we find out? Whatever comes to our senses in that state must be documented and saved as a sign or symbol so that it can be helpful to us later in the process, as we return to reality and integrate the unexpected impressions we received. The goal is to break the box, and once it's broken, give each part life of its own and let them dance freely until each façade becomes its choreographer. That's the core idea of the Freedom Tower Singapore.

Whenever I feel the need to get to my extreme, I take a conceptual model that I developed, some sketches or some signs I drew and start stretching them, breaking them, flipping or twisting them until the extreme motion and action I operate on them, the dynamic, decisive action, helps me understand the limits of the matter or sign.

I work with extreme, unexpected actions that don't appear from within the order of the model but are just another way of discovering a new form of existence in all things.

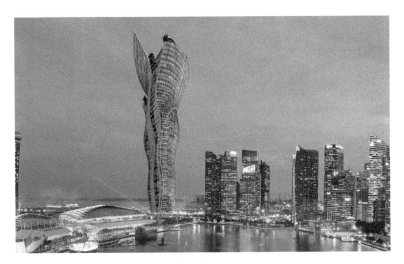

Rendering - The Freedom Tower Project, Singapore
A mixed use tower with four hotels and cultural / natural spaces

The Freedom Tower Project, Singapore
Morphological shift- breaking the box into its spatial freedom

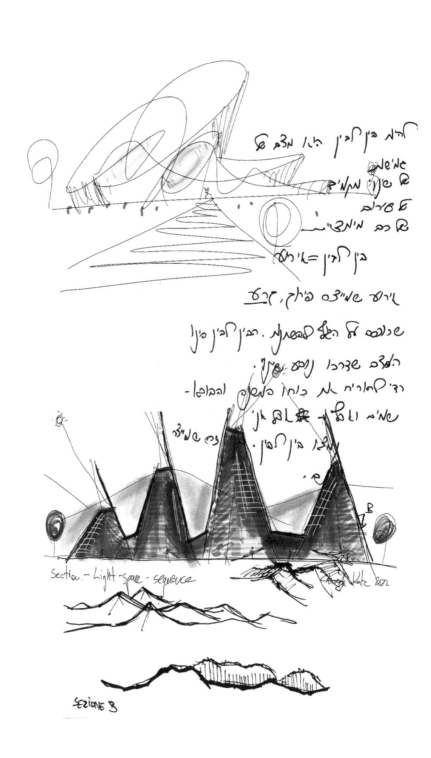

Section. - Light - Space - sequence

SEZIONE B

Chapter 12 - Creativity & Fears
Ego, Perfectionism & Blocks

The first important message of this chapter is that fear, perfectionism, or blocks are part of life, and we all experience them on different levels. Some - a temporary, general worry, or, some - deep anxiety and panic, and we are frozen with a helpless feeling. They are all-natural, even the unfortunate difficult ones. I have experienced them all in person, from anxiety to existential fear. They paralyzed my life and shrunk me down to the hapless instant of now. Same as the destructive ego affecting my creative freedom, through the perfectionist approach creating a massive wall you can't climb or cross. I knew them all and survived to tell. From the observation to the attention to the process I went through while it happened, I can share some critical insights that might help those seeking to overcome their concerns and use them in their creative process.

Fears

During certain phases of research, some fears may emerge: fears of getting lost, of being judged, overexposing deep, intimate thoughts or feelings, almost as if we stand naked and vulnerable

in front of others. I remember those fears, and once I allowed them to teach me an important life lesson, I considered them positive things, through which I had to find the courage for "out of the box" solutions. Each creative act needs, by its nature, a bold approach to dealing with ourselves and those who surround us—the courage to create chaos, an earthquake, a void, and go into the unknown. As control-loving creatures, spending time in the unknown is fearful. It exposes our lack of belief in ourselves and the lack of trust we need to reestablish with our most intimate being, concluding that something fantastic awaits us at the end of the process. It's always in our benefit for our well-being, even if it's not visible. Always.

The word FEAR is too powerful and contains different types and levels. One of the most common fears of all times is of the unknown and thus the uncertain. We can't cancel those fears from our existence. They are primary and have followed all humanity since its genesis. The creative process, because of its drive to authenticity and a deeply personal expression of who we are, takes into account at the same time the courage that comes with it, which is also primary within us. In that case, since fears can't be diminished, we can only increase our courage and trust to match the proportion of our fear. Once we give fear its legitimate place, we can understand its dimension and what kind of a creative solution is needed in the form of trust in ourselves.

What helped me in that phase was the fundamental acceptance that we are not our fears. This means there is a separation between what happens within us through physical or psychological sensations and our awareness. Fear starts for a particular reason, but once it has developed, it then depends on us if we identify with that sensation. Once we identify with it, we become it. Fear is a protective feeling that works to our benefit to help us in times of real threats. In other situations, it brings a mes-

sage or a sign for us to understand. As with every alarm system, sometimes it creates false alarms; A false alarm of fear, a wrong signal to our body, which is now in motion and takes time until someone finds the switch to shut it off, so the only thing to do at that moment is not to identify with it but try to separate it from us. It's happening, but it's not who we are. As with every skill, such detachment requires practice and constant improvement by keeping a safe distance from fear and entering into the role of the observer. As a scientist who examines a clock mechanism, we need to slowly engage in dialogue with the fear itself by asking questions to observe what it does and how it works.

The fear is changing our perception of time. The stronger the fear, the closer we get to the moment of now—the immediate instant. Fear works and acts in the now. The difference between living in fear and living the moment with creativity is the level of comfort, freedom, and positivity we allow ourselves to move through. Fear tends to cancel movement; it paralyzes us because it tends to bring us to one point. On the other hand, creativity creates free movement in all directions and expansion.

Many techniques prepare us gradually for the creative process, such as everyday practices or habits by which we can get there with fewer worries and triggers. There are also some methods used when fears are already rising that instruct us on how to place fear in its proper place without allowing it to take over. I give those exercises to my students based on a deep and complex understanding of their needs at that moment. Sometimes it's about placing things in the proper context and proportion; sometimes, it's the guidance they need to know that someone is walking the path with them, that they are not alone, and everything happening along the way is just right. I mainly strengthen them by making them realize that everything they go through is an integral part of the process. In my experience, in a moment

of "fear crisis," or any other extreme feeling, it is highly recommended to look for signs and immediate expressions of the fear in us. Each artist in his language does it through characters he is familiar with: a sound, a chord, a brush stroke or a fast drawing, a movement, or a short dance, or any other way that translates the experience into an authentic sign that reflects the truth of the moment. Through this act, we detach a part of ourselves from the fear itself and observe it from the outside, where it transforms the whole event into a more positive and creative process. It is recommended because all senses are heightened and sharp in that moment of an emotional peak.

Your sensitivity is in its best condition to reach new original insights. The fear gives us a great chance to discover new things about ourselves and the creation we are working on. Some of my most extraordinary insights and inventions came during anxiety and panic attacks. It was very unpleasant, terrifying, and freezing, but even those moments can be transformed into moments of discovery of knowledge. In most cases, when the moment passes, our system is still alert and in perfect sensitivity. That's the time to ask questions and receive answers, document them, and engage in dialogue with ourselves.

Fear brings our vulnerability out to the open. The layers are peeled, and the ego is put aside. Our source reveals itself and exposes its originality. That's the perfect moment to look inside and observe a new side of ourselves or our relation to our creation.

Ego

We all have an ego; we all work with it and use it in different situations in our lives. Sometimes it helps, but with creativity, not so much. The ego (and I don't mean to enter into other psy-

chological theories) is the "higher me" who demands its importance above all. There is a thin line between self-love, which is necessary and always important, and egoism, which comes from judgment and puts the self above the rest, saying, "I am better, more talented, more worthy than all." Self-love comes without any relation to others or anything. It is pure, clean, and recognizes the beauty and actual value in us without canceling or competing with the beauty or importance of those around us.

For the creator, it is necessary to love himself, contain and appreciate himself, and receive with understanding and love all his sides and layers with a positive value. That's the security he needs to stand against all uncertainty and shakedowns of reality and against all negative voices of the "good" people around him who try to take him away from his center.

Nevertheless, the ego works out of a void, the absence of something. It creates a false power, an irrational and useless competition with the world. It nurtures itself through the weakness of others. The ego itself can't afford to show weakness. In that game of hidden forces and the need to constantly win, letting go, giving in, or synchronicity with ourselves is its most significant threat.

In the creative process, we must accept our "ignorance," not because of a self-dismissal, but because of strength and awareness that we can't ever know everything. We constantly need to learn, grow, and discover the new. The creator fills its "emptiness," the healthy void of the unknown, through curiosity, passion for knowledge, and the understanding of being eternal students of the world and ourselves. He, the creator, keeps himself constantly open and exposed, willing to admit his mistakes and love them because they are the milestones toward his discovery. That's the basis of his creative growth.

Creativity's first and fundamental principle is admitting we don't know something and wish to learn. Without it, there would never be any creative work, or even man's mere existence would be in danger. If we cannot admit that, we will miss all lessons and signs, the clues and insights that await us along the way. The ego says out loud: "You already know everything! Why waste your time? No one can teach you anything new!" This is where the road toward self-destruction starts, toward the creative abyss. This is where the artist stops creating the new and distances himself from the original, the authentic, from himself and is condemned to copy others or create the thing over and over again with slight changes.

At the beginning of each process, I always put myself into deliberate forgetfulness. A state in which I forget all I have learned so far and collected in my life from previous experiences or projects and enter into the new one as if it's the first-ever. As if I must learn everything from the beginning, get excited and curious, and experiment as if it's the first time. There is no danger in reaching the exact solutions as in the past, and there is no danger in wasting my time. I state this with certainty because, after 20 years of planning and designing projects with that approach, I always reached new insights I hadn't known before. All solutions were innovative, unique, and different from each other each time.

Another effect of the ego is preventing a higher complex knowledge from being received because of the belief that everything starts and ends with me. I am the alpha and omega. At that moment, we are blocking all our sensitivities which affect our creativity. Since we didn't allow the universe to be a partner in our creative process, the result will lose its potential to affect the people who are exposed to our work. That's where a different approach is needed — to accept my role as a mediator, which

controls and diminishes the ego.

Once our creation is finished and exists, it can be in the form of a big-scale building, a skyscraper, or a whole new city. The size of the creation is out of proportion to our size as humans. Once the architect identifies with its creation and says, "This building is me!" That's the moment where everything collapses. This is where he destroys the future, creative potential. In identifying with the creation, the ego transforms the architect into a megalomaniac and drives him out of his mind.

The ego as a restrain-less monster takes over his whole being. It hurts the most precious thing he ever had: his direct connection to creativity, which develops only through the humble secondary role he takes in the creative process. Therefore many "architects" feel like gods. They think, "If I, the small, insecure creature, was able to create such a huge thing, and this building is me now, then I am bigger than all those small invisible people who can compare to my abilities...." This is where the moral and spiritual corruption starts because he doesn't understand that the powers, which made the creation possible and realized in the world, we're never meant to stay within the artist, but go through him. He must be careful of the destructive effects of his creation.

This pride hurts the sense of responsibility, love, and empathy he must actively maintain with devotion throughout his process, working for others and their well-being, instead of the other way around. His heart and principles are not in the right place anymore, in the place of helping, doing something good for the world. Instead, he looks for bigger and more extensive work to fill the void of his insecurity which already has grown into infinite proportions. He constantly tries to prove that he is bigger and stronger, and society is not the goal anymore, but himself in

a competition against his own "monsters." At this stage, he will do anything and hurt everyone who blocks his way forward.

I learned this risk when I was just a student and had the privilege in my second year of studies to exhibit my project in the Biennale of Venice: the holy of holiest of all architects in the world. The honor and the international recognition of my skills was and still is a once-in-a-lifetime thing for many people, if ever. I felt the effect of such success and decided not to go to Venice and see my work there. Some instinct told me not to identify with the creation and the "noise" around it so I won't fall in love with my image and the false power of recognition or publications.

I asked myself, how could I protect myself from the destructive effect of the final work with its enormous size and scale? At that point, I met a friend, a writer, who told me about the experience he had at the moment when his book was first published. "I identify with the creation and the writing all the way. I am all characters: I love them, I hate them, I talk through them, I know all their relationships and difficulties, and I am them, and they are me. This is how the book and story come to life, out of a total complete identification but limited in time. I worked on the book for a year, maybe two or more, and I am connected with all my being to all of it. Then comes the moment of finishing it and letting it out into the world. Once it's out, after the print, I work on a detachment process. I cut the cord of life between us, and once it's out to the public, it is not mine anymore. It belongs to all those who read it, and they will decide what to do with it. I can't chase each reader and yell, "No! No! No! You didn't understand the character at all. It's not tragic!" I would have to pass from one house to another, sit on endless couches, drink gallons of tea, eat hundreds of pounds of dry biscuits, and explain the essence of each character and their relations to each reader. It would be

crazy! It's not mine anymore." I like that reality does with the story as it pleases, and through the people, I understand more hidden layers of what I wrote but didn't see it.

This is how I decided to act as an architect and artist. Once the creation is out in the world, it's not mine anymore. The reality, the people, and the environment will do with the creation as they please. If they decide to build, destroy, love, or hate, that's their choice. I detach myself from identifying with its existence in the world. I am attached to it only by the creative process I went through: the process that taught me everything I need to know and grow from.

The tangible manifestation of the creation in the world shows other layers of its existence we can learn from. Still, in that case, it's just a matter of knowledge. In this phase, the creator has to be careful with the publication and recognition of their work and remember that it doesn't change the need to go through the same creative process all over again as new, with all its research, experimentations, and the search after the original, innovative and authentic. In my final year of studying at Bezalel (Jerusalem academy of arts), where I finished my diploma, I won a prize for excellence in an urban project, which showed a new way to consider urban planning. The project showed how a small crater city in the desert could grow, develop, and expand each year like a dynamic living creature and then, a year later, shrink and return to its original size without any constant changes or footprints. Through flexible and movable structures, the planning of cultural or public events throughout the year, and the connection between time management and the flexible space building, you achieve living urbanism like a beating of a heart.

At that time in 2009, it was an innovative idea, and I was asked to show the project to the government at the national

planning and construction office. The feedback was terrific with extraordinary astonishment, and the words said would make anyone get excited. I felt my ego rising, the monster had woken up, and my feet started to lift from the ground. I stopped looking at people around me with the same eye level and felt it was going wrong.

On my way home from Jerusalem to Tel Aviv and my rented apartment in the center, I stopped at a coffee shop near my house. I saw a sign on the door - a job for a dishwasher. I went inside and started working. For some months, I have worked in that place as a dishwasher, hoping to get my feet back to the ground and put that ego monster back to sleep. On one of those days, the owner of the place asked me personal questions and what I do in life. I told him the whole story and why I came to work, and he was astounded. Then he laughed out loud, saying - one day I will be able to say that a famous architect once washed my dishes!

The approach to the final creation is the one to determine the beginning of the next one, and that's why every artist and person should better balance the hypnotic influence of reality on our work. Today as an architect who works in different parts of the world, I can say something that very few could admit or say out loud or even think as a possibility: I don't care if my design will be built. As long as I had the privilege to go through the creative process in its planning, reach new insights, and bring it to the phase of being able to construct reality from that moment on. The people around will decide its destiny. I choose to be responsible for the dream, the vision, and the showing of its potential.

Every professional wants to see their work realizes and out in the world. I don't feel that way. As long as I have dreamed out of love and the desire to improve the world, done some good, and

brought the dream up to the threshold of the people responsible for deciding about its realization, it's not in my hands anymore. I find comfort in that kind of release.

Perfectionism

Many students I have taught and architects I have met have the same problem of perfectionism, believing it's a blessed, excellent quality. Many take pride in it and flash it in job interviews or front of their clients. In my opinion, it's a curse. Perfectionism blocks creativity because of the uncompromising need for perfection, which doesn't allow any flexibility or imperfections within each step of the process. Within perfectionism lies a constant interior judgment- checking, shouting all the way that the work is not good enough. As a result, the motion moves one step forward and two back instead of being in a flow.

In contrast, the step back is always more significant because of the fear of making mistakes. So it happens that the perfectionists go back to the beginnings, again and again, to make sure everything stands to the extreme standards of the ego. In such a process of an obsession toward the perfect solution, there is no room for intuition, instinct, checking limits and boundaries, or staying in the unknown. The perfectionist needs immediate proof and security, constantly feeling that everything is in its place - all that is nothing but a block toward creativity. In this case of the perfect approach, the person is following the fastest path toward known solutions without any potential risks. The act of the perfectionist comes out of fear instead of courage. He works without understanding the complexity of the creative process with all its unknowns and imperfections. The strive for creativity and perfection is contradictory. In creativity, there is no perfection, at least not one you can foresee.

Historically, the usage of geometry in the renaissance period to express the perfection of the universe was just a partial expression of what man can say of the universe. It wasn't the discovery of the hidden laws of understanding the infinite complexity of life. The risk of that approach is the repetition of similar solutions only in slight changes. As a result, the "perfection" remained inside the churches and placed spiritual practices as opposed to the people's private residences and private world. The limited man is trying to express the universe's perfection in his invented language- mathematics.

The Greeks were closer to the understanding of a "perfect imperfection" in their temples where a "correction" was introduced in the structure, an optical illusion, a mistake to correct the limitations of the eyes perception. Hence, things appear to look perfectly straight even though, in practice, they were nothing but distorted. They had a concept for it- Antis. The free, flexible treatment of details with the hope of reaching the "perfect" perception. That's a fundamental critical approach that perfectionists can adopt as a middle ground - the understanding that the whole and human perfection lies in different imperfect parts and a flexible process of flow and intuitive understanding of perception.

Personally, I try to change the attitude of those who strive for perfection by focusing their energy and will on other people and their well-being. Dedicate themselves with the same enthusiasm to understand themselves. That's the right balance that helps the creative process—trying to lighten the aspiration for perfection with striving for childish playfulness and enjoyment of experimentations without any sense of responsibility.

Some students start their project with an imaginary thought or impression that tomorrow morning, someone will take their

plans and build the building. The responsibility that comes out of that impression, the fear of judgment and identification with their product, makes them progress slower and more cautiously, expecting perfection of themselves before even drawing their first sketch. The fear of the empty white sheet it's a fear of making the "wrong" sign instead of trying recklessly, with playfulness and enjoying the process.

The perfectionist's worst enemy, the biggest nemesis, is the MISTAKE. The creator, who understands creativity, knows that mistakes are a blessing! There are no mistakes, and everything is a part of the process of slowly reaching the right direction. It happens through corrections, through mistakes that help you figure your correct way. Since childhood, we were taught that mistakes are the ones to avoid, and you get a low valuation if you allow yourself to make mistakes. Then, in time, you reach adulthood, and you are sure that life is about avoiding mistakes. Instead, for those who learn creativity, know that your mistakes are your best friends. You should strive for them, love them, for they are your guides toward the new and original.

That's why in those early stages of research and analysis of the project and concept, I work with the students on awareness change, lowering expectations, and bringing out the child in them. I try to make them fall in love with that playful process they remember from their childhood where you trusted your inner instinct and were able to stay in the moment and collect more and more moments of joy and discoveries.

Blocks

In each process, same as the creative process, there are periods or moments of blocks. Writers are familiar with it as writer's block. With artists is more about the inspirational block. Creativ-

ity, at its core, touches all our layers, the mental, spiritual, and emotional, and influences our mood and motivation. That is why it's natural for each one who creates to encounter a particular block or limitation sometime in his life.

The block also reminds us to be brave again, overcome our limits, and find a way or solution to loosen some of the seriousness and expectations. For the child who plays in the sand, there are no blocks. Whatever comes out that's good enough for him. His purpose is to have fun and enjoy the temporary discovery. The feeling of the sand, the water, the hands that change all shapes, to be in the moment because this instant has no block. It has a flow. In times of writing blocks, I would take a clean sheet and start writing without thinking about the words. I write down whatever comes fast into my mind. The words would pile up, and with it, the security in writing until the magic would happen, and I would enter into a new flow filled with immense fun, just for the mere writing.

This fun would quickly transform into passion, and the block would disappear. Blocks are broken through actual action. With the momentary flow-thoughtless, without a plan or expectations, just with simple fun!

*Conceptual sketch - Development of a dynamic space based
on different senses and sensitivity sequences reach-
ing a unique experience through motion-space*

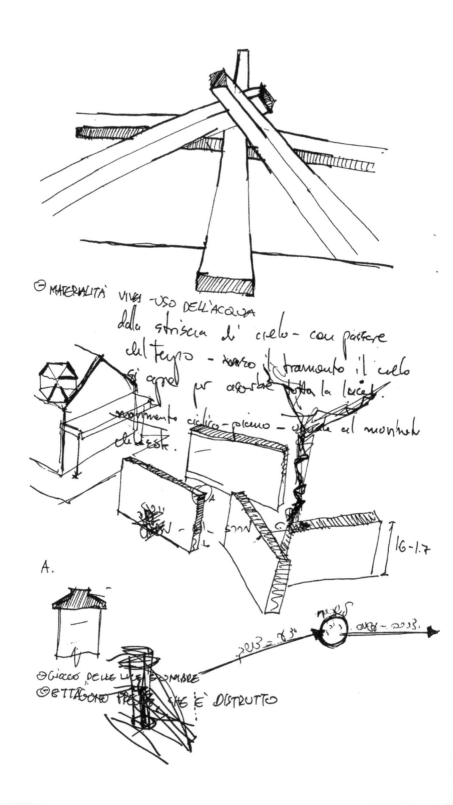

⊖ MATERIALITÀ VIVA – USO DELL'ACQUA

della striscia di cielo – con passare
del tempo – verso il tramonto il cielo
si apre per assorbire tutta la luce.

movimento ciclico – piano – verso al montuk
che resta.

16 – 1.7

A.

⊖ GIOCCO DELLE LUCI E OMBRE
⊖ ETTAGONO PRECISO CHE È DISTRUTTO

Chapter 13 - Creativity &
The Reaction to Life

Creativity always seeks the connection to its time, the contemporary problems or challenges, and life's stimuli as they present themselves around us. The creator lives his life and receives inspiration from everything that surrounds him. He interprets and gives solutions to the situations of his time and place. While writing this book, life has brought a new global challenge in the form of a virus (corona). This created distance between people and, as a result, imposed feelings of loneliness. Humanity is now trying to use its highest forms of creativity to find fast solutions for the survival of people and the survival of their quality of life.

Many other problems are presented in our time: the third age, extreme climate changes, inequality between people, violence, wars and conflicts, hunger, and the lack of natural resources such as water. All these are just a part of our generation's challenges, and creativity has the power to solve them. After the destruction, it will be the job of the dreamers to envision how to build it all back and bring beauty, happiness, and well-being to the world.

I see my job as an architect who works to answer those challenges with the help of design and space, as the following projects, for example - a vertical farming tower inside useless office skyscrapers due to the corona. Or treating mental and

emotional problems through architecture - Archi-therapy, a dynamic architecture used for treatment and healing processes. Or buildings that use sustainable energy or ones that respond to the conditions of their environment to save energy through AI and kinetic motion of the structure itself. These are just a few examples that I have developed recently and tried to offer to the world.

Light drops, Helsinki

There are places where sunlight is missing throughout the year and most of the day. Millions of people miss the sunlight as lovers miss each other from a distance. This absence of the sun creates many physical and mental diseases or effects, such as neurological and psychological disturbances, which humanity tries to deal with and find innovative solutions. The project responds to this problem and creates a public, urban space in the shape of a drop that can contain up to 30 people each time. This glass space is filled with special artificial light, thanks to unique lamps with a sunlight spectrum that change the quality of light during the day and are controlled to enhance the effect of the sunlight sensation. In addition to the lights, there are sounds and frequencies reacting to the light and spreading inside the room to improve the healing effect and relaxation. The people sit inside as if in a transparent sauna, on glass stairs, washed by light during their lunch break or on their way home, load themselves up with positive energy through the senses, and gather in a place that allows communication and dialogue between strangers. These Drop structures are movable from one square to another or different cities and bring light to all distant places. This creative multidisciplinary design combines architecture and design, technology, sound, urban design, and medicine to

heal people and improve their lives. This is a perfect example of how creativity provides an answer to the current environmental challenges.

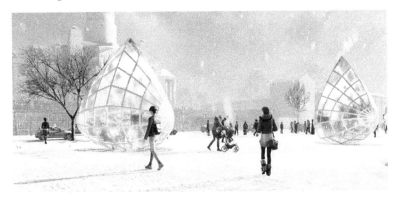

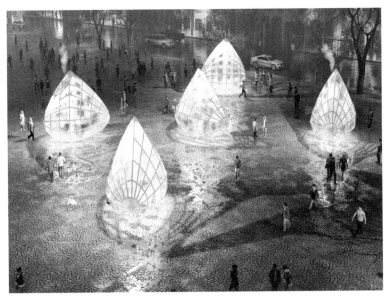

Rendering - Light Drop Project, Helsinki, Finland
A healing space for places in the world which lack sunlight most of the year.
An urban space for social/ cultural gathering up to 30 people, to expe-
rience sunlight sensations together with healing sound vibrations.

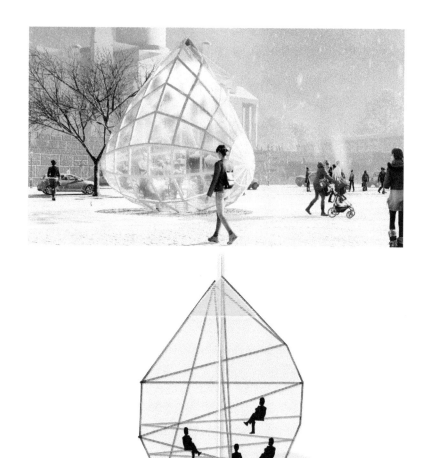

Interior View Section - Light Drop Project, Helsinki, Finland

The Sunsetarium

The sunset is when all the dramatic changes in the sky are happening. A peak moment before we get a glimpse of our real

place in the universe, just a moment before the windows of the skies is opened to the infinite, a magic that happens every day as new and never the same as before - the sun's last dance, fast color-changing motions and shapes of our environment. Wherever I visit in the world, the sunset is when I go out and want to experience with other people like me, as a holy instant of man in front of nature's forces.

The Sunsetarium is a concept I developed for a social-cultural meeting place and experience the sunset together in unity. A place that connects with the sun, a dynamic, changing place where light, materials, reflection, and shadows are all part of the design and affect the space. The strategy was to create such space in each city along the Israeli coastline or in each country where tourists can meet and pass from one sunsetarium to another as an attraction, a creative social place to bond with others in that particular moment of the day.

The potential of the sunsetarium is in creating a community through a dialogue with the setting sun.

Rendering - Sunsetarium Project, a cultural/social meeting space for sunset lovers to celebrate the ritual of the setting sun

Vertical Farming skyscrapers

One of the world's biggest challenges is the growth of healthy organic fruits and vegetables. As a result of the corona virus and the change in working habits, many office towers were abandoned, and people worked most of their time at home or in temporary working spaces. A tower, which remained as an empty concentrated structure, could transform itself easily into a farming tower, a vertical field divided on each floor into different vegetations with different lighting and reused energy where crops are grown in optimal, controlled conditions. The roof of such a tower can be used as giant rainwater containers with wind turbines for energy collection. Underwater parking spaces of the building will work as water collectors. The whole façade of the building with solar panels would be used to reuse the sun's energy, transforming it into electricity—a farm skyscraper in the middle of the city.

Many professionals worldwide are aware of the global and local situation and study, research, and work with the understanding that only creativity is the most precious resource of our time to bring solutions to all problems. For the creative person, these solutions will come naturally almost instinctively.

The creator must not live in a bobble, detach himself from the news or everyday challenges around him, but be aware and curious about everything that is happening, even imagine alternative ways for people to live better. Creativity is needed precisely for such events and places as in our human history. The environment presents, at times, critical or everyday challenges and difficulties, and the man is called to show his greatness and survival skills through his creative thinking. After survival has become apparent for us as a human race, we passed to the age of "life quality." Creativity worked mainly as an answer to culture,

artistic expressions, recreation needs, free time, or the enhancement of the general quality of life.

Rendering - Vertical Farming Project Proposal - Tel Aviv

These times of pandemics bring us back, to an intermediate phase, between survival and life quality and call for the man to reinvent himself through creativity. Mechanics and technology will save us a lot of time and the need for logical, calculative thinking. Some tools do it much better than any man already. One thing remains as our eternal primary purpose - to be creators! The near future will bring with it the demand for creative communities and groups of people who research and develop

the visions and dreams of man.

Same as the scientists who receive infinite amounts of resources to deal with diseases or treatments or understand some dying planet somewhere endless light years away from us and maybe find a small rock that will prove with a high chance that some billions of years ago, life existed somewhere out there, perhaps some of those resources could be transferred to creative learning and developing of those skills for our local and future problems instead of the past.

It is vital to have "creativity specialists" for private and public companies or sectors, to work holistically, with the workers of each company or organization to enhance one another as people through creativity, but mainly to reach a new level of productivity. Just use 10% of that budget to teach people how to reconnect to their creativity and work as creators using their imagination and a sense of ingenuity. All of humankind will profit from it.

20/12/21

Muse City, Cyprus - Design sketch of a city skyline with
"The House of Inspiration" building

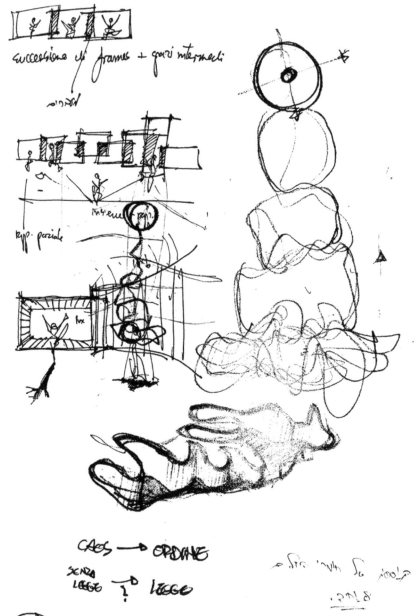

successione di frames + gioci intermedi

inizio

rapp. parziale

interno

lux

CAOS ——→ ORDINE

SENZA
LEGGE ⇄ LEGGE

PROCESSO

per movimenti circolari = eco = abbraccio
→ movimente rettagolar = contrasto = differenza

Chapter 14 - Creativity & The Role of Society

Creativity is considered, for the most part, the ability of a single person, a creator, who finds his "luck" and becomes an artist to express his feelings, thoughts, and emotions, his whole being, into a new language of his choice. Nonetheless, man doesn't live in a void or total isolation since we are a part of a broader fabric of life. Creativity is directly related to the society in which the single person operates, lives, and grows.

The direct or indirect role of society lies in putting limits on the creator, limits which he will try to break or undermine, and the creation of new freedom - the security to act and sharpen your skill for the benefit of all.

This society encourages new and different perspectives. It sees its survival and higher value in the future, not in the past. The advanced society, the one that sees innovation and the human genius as an essential factor for its survival, will invest its efforts in encouraging the individual for critical thinking, "absurd thinking," or any other way that puts the general and common under a question mark. Such a society considers the child, the young, as its promise and goal rather than sanctify-

ing those who are not within the living (yet still respects their memories). It's a society with strong roots in its history but with flexible ones as well to allow it to grow new roots toward the future through mutual hope, a mutual sense of destiny, a common prayer for redemption or the "fixing of the world" (Tikkun Olam) or the upcoming of the messiah (as a symbol for a better future). In contrast, in each such prayer, the visions and dreams for the future are being praised instead of the traumas and tragedies of the past.

Society is responsible for the individual's creativity through encouraging culture and collective expressions of arts by exposing alternative realities. This shapes its structure through the new stories and myths created by its members. They are not scared of questioning or doubting a particular notion; they see themselves as solid and secure enough to question its existence, its borders, and redesign themselves through new narratives.

The creative society encourages the word the stories. It is fascinated by new ideas and inventions, ready to invest resources into their development, experiments, and manifestations. It's a society that gives the young generation a responsibility to make serious decisions and develop innovative solutions - right to their time without wallowing in the past. Such a society loves the mix and connections between different worlds and the multitude of opinions. Sometimes, inside the same individual, there are other, even contradictory, opinions. Such a society aims to help its individuals come into arguments and passionate debates to find truth or justice. Creativity stands in the realms of truth, and such a talkative society always looks for the truth of things.

A creative society has a spark of anarchism. Some of its members love to break the limits and go against the same institutions

or the top-down laws made by its leaders. It's a society without a fixed enclosed constitution or living program. However, it still has the flexibility of becoming and changing in reaction to life's challenges and needs. Such a society encourages the search for improvement and never takes reality or its culture for granted. It constantly asks how can I improve that. Even as "national foods" are experimented with every day to find a new improved dish, trying to find new tastes or combinations, a new technique, or relations, even if at the end of the process, we decide to stay with the good old way.

The creative society is a patient one. It has the passion and interior thirst for its dynamic expression. It knows how to inspire without letting its public ego express superiority. On the contrary, in such a society, there lies constant healthy insecurity about its identity, admitting that it still has space to define itself. As a result, it can allow itself to research and experiment with new definitions more suited to the state of mind of its individuals.

A creative society is aware of transitions that happen over time and doesn't go not against them. It tries to express the spirit of its time and the forces working in it, trying to bring life into the hopes and dreams of its individuals or groups. In such a society, where an individual is asked to create and be creative as a part of the society's social myth of survival and excellency between nations - many of its individuals will develop their creative skills and are expected to be part of the new forming of its objectives.

Nonetheless, creativity can't grow only out of society's encouragement. The individual supposes to contribute their part - which is the most important one. I remember Frank Lloyd Wrights' story about the fulfillment of the personal potential

together with the right environment. He described a farmer who wishes to grow new crops in his fields, prepares the ground, and buys all necessary tools for the success of his crops. As everything is ready, he brings a tiny bee, shows her the field and all the preparations he had made, and tells her - now it's your turn! If you don't do your part, you are one hell of a bee!

Society should create the maximal conditions within which the individual creator can realize their potential. Sometimes society places certain evolutionary-like conditions where we face many limitations and difficulties, so only the "Strong" creatively will achieve the breakthrough. In this sense, difficulties, extreme limits, problems, and challenges encourage survival and finding the most creative solutions.

Today's global and local society has made instant exposure to knowledge and inspiration quick and easy. With the help of such accessibility, innovative solutions are simpler to reach. It creates a significant advantage for the creator because of the access to infinite knowledge - the endless pieces of the puzzle he can use freely and offer with it its creative, complex work. On the one hand, the more exposure to knowledge society allows, the more innovation it encourages. Even though the massive flow of information makes it difficult to focus and select the critical, most valuable pieces. Only 25 years ago, when I was just a child, the only knowledge we had in our reach about the world was in the form of 12 encyclopedia books on my shelve. The whole universe was encapsulated in those books. Today, as an infinite library of knowledge and inspiration, the Internet challenges us with screening processes, working on our skill of choice, and recognizing value.

Some societies have a hard time creating the best conditions for their creators, and they are sure that with some small, simple

changes, they will be able to raise the new Da-Vinci's of this era. They don't understand that such a process is complicated and needs a deep, rooted solution that comes with persistence and authentic encouragement for creativity. The individual needs to feel and understand that these are the principles of his society. It is not working artificially to reach a particular hidden goal. Still, it's a deep wish and needs with the right intention.

In the past years, I have been working in Israel, belonging to its Jewish culture, and as a nomad of the world, since childhood. Many people have asked me why I keep choosing to go back here and why I keep such a strong bond to this place, even though I am a resident of the world, having lived in many places and absorbed so many different cultures, and I don't belong anywhere.

Israel is the only society I have known so far that creates and encourages an environment for creativity and innovation. It is its fundamental survival need, but on the other hand, it also creates many limitations for the individual creator, making it even more challenging to break through, especially in the most difficult place—the big league of challenges.

I only wished society would live with that awareness and recognize it strongly. Unfortunately, internal processes undermine creativity, processes, and development that seek for the individual to ask fewer questions, to be less doubtful, not to disable its mere security, and try to gather around a common, collective, and agreed-upon truths. These tendencies will prove themselves wrong shortly, especially with the younger generation that needs constant nourishment and encouragement for creativity by the institutions and the general public's approach.

The Jewish culture used to question everything, even God himself. It demands innovative thought from each member of each age. It encourages the child for original thinking, critical

thinking, independence, and full of doubt, all for the reason of reexamining the ideas and concepts defined by the elderly wise interpreters in all history and being able to say something new, different, opposite to them. This attitude, this type of culture, backed down from the beginning of the 19th century, and even more so with the establishment of the state of Israel. Judaism is going through many changes, and a big part of it distances itself from questioning and critique toward an environment where all accept only one truth without any possibility of undermining it or creating an alternative one.

The "Halacha" (book of laws and rules for everyday practice), as states' constitutions, has to keep a range of flexibility to allow the dynamic existence that grows from it naturally and based on reaction to life's changes. They have to allow creative solutions for the everyday problems of the contemporary person (while constitutions and religious laws are written and refer to the world and man of their time). The flexible society, the one that lies in constant tension and conflict, internal drama, and the search for an identity, is the one that works as a fruitful ground for creativity. The dynamic society, as the dynamic individual, is the best match for the rise of the highest form of creativity.

A society with the element of surprise - an open debate without any judgment, a brainstorming, talkative habit (like the studying of the Gemara)- becomes a society that knows how to connect its members and unite them with the purpose of day-dreaming and visionary thinking. That would be a society with high valued individuals in their maximum potential who will, in their time, improve and upgrade the collective. You are wondering how? How can a hi-tech company or any other organization enhance and increase the creativity of its members? Here are some fundamental principles:

1. Create constant and straightforward challenges, with the individuals' encouragement to find original, unique solutions.

2. Encourage a culture of doubt in the organization, ask the existential question and embrace dynamic thinking.

3. Encourage playfulness and positive childish experimentations.

4. Encourage and develop the entrepreneur culture, the "daring," and allow the youngest ones to have more responsibilities and be a part of the decision-making of the most critical decisions.

5. Develop a light atmosphere, a flexible space for trying things without a definite purpose.

6. Develop multidisciplinary thinking and constantly broaden the individuals' knowledge with questions such as how that new thing connects to my field?

7. Create limitations and boundaries with intuitive existential needs, which demand out-of-the-box solutions.

8. Encourage dialogue and positive debate.

9. Teach the individuals how to diminish or silence their egos.

10. Enable extreme or absurd work and analysis, which leads to groundbreaking solutions.

11. To demonstrate that the rules and laws of the organization are flexible and changeable.

12. Open up to the authentic - to embrace and value the individual's personal world with all his personality and complexity.

13. To come up with challenges and the shaping of different

solution thinking patterns techniques and conduct constant experimentations for various small groups within the company and examine the collaboration and connection added values created by the mix or unity of some members. That's where the best teams are born.

14. To exercise critical thinking without judgment. A brainstorm-like process.

As a student at the University of Florence, I grew up to be the artist that I am thanks to the institution as being, for me - the biggest enclosed educational and creative "jail". The higher the walls, the more you are asked to find the wings to fly. Since the anarchist personality I had in me, I was constantly looking to "break out," to be free, and I had to work harder than others to discover higher skills to prove my theories and creative thoughts.

"You are on your own," so I was told by my professor Andreucci, "what you are looking for, no one here can give you. You would have to find the artist in you, your creativity, on your own, in a very personal journey." And so, it was!

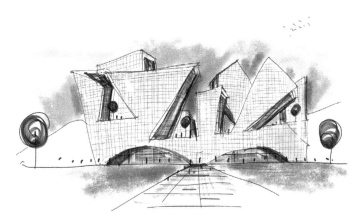

Conceptual sketch - "Breaking the Box" building complex

Chapter 15 - Creativity & Motion

I have practiced architecture since I was sixteen years old. As a student in Florence, I used to walk at night in its small ancient streets where the geniuses of art expressed their greatness, and in those silent hours, the old city whispered its secrets to me. The biggest secret I have heard through her stones was, "I want to live! To be in motion. I am tired of standing still as a frozen statue. I wish to change, develop, excite and surprise. I want to live!".

I then realized that architecture needs to break through outside its static stones, which keeps it still on the verge of dying. Furthermore, it was time that architecture opened itself up toward new worlds and fields that are not directly connected with and work with. It was about time architecture expressed the tension and motion within me. That tension, that inner motion within me, is the infinite well of creativity I draw my powers from. It must respond to life's changes as a living creature and adapt to the world, break all fixations, and stop copy-pasting the exact solutions, as each human is different from the other. I took it upon myself to live a nomad's life, a way only a few people choose. A nomad in the world of architecture, all left was to research with childish curiosity, find the connections between things, improve my skills, feelings, and sensitivities, and search

for an authentic expression out of attention to what reality wants to be through me. Architecture started in me like a dream and became a playground, laboratory of experiments, and a religion. Today it's my greatest love and passion.

Creativity is the motion from the emptiness, the void, toward the realization. It's a healthy motion of all-natural things. In each step, there is a constant motion only in different directions and qualities. In each phase, other things come to light. Different parts expose themselves and ask for a tangible manifestation in a dimensional world with all its forces moving, affecting at all times.

Dynamic architecture starts inside the architect's world, a world full of tensions and emotions as a reaction to life's changes expressed within him. It involves all his physical, mental, emotional, spiritual, and intellectual layers. All his world lies in motion, looking for an expression, even if he is confined or enclosed physically. Such a vivid and strong tension happens within the architect who believes the reality is just a recommendation and sees the beauty everywhere and the potential of what could be in life. In contrast, he is driven by love and the will to help others and make them see the same magic and irresistible secrets he discovered.

Principles of Dynamic Architecture:

1. Dynamic architecture starts inside the architect's world, in him, inside his tensions, and all synchronized components from which he is composed and work together in motion.

2. Dynamic architecture is a result of a multidisciplinary creative process.

3. Dynamic architecture strives to create a physical motion of the structure or its parts.

4. Dynamic architecture reacts to its time and the problems of man in his environment. It grows out of love and empathy for the other.

5. The dynamic architecture will create an internal motion of amazement, a spiritual-emotional movement within the visitor or a user.

A Living Architecture

Dynamic architecture recognizes the life and its unstoppable motion, its infinite changes as a fact. Its role is to mirror its time by creating a place that represents the changes we have gone through. It mustn't look back and repeat, copy the past, but see in the present, its source of inspiration, and look at the future with the vision for a better world. A living architecture answers the problems and dreams of the man who lives today and tomorrow. Each copy or slight modification of past patterns, such as the typical "living boxes" known in every corner of the city, will only increase the gap between the changing man and his future needs, which already ask for different designed places, better suited, healthier, more beautiful to today's, tomorrow's standards.

A living, dynamic architecture takes its roots from the connection to all fields of life, especially those that express human creativity. Imagine a dance, meeting music, meeting a painting, becoming a sculpture, meeting technology, materials, and lights; all these intersect in architecture and transform themselves into a place inspired by all these. A place that moves physically as a choreographer, the structure in motion, light, and shadow constantly changing and affecting our movement inside of it. Imagine a space that surprises you, is unpredictable, and reveals its unique quality each time as new with its constantly changing beauty. Imagine one day in spring, and everything is painted

pink or yellow, the same as nature does with the passing time, so can we learn from its magic.

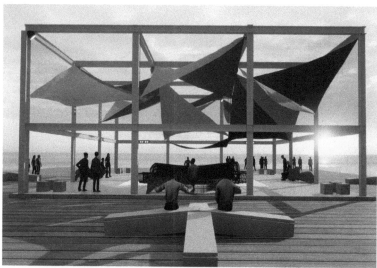

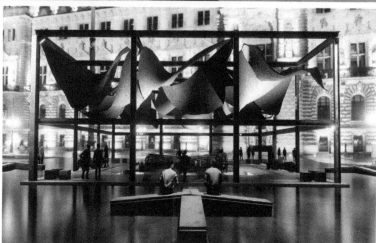

Rendering - Architecture As A Living Music" Project or (DNA of a Home) inspired by the music of the artist David Broza. A dynamic, reactive space, changing based on live played music and dances, interprets the sound into a constant structure motion

Architecture That Grows From Inspiration

The aim of living dynamic architecture is to create a tension in space, in the building, and especially inside the world of those who live it or experience it. This vivid experience is not an accidental byproduct but made with an aware choice by the architect who wanted and designed that experience.

You recognize dynamic architecture when there is a clear story and concept behind the planning, a concept deep and complex enough with tensions of different worlds that "Combat" inside the architect's mind in searching for a concrete expression in the world. When it's out, it is clear to all sensitive creatures that this place makes our spirit dance.

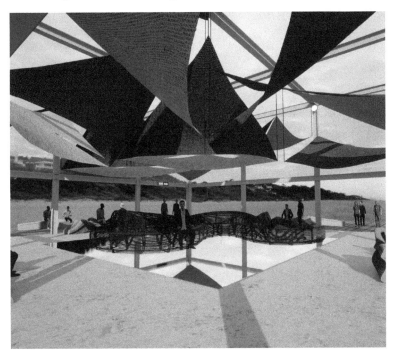

Rendering - Interior View of the Dynamic Project Architecture As A Living Music" or (DNA of a Home)

David Broza before the concert *Research - Professional dancer, Micha.*

Shape to structure

Motion to shape

Structure to space

The first type of motion - Synchronicity

Synchronicity is a field of forces that consider each other, creating minor adaptations and changes toward one another so they can allow a constant flow and motion. In synchronicity, there is the recognition of the rules and principles of each force. For example - if I dance by myself freely, and another dancer comes into the same space wih his movement, we approach each other from different directions. It's clear to both that there will be some connection between us at one point or the other. If there is a will to synchronize, each one of us is trying to learn the laws of the movement of the other. The beat, the flow, the patterns. Then, a decision is made to change something within our motion and adapt, to consider and fit the other in some way, or we both decide on a new rule, rhythm, or pattern and change ourselves based on that so we keep the constant flow. Otherwise, an intersection or interruption will happen due to the interference and stop all motions. The goal of synchronicity is to keep the movement going with mutual consideration, attention, and change. In the peak of synchronicity, there is a moment of freedom, a unity of forces, a spiritual uplifting while moving, where the other becomes us. We become them momentarily and go forward as if one whole unite. That feeling exists in many experiences we have in life - when we create music together, dance, sing in harmony with a group, and so on. That peak moment of synchronicity is remembered as one of the strongest sensations of happiness that has no match.

In creativity, there is a fundamental need for synchronicity between all layers and parts which compose the whole creation. All those forces in motion, the interior, emotional, mental, spiritual, physical, intellectual, and environmental, are supposed to synchronize into one flow that gives birth to creation in the world as the expression of all those dynamics. Creativity is a

constant dance, a choreography of creation. Motion equals life. To create something with a life in it, we must be in continuous motion (either an interior or exterior) ourselves and express it.

The second type of motion - Balance

As opposed to synchronicity, even though a balance looks like the absence of all motions, like a rock standing still in its place, the balance results from many equal but contrary forces working simultaneously. The result is a non-motion. Staticity.

Balance is another form of motion, even though it doesn't present any change of place or space. A balance makes sure that all forces equal zero. That is why it is in non-motion. Nonetheless, these non-motions result from many opposite motions in practice. The balance motion is essential in creativity because it allows that moment of silence, pause, and depth. Same as in sounds, the silence is a sort of a complementary non-sound, yet a sound that only through it we can understand music.

The third type of motion - Harmony

Harmony is the ability to allow different motions to co-exist in partnership without a threat or interruption. Harmony is a motion that keeps the coexistence of all components in their natural state. For example, harmony between man and nature exists when the natural existence of all animals, vegetation, lands, and all living things in the environment, including man, is kept and lives next to one another instead of at the cost of each other with the alternation of the natural existence and motion of the other. Harmony is a field of motions. Like in creativity, that field allows each layer to be expressed freely and naturally without the one (technical, practical, or material) becoming the

essence of all and at the cost of the natural need for expression of all others. Creativity seeks harmony between all its components. As a result of all those complex but combined motions, a whole creation is realized. All strongly feel a feeling of wholeness.

In the creative process, there are some challenges with the transitions between the abstract to a concrete expression. Most of the time, we are faced with abstract notions and principles needing a tangible sign. For example - Love. How does love look like a sign? One of the ways to decipher the hidden signs of the abstract is by imagining its motion. What would its move and choreography look like if love were a dancer? Once I see it in my imagination, I try to translate its movement, its principle, or characteristics into an exact sign (or signs). The motion is the transition from abstract to reality. It's an essential tool for expressing spiritual and emotional principles more clearly.

The Angle at the Cabin, by Giovanni Michellucci

Each time I imagine architectural movements, I remember the story of the Florentine architect - Giovanni Michellucci. I came across it as a student in Florence and fell in love with the depth and innocence in his writings. He described himself wandering in the Tuscan Forest near his house and the smells and beautiful sights of nature accompanying him on his way. As he walks, he notices a small cabin in the woods, a tiny cabin that could barely fit one person in it. It was an almost torn down cabin with a tiny door slightly open. As he approaches it, he looks inside through the small crack and sees a wing. Flying slowly from side to side, dancing in the air in that small cabin space. It's an angel! He said an angel that creates precisely, with his existential motion, the exact space he needs. It amazed him that such a small space was enough for an angel, and a question

came to mind - why is space never enough for man? Why do we always wish for bigger and wider? Some creatures know what they need through their motion and reveal the suitable space from themselves in which they maintain their magic. These creatures are angles, and therefore Michellucci concludes that the world needs to be changed until a man turns into an angel and understands his true motion, creating a suitable space to live in out of that awareness. Is it possible? Yes, it is!

Something in that internal dialogue, that innocence filled with hope, at the end of his life, got into me. My being and my wondering about motion as a space catalyst, a motion as an expression of our soul (the angle in us) that knows better what the right space should be in the world. Out of those questions and yearnings - some of my most fascinating projects were born!

"Music is a Living Architecture" project

This project starts with music as its inspiration for the physical motion of the whole structure. The chosen music was based on the "Bedouin Love Song" by the artist and musician - David Broza, played at his desert Masada concert in 1994, a four-minute tune. Before he starts the known song, he plays and wanders around on a personal journey through the sound of rare courage to "get lost" in the music until finding his way back to the harmony. It's an extraordinary song, full of emotions and power. For many years, it was my inspirational song whenever I wanted to connect to creativity. It has an abstract expression to motion as I was always looking for. It is a motion I do myself in my life, from chaos to order, from emptiness to existence.

I dreamed of transforming that music into a place, into an architectural space that reacts and moves, showing us the beauty behind the sounds. I dreamed of making that music into a living

place that "dances" based on the artist's spirit inside the music and architecture as a choreographer, which moves and creates its own home through motion. Emotion becomes a sign, a sound, and then the music becomes a space.

What does music dream of? It dreams of existing as a real thing that moves and changes, a concrete, material expression in motion. So, I took that music, and my first challenge was to find out how music (that abstract language) looks in the physical world. The sounds went through different filters, which mediate between the abstract and the concrete in the music, through equalizers and software that express graphically, and visually the quality of the sound's performance.

I made the music pass through me and guided me intuitively in creating signs, lines, and shapes in constant motion. It was an experiment of synchronizing the body, mind, and spirit in a flow and seeing which visual expressions come out of it, without any thought, just intuition.

On a different occasion, I asked professional dancers skilled in improvisation to meet outside, hear the music for the first time in their lives, and be filmed. At the same time, they interpret the music intuitively through their bodies and see what kind of shapes and forms geometry speaks through them in motion without any preparations. We used the film to edit them to find the hidden geometry patterns of the movements. We shot the whole experimentation in different locations outside of the public space. It all led to the basic principles of the project, the translation of motion into the structure of flexible fabrics in motion, creating different compositions of temporary spaces based on the playing at that moment, and reacting to live music directly.

Through this project, we can now see what kind of a space

each artist created through their music - what kind of space is hidden in Beethoven's symphony? A musician can play live music inside the space, connected to the system, and make the whole structure move directly as a response to its playing, a space in motion resulting from his state of mind. As opposed to the saying Goethe - architecture is frozen music. I am trying to prove that architecture is living music!

The connection between the emotional, spiritual, and architecture reacting and shaping our environment, as a choreographer of space by moving its structure, is the main goal of my project. The experience of synchronicity between the music played live, and the changing space around us is an extraordinary live effect of architecture in its forming and being, but also the spatial manifestation of music. This achievement opened up the way for using such dynamic architecture for therapy and healing of emotional and mental illnesses.

Archi-Therapy

Archi-therapy is an architecture that expresses our state of mind and emotions, defining an emotional space that stops being abstract in our mind but becomes real and concrete, a place we can enter. For example, we can create the space of our feeling by movement, which determines the formation of space, and then walk inside the space of our happiness or fears, examine it, and remember it as a vivid image.

A person experiencing an anxiety attack or panic attack expresses his feeling through motion, a dance, or an intuitive movement connected to his feeling. That movement, while connected to sensors or flexible fabrics which determine the space of his feeling, gives us the first, raw definition of the space of his feeling. That space can be examined. He could walk inside and

around it and understand the different views his emotions have created. That space becomes a tangible image and place in his memory and reality.

He can film it and come back to it and would be able to see for the first time in his life what his feelings space look like. The feeling gets a place in the world by transforming an abstract feeling into a concrete space. He could move literally from the space of his fears to the space of his happiness without needing to imagine. It is now real. That experience can be used in therapy sessions as a part of the healing process from traumas or different emotional challenges.

Archi-Therapy inital concept / sketch

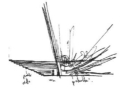

Chapter 16 - Creativity & Nomadism

The nomad, the wanderer, is destined to discover the world, the one inside of him and the whole world around him. The movement of the nomad started with the understanding of alienation and foreignness about our surroundings. Once we became intelligent, willing, and moral creatures, different than the natural environment around us, we became foreigners. With that understanding, the necessity is born to wander, to look for a different home, an identity with a place or a sign that can express our being. The nomad seeks a home, even a temporary one, and his wandering assures the open question within him in constant tension - what is a home?

With the changing of places and the discoveries of new environments, the nomad is asked to use his intuition and all senses to survive as he adapts and orients himself in the new world. In times of change, all his senses are heightened because everything is new and surprising and could be used for his understanding or identification with a place. Each small detail is meaningful and filled with inspiration. The nomad is also open to the universe and its inspiration at all times. Each shape, texture, color, law, and principle he understands become the center of his attention for research and analysis. The nomad stands in a deep creative awareness thanks to the motion he is in and his sensitivities and readiness to accept the new as his own. As a "dancer" in the world, who defines his own space through his

movement, he also reacts to his environment. He is his creation, while each step defines his world anew.

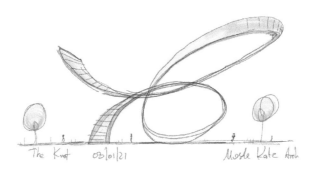

Conceptual sketch - "Connectivity", Design of a Public Space

The nomad or wanderer is a creator by nature with vivid instincts and intuitions. He stands in constant dialogue with his interior and exterior world. He creates with the help of all the insights he gets out of the existential questions. He is a creator in motion, even though his nomadism doesn't require a geographical change. The interior wanderings are just as powerful and show the wide ranges of his dimensions. They discover the infinity in him. An internal wandering made extraordinary creations.

In his "Divine comedy," Dante represents it better than anyone else. In times of personal crisis, a man chooses to enter his worlds and expose them to all. He crosses memories, thoughts, and characters to reach the ultimate manifestation of his motives. The thing that makes him move and get his distance is:" the love that moves the sun and all the stars"- motion is the law that creates worlds.

Each nomad assures their growth as a person, which is a critical development for each creator. Each creative process asks us to "leave" our comfort zone or known world and wander. To leave our land and walk toward new worlds. This is the way each creator who wishes to reach his most profound and most powerful creation must take upon himself the motion of nomadism (inside or out), to get lost and find himself again, survive the encounter with the infinite and give his sign, of his existence in front of the rest. As old sailors on an old wooden boat, with the wind of curiosity on his back toward new horizons into unknown lands of his soul.

The wandering is a part of the creative process in the search for inspiration, for a question, and the things we wish to express in the world. We "give up" on our security on our way to the unknown, let things surprise us, and feel the powerful feeling of finding a sign or an orientation after losing. All this is a part of our growth and the strengthening of skills and sensitivities. This strength allows us to return to the same process of constant wandering as creators.

Once the nomad has gotten used to the beauty and amazement in his discoveries and felt the uplifting of his spirit by the whole process, he can't do otherwise but go back to the same addictive feeling. As Dante's Ulysses, who asks until the last of his days to go back to his nomadism which is his life's purpose, to find inspiration and knowledge as a result of his motion in the world: "Fatti no foste a viver come brutti ma per seguir virtute e connoscenza." Out of fear, in the first steps of his journey, now he finds a safe ground, he reaches an innovative and unique perspective, and new horizons open up before him.

*Don't let yourself live a life of ignorance, but follow the virtues and knowledge. (Canto 26, hell, The Divine Comedy)

The creative nomad leaves on his journeys to new worlds for a reason - to come back home with the findings, the treasures he collected in his paths. The further he goes, the deeper and often he wanders, he will find more elements and building blocks of his creation. These will make his work more exciting and complex, more controlled and aware.

The instinct - is the higher wisdom and infinite knowledge that guide the creator toward the right path. The creative nomad sharpens his inner voice, which is the most important one in his process. That voice is his guide, friend, and companion in his nomadism, which he can trust. The nomad discovers through his motion all the layers and components of which he is made and understands he is not just a physical being that answers to practical needs, but a whole world of qualities, strengths, weaknesses, limits, and if brave enough to cross them, to see his infinite new spaces. He lives with silence as a friend. The silence in him is the force that pushes him further inside himself. Silence has a tremendous role in creativity - it opens a new space for expansion, and it works as a platform for motion. The nomad is riding that silence until he reaches a boundary. Same as there are many different sounds, there are also many forms of silences and, therefore, many forms of motion the nomad can achieve through it - vertical, horizontal, into contrary horizons, between times, in synchronicity, in a twist, or in chaos toward all directions at the same time.

The creative nomad usually returns to the same point as an ancient nomad returning to his tent in the middle of the desert. The feeling of home and the memory of it, the sense of the child in him, is the one that brings him back to his origin. Still, with different changes and insights, he picked along the way and uses that to close a full circle while opening new ones - to which he will travel soon.

The nomad needs to wander so he can build a space of chaos and disorder that contains all his fears and insecurities, but that's where, as his own God, he finds his original, authentic expression and order in the chaos, dividing darkness from light, water from the sky. That's where he creates, out of the emptiness and abyss where everything is not yet formed. That creation feeling is the uplifting divine sensation he searches for in his creative process each time. The nomad's motion brings tensions from within and outside, a tension that works as a basis for all his questions, dialogues, and discoveries. Each discovery points to a new motion that leads to further tensions and questions, and so it goes. In his nomadism, the creative, curious person constantly asks - how are those things related? Do I belong? What is the law that connects me to this new place? Those existential questions allow him to recognize new information, receive new inspirations, and accept the unknown as his temporary and flexible identity.

The nomad is in love with motion, loves the temporality of things, and dismisses the constant fixed reality. Dynamics is his source of life, as it is of creativity. He needs that movement as his life's "dance," values it, and craves it as if he were a lover. Once he is out there, he can't return as he was. That's why he can assure that his creation will be different each time and unique with original discoveries. You are secured, you creative wanderer, that each movement will guide you to a new understanding. When they tell you to think outside the box, it means to take up a motion that leads you to nomadism, out of your limits and beyond. That's where you will reach the new and original in you.

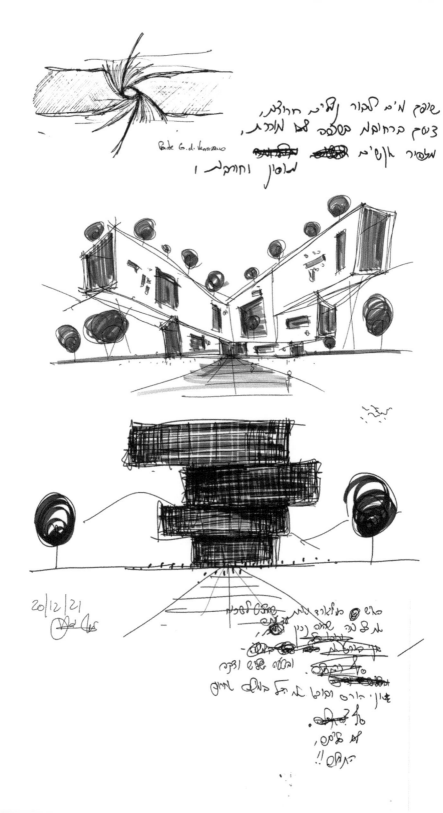

Piade G. di Venezano

שופ מ"מ לאבור לסי, תיק חלוג,
בעתק הרחומת ספסם מל עודק,
משפיד עליו מ"ק ~~~~~~~~~ ~~~~~~~~~
לשלו וחחמל 1

20/12/21

Chapter 17 - Creativity &
The Question of Home

When I was just three years old, we moved for the first time to a new country, and I had to learn a new language and adapt to a new environment. We moved many times since then - when I was six, ten, twenty-two, and so on until today. In all those periods of constant geographical and cultural changes, there were infinite movements I went through within me as well. The home concept which is a stable root connected to a place, a city, a neighborhood, or a language. This language is supposed to be identical and constant for a long time, with some friends and familiar faces, all these components which you build your identity and the stable relationships of your life, all these things I never had and had to develop a new concept of home each time. The home was, and still is, a flexible thing, and I had to find an alternative root to be a physical or geographical connection.

The concept of home is dynamic for the wandering child, teenager, or adult. It's an open existential question that knows no final understanding or feeling. To this day, I keep asking myself what a home is, and in each period, the answer changes. I used to be jealous of kids who knew how to answer immediately when asked what their home was and had such a strong connection and identity with their place. I kept this jealousy for many years. I was even jealous of cats.

Five years ago, as I lived in south Portugal, in the Algarve, I spent my time in a beautiful, isolated house on the hills in front of the ocean, a fantastic mansion built with the local cultural style. It was a white building complex with humble decorations, a red tile roof, slight coloring on the walls, and a lot of vegetation.

I was alone in that house, living and looking after the owner's cat. His name was NEKO, but I called him "Susu Niko the 3rd". He (who was a she) used to walk around with a breath of nobility in the territory in which he was born. I felt that he was the true baron of the area. Every evening, at sunset time, we would meet, me and Susu the cat, at the same spot on the roof, sit next to each other, and look at the ocean and changing colors of the sky. He used to stand on his front feet, his head up high, his long mustache hairs blowing in the wind with grace, and every once in a while, he would blink with eyes and turn his face to the sides with confidence.

One evening, during our usual meeting on the roof, I looked at Susu and tried to read his mind. He, the king of the place, looks at his kingdom with peace of mind (even though at nights he used to fear noises and thunders and ask for shelter under my blanket) made me admire him because this cat could say something I could never imagine in my life:" This is my home! I belong here!". This cat knew better than me, I suppose, what a home is. That night I decided to leave Portugal and return to where I was born, the same clouds and dunes I have known from my memories. Since then, I have asked the home question more often, and in my opinion, it is the only question a human is destined to ask all his life.

On one of the nights in Haifa, I went to watch a screening of a documentary film by Dafni Leef. She was a magical girl who walked one day out to the street screaming in her way that she

didn't have a home. Then in 2011, she started the most prominent social protest in Israel, with millions of people supporting and screaming the same thing. At the end of the film, Dafni was there to answer questions from the crowd. I asked her, now after all that's happened, what a home is for her.

Her answer was a deep and wonderful thing. I identified with deeply - home is an anchor. This stable place allows you to move freely in the world and then return to the same spot from which you started. And so, keep moving when there is one clear fixed point. A home that allows you to move in the world! As opposed to most answers I have gotten from people to this question, which had mostly the concept of statics, of staying put and stable, here, a home is a catalyst of motions.

If we ask each person what they do in life and what they dream of, we will see that underneath all their wishes, needs and aspirations lies the question of home that moves the strings of our lives. The question of a home, with all its complexities, is at the heart of my projects and creations in my search for a place of my own in the world. It is my infinite well of inspiration and original answers. My creativity grows out of that question.

In the question of home, there is an undermining of all that's safe and secure in our life, and something in that stability starts to shake. That internal tension creates a small void, minor chaos of its own. It demands a new answer, vision, and insight about ourselves and our life relationships. The question can generate uncertainty that is so much needed for us to grow and be re-born.

What is the DNA of the home? The home question has a direct relation to our emotions, our spirit, our intellect, our culture, and our religion. It affects all our existence. With time, the home question changes to a different one - what is the genesis of a

home - it's beginning.

The question of its beginning fascinates me to this day. I keep discovering new perspectives I haven't imagined before. As a result of this question, I teach my students to search for the DNA of things, of the concepts they are researching in their creation. Why is that so? Because in revealing the home's DNA, we understand its creative principle. That principle needs to pass through an alternative evolution and reach, at the end of the process, an original, innovative solution.

That's creativity. All it needs is one different rule that changes inside the process, and in time, we reach an unimaginable destination. Try to think about the Earth and one law that suddenly changes, like gravity, and become more assertive in its influence. It means that in time, all creatures and humans will be short and smaller because of the gravitational pull toward the center of the Earth. Once a rule or a principle is changing, we can create new proportions, new shapes, new relations, and a new world. What would such a world look like? These are the "materials" that awaken our imagination.

The home question is directly related to our identity. For the creator, the more he keeps this question open, the more he keeps the inner tension active and a constant state of search or discoveries, which are all the sources of his growth and creative expressions. The home question keeps sculpturing us, leaving our spirit with curiosity. The secure and consolidated person will have difficulty reaching high levels of creativity since he lacks the void, the chaos, and the movement of tension needed to awaken the need for the new.

The flexible identity, on the other hand, allows us to receive new definitions from different origins and cultures and become more complex and exciting. It is influenced and influences back.

A sort of emptiness must be filled as new for that to happen. The home question helps us create that void, point out the unclear spaces in us that will be redefining our life story by the new understanding of who I am, and how am I connected to this infinite fabric of life with its infinite particles, what is my place and role in this?

In these times when people immigrate more frequently, for economic reasons, cultural, climate change, or wars, the home question is actively present again, not just for the ones who change their world and move, but for the local ones as well who receive the new identity and culture into their environment.

They ask long-forgotten questions like - who are we now? What is my home since new people are a part of this story and affecting the known habits we have had so far? The home question arises everywhere in the world after being unasked for thousands of years. It hits everyone who never dared to question his security. The purpose of this question is a new, more profound human and cultural development, mainly to bring us back to the creative dimension.

The concept of home is an abstract notion, and I find myself researching it all my life. Not the apparent home - the one with the door, windows, and roof - but the deep sense. Professor Yeshayahu Leibowitz (which I highly admire), in his innovative interpretation of the Genesis of the Bible and the story of the creation of life, stated that - the Bible dedicated only 30 verses for the description of the creation of the whole universe, its infinite space, its stars, the planets, the life on them, nature and all that exists...for the building instruction of a wooden tent for God, the Bible dedicated 300 verses with specific detailed instructions of the dimensions of each beam and its decorations. Why is that, he asked. His explanation for it was - because the Bible and men are

not supposed to understand God and the universe at all, but only of the status of man before God, which is, according to Leibowitz, the only true meaning of man's life.

As opposed to him and following the argument culture I come from. I would like to offer an alternative reading to it. In my opinion, it symbolizes the proper relation of man's reference to the universe. Thus, the essential role of man is the home question! The human is home seeking, home-questioning creature and looks all his life for his spiritual, physical, cultural, and emotional home. That's the forgotten question that lies beneath our actions in life and is kept under the surface for thousands of years - what is a home?

Eventually, I have decided to initiate an artistic-architectural project that expresses my research and vision about the HOME and the DNA of the home as I see it. I researched where it might come from and the conditions for its development. I met many amazing people who helped me understand what a home is - a writer and a theater director, a philosopher, a musician, and an artist.

My meeting with Dr. Moshe Halbertal (Professor of Jewish Philosophy)

The meeting took place in a small coffee shop in Jerusalem on March 28th, 2018. Its wall is covered with natural raw stones, and a vast arch defines the interior room. We sat next to the window overlooking the street and had a warm drink. Around us, many youngsters were busy with their cell phones. Some were talking about everyday matters. When surrounded by children or the young generation, I always try to lighten the mood and laugh about situations in life, so I thought it could make a great beginning of a joke - a philosopher and architect meet in a coffee shop and speak about home. Some moments later, the professor

created a unique depth and put it all into its proper proportions. That meeting took place to understand the meaning of home, the DNA of the human home, and where it came from. A home in its abstract purpose through cultural - religious or spiritual sources, the Bible, and its interpretations.

Me: "Lately, I have been dealing with the question of Home. What is its source, and where did this need come from? What do you think is its moment of genesis?"

The professor: "If we consider the question of a home through the story of the genesis, this is where it becomes a crucial question. The story of the creation of the world and men is the establishment of the situation of the human being - death and paring. These are human conditions; before we begin with Abraham, we start with the conditions of men - violence, the first murder, the expelling from the garden, and the fact that the human doesn't feel entirely at home. He is not at home.

And it starts by becoming a creature who understands right and wrong. What separates him from the world is his moral awareness. Nature doesn't answer to good or bad. It has inertia, and man was naked and a part of nature in the beginning and had its place. The world was his home. I always asked myself - why he was suddenly ashamed after understanding right and wrong? And that is related to the homeless feeling!

And being home-less starts with a gap. A gap between what needs to be, the wanted (the dream), and what is - reality as it is. We are strangers in the world because we have the categories of moralism, to which the world is indifferent. Maybe it's connected to the Ramban, who asks the same question (why did the Bible start with the genesis?). He says that the condition of man as a deported from the garden, being in exile, is the basis of the Bible. Being homeless and exiled is where it all starts,"

Me: "If so, what you are saying is that in the core of our existence lies a motion. A dynamic. The nomadism and the wandering and the constant search...."

The professor: "Yes, it has to do with the fact that man's home is temporary. The fact that the land, the place, is conditional. I wonder if you are looking for this in your research?"

Me: "Yes, sure! I look for the DNA. I am not interested in a wall, a roof, or doors. I'm looking for the essence, the moment of birth of the home concept within us. I imagine that primary creature in an infinite space, on Earth or even some planet, who knows, and before every other common need, the home question arises, the one that leads him, guides him in all his decisions along with his life."

The professor: "The question is, how would you define what he is looking for when he searches for a home."

Me: "This is precisely the DNA I am trying to decipher; this is where some interior motion is happening, which is related to fear and insecurity, on the one hand, maybe to instability and the exposure to dangers. On the other hand, it might be an opposite motion of concentration within himself and looking for his sign in the world.

That sign can be the thing that protects him, a sign or symbol that builds his identity and sense of belonging. A place or an indication that results from his dream of being in the world. In that tension between fear from the exterior and the interior plan lies his search for a home, or maybe I am missing something, and there is a further depth to it? The motion you mentioned is one of the main concepts that led me to understand home.

This motion seeks balance and synchronicity between yourself and your environment's other forces. I deeply related to your

statement of a "changing, shifting" movement that lies in the basics of the home. It's not the expected stability or statics, the halt. It shows something extraordinary I have discovered myself as well - underneath the home, that stable, secure thing in our mind stands the most unstable thing we can imagine and is in constant motion. That's unexpected to find behind the scenes the exact opposite of what we imagine all our life. I am curious to unveil and discover that place underneath, that abyss, and origin."

The professor: "It's true, in that origin, as we started interpreting the biblical source, that's where the human begins from a state of homelessness because he is an integral part of the world. He walks around naked and in the same status as other organic creatures already in their home. That was his primary condition, being one with nature. In that state, he has no reason to wonder about his home because he is already in it, in his natural state. Then, he is exiled and forced to look for a home.

The creation of home results from entering a state of alienation and fundamental foreignness about your environment. In that case, the man creates his space, place, and existence beside the world because the world is not his anymore."

Me: "In your opinion, he understands it only after the exile? Because if he is a part of nature and now deported from his first limits into new ones, which are also natural to which he belongs, apparently, over there, would he then feel at home as well?

The professor: "That's right, I think he understands as he starts dressing! That is also a definition of a home. The man is the dressing creature (opposed to Nietzsche - the man is the blushing creature).

Me: "So, by dressing himself, he introduces his first concept of a defined place. He describes the immediate, most precise

space of himself in the world through the clothes."

The professor: "Yes, but he gets dressed only as he understands right and wrong (good and bad), and that knowledge uproots him from the place."

Me: "In that case, the understanding of the good and bad concepts makes him realize he is different from the rest of the animals, feels his strangeness or his uniqueness, and as a result has the need to create his place, which expresses his new unique being in the world...."

The professor: "Yes, but I wouldn't say it's because he understands it and the animals don't, but nature is indifferent to the awareness of right and wrong. For example, gravity doesn't care if an innocent boy falls from the 4th floor. The indifference of nature brings to the sense of redemption where the gap between all that exists and all these wishes to exist is as small as possible. So, in my opinion, the beginning of a home comes from the strangeness of man to its place and as he starts wearing clothes".

Me: "Morality is then, the source of strangeness. Strangeness or the sense of feeling foreign leads to the need for self-expression in opposed to the environment".

The professor: "That's correct, and here we find the ambivalence because he (the man) belongs and doesn't belong at the same time because he is also determined by the same laws (gravity, etc.) Kant would significantly state (related to Leibowitz's doctrine) that a man is able to cast an unconditional duty. It is his freedom to decide and choose regardless of any environmental conditions. That freedom makes him a transcendental creature with free will and no conditions.

On a different thought, about the wooden structure (God's

home) you mentioned before - in all the Bible, from all the descriptions given, the ones for the temple are the most detailed ones. I think it concerns the concept of "the sacred." By that, I mean a sacred place that has infinite clear orders and rules. You can't make a "shortcut" inside a temple; you must walk precisely because this space is not instrumental. It is not in your control. It stands for itself. It means that inside a sacred place - the possibilities of errors are many. There are constant rules and restrictions you must follow. It has limitations and mediates relations. You can't just walk around there. It's not your home!

Let's take a secular analogy of a space like YAD VA'SHEM (the holocaust memorial complex). Students come over and have picnics in the central plaza. That's why the instruction of a place keeps its essence and idea. It is connected, in my opinion, to the problem of the temple mount in Jerusalem.

When someone says, "if it's sacred and holy to me, it is mine!" He doesn't understand the concept of Sanctity or Holiness because sanctity in its essence is a limitation of sovereignty, of control. In a sacred place, there is no personal control or ownership; therefore, this concept is about the lack of control."

Me: "In that sense, in the concept of home, no sanctity can exist...."

The professor: "Yes, and as opposed to a sacred place, in your home, the level of tension is lowered. Let's go back to the comment about the temple building. If you put one beam incorrectly, that's a significant problem. This is the way it's a place filled with instructions; in that sense, it is not yours. You ant go inside just like that. When you enter the holy of holiest, only the higher priest can, after he performs different rituals of preparations. The entrance is restricted, limited, and filled with conditions and instructions.

On the other hand, a home is where you don't need to ask for permission to enter. An interesting Talmudic legend, "The Higher Work," talks about the higher priest who must go through infinite rituals before entering the holy holiest. Still, the simple maintenance workers can enter just like that without preparations. The concrete work is the "higher work" and is more important."

Me: "It might be connected to the fact that the higher priests as a tribe could never possess any land and territory and never have a home?"

The professor: "That's right, you might say that the land of Israel was never our home in that sense, it's a holy place, and our existence on it is conditioned. It's not heritage, and the option of exile is always there. People make mistakes when they think this land was given to us as heritage. It was given to other people as well in different periods. This unique place of awareness has exile as an option in its fundamental definition...."

Me: "There is no such thing as any nation! That existential insecurity we sense here. That dynamic influence from underneath, at the national level as well. Such a thing exists only here. A home for people with a motion-based home."

The professor: "Definitely, it starts with the verse "For me the whole land..." including its economic consequences. In the fiftieth jubilee Jewish law, you wouldn't be able to have any ownership of the land. There is no intergenerational accumulation of lands by a single person. Each land you buy goes back to its original owner. Why? Because "for me the whole land...."

Me: "So, in a place which is unreachable by law and forms its origin, how can a man create a home sense in it? What kind of home results from such instability?"

The professor: "He is constantly a conditioned tenant...."

Me: "In that case, the typology of such a temporary home, a dynamic home, a changeable home with unclear limits and borders. An amorphical home rather than a stable one."

The professor: "Definitely, a national home is a problematic concept. He doesn't claim any ownership but the expectation of standing inside norms. It's an interesting awareness. That's why Abraham, with a promised land to him, says - like you, I am a foreign citizen". He is not the natural heritor of the place. He buys himself a piece of land to be eventually buried in when he dies."

Me: "I still ask what kind of a home awareness can come out of it? It's not the same awareness of a home with which Norwegian lives. Who is aware and knows that the land he calls Norway is his? Without any doubt or conditions. For us, the uncertainty, the exile as an option, lies in the source of our awareness. If I try to be more precise, the concept of home stands between two poles, two horizons—the one of instability, motion, and uncertainty.

The second is that of the will, the yearning for a constant, stable place. In between those two horizons, the man is living his life and creating something, which is the result of this dialogue with both ends. Everything is constantly changing, depending on the most potent force that pulls him, like stretching a flexible fabric toward different directions based on the strength of the force we apply."

The professor: "Interesting, it's a beautiful description. I would say two things to that: the one - the human need for a home starts with the fact that man understands that he is a "double-creature" that he is not entirely natural. Otherwise, he wouldn't need any home or territory and would be a part of everything. Maybe he would limit his area just to keep his offspring's safe, but that's a very particular use. So, he starts with the need to

build a world!

The home awareness starts as he starts to wear clothes and cover himself - being a cloth-wearing creature. And that's the fundamental gap he finds in the meeting between his moral awareness and the world's indifference. The world looks strange to him, foreign. The world is indifferent. That's where it starts. Even inside the home, the gap will still exist.

What is the law? The law is his home. It says - we will create a space where the gap between what's wanted and the existing is as tiny as possible. But even in that artificial home man creates for himself, he won't be able to escape that gap. This is how it happens when a man suddenly realizes - I don't feel at home anymore. He says - the gap between what he wishes to be in his wishes, and what's there in everyday reality, that gap is too painful".

Me: "And he also can't bridge that gap or create any motion of change."

The professor: "Yes, that's why he has one option to narrow that gap or change himself, but here, he starts losing himself. Another way to look at it is through the "sacred" concept. To be somewhere sacred."

Me: "So we are examining the home concept through the "sacred"?"

The professor: "Yes. The concept of "sacred" in a definition is a limitation to a non-mediator relation. In the sacred, I am limited in controlling and choices. The profane, every day is where I approach when there is no mediation or norms to follow. "

Me: "Even there, in the sacred, I am a foreigner. The same strangeness we talked about, about nature - a world we enter, and we know that we are not an integral part of its surrounding.

Same as inside the sacred - we see this place is a different dimension, and this surrounding is not "ours."

The professor: "There is tribal yearning for it, but it's not his."

Me: "It's interesting how a home is fluid and flowing between those yearnings. Between the sacred and the natural. In both, it's not our place, but there is a yearning to be a part of both."

The professor: "I am now trying a different idea and thought about the Sukka, the tent, the temporary home."

Me: "Yes, that's the project I am working on. Where the roof, as its most important defining structure, moves between different "yearnings" in constant motion, a dance almost, creating new spaces underneath while moving to different forces.

If its music and sound, or the artist himself or the environment that creates a reaction, in that reference to the home question, I would like to ask for your opinion on something - according to Heidegger in "Sein und Zeit" he exposes the being of man through the question of time - the forgotten question. In opposition to him, I thought that the home question, the DNA of a home as we try to ask it here, is the forgotten question? Isn't that the question that will reveal the real being of man?"

The professor: "Interesting. The home question instead of time...."

Me: "As we see now, with the motion and relations to the environment, the foreignness in front of nature, belonging and yearnings, all those things come from the home question, maybe there lies the true answer to the being of man?"

The professor: "In Heidegger, what makes us "thrown" into the world, our entering point inside the world is arbitrary. Birth

and death are both arbitrary. And it's the time that awakens us. In that sense, we are a part of the world. He would say it's an awareness, but if we begin with moral categories, it's a human problem only. The "problem" of birth and death is human in the deep sense of the word. The norms are the ones who make us strangers...maybe the forgotten question is the home question...."

Me: "It is interesting how you emphasize that the home question is first and foremost a human question. As such, it starts as the human categories appear with moral thinking as reasons for the separation from nature. Moralism is the beginning for a home, then?"

The professor: "That's right. Knowing good and bad doesn't allow us to walk around our necks. Because being naked is the immediate sense of belonging."

Me: "Do you think before the man knew good and bad concepts, as he used to walk around the garden, giving names to animals, defining things and acts, all that wasn't enough to look for a personal expression of a home, as a creature that has a language?"

The professor: "Following the RAMBAM, but from a different perspective, it is interesting to see how God says about things that they are good...and "it was good"...only one thing he considered terrible in the creation - for the man to be alone, so he made him a partner. The man with his language is an existential condition. I wonder if the awareness of home starts already there..."

Me: "You mentioned something that reminded me of the role of language. Everything that God creates happens through a word said out loud. "Va Yomer." First, nobody hears him. But I believe that creation goes through the word that already contains the whole work and the spirit of things in it, its sound, its

frequency, and in the world lies the image of the things even before it manifested in matter.

So, I wonder if already inside the language lies the home concept? And the man as a language speaking creature has already the category of creating a home thanks to the language he possesses?"

The professor: "I wonder if the man had already a secret language. It's a serious problem. The Rambam said - "Va Yomer" - the word God says each time is a will. Not exactly the word per se. Many actions God does, come together with a language of divisions ordinating. The language is the dividing act inside the chaos. It creates categories. The biggest creation is one of the words which allows us to define and separate between things. Without a language, there is unity, but the language creates categories and singularity of things: light, darkness, sky, water".

Me: "I would like to go back to Leibowitz and his innovative claim that the universe and the whole creation are considered indifferent except the man's statue in front of God... Maybe he is not indifferent? Perhaps in the genesis and the creation of the worlds through words, the man discovers the process of creativity, of the creation of a home, which is his primary purpose in life.

It's being shown and mediated through God himself, where we are introduced to the first elements which we create a place. Give it a definition inside the chaos. We are not exposed to the stars and galaxies. This story tells us of God's practice and method in creating a home inside the infinite chaos. To the process of creating a sign inside the infinite, isn't that what man has been seeking all his life? And all happens through the word, which is the will and dream in the form of a sound with a meaning.

Maybe this is where we begin our home question, homemak-

ing, right from the start through separation and order, through words and language and a potential space which is still not there existing but already being expressed in plan, in vision through the word. Earth and sky - before there was a sky, there was the word "sky."

The meaning in a language then was expressed out loud, and just after that it manifested in matter. In that short description of the creation of the universe, man learns the home creation process. The word is nothing but a sketch, a drawing, a sign that contains the whole idea of a home in spirit as DNA, and only later does it receives its purpose in factual matter."

The professor: "While you were talking, a thought came into my mind about the tent of the congregation - it's a place of meeting. You could say, a home is a place where you could find me in it. If you look for me - I am home.

That's the place I can find myself as well. A concrete place with a coordinate and address. It's the theological meeting of this tent - it's the place where the man wants to meet and know or find himself."

Me: "That's interesting. It means that this temporary changeable tent moves from one place to another, this dynamic space, is where man is finding his connection to God and himself. This place is nothing but a fabric structure—a dynamic roof.

I wonder what a home is to you on a personal level"?

The professor: "In my experience, a home is a place where the tension level is low. But I must say, it brings to a different type of conversation...a home allows space for expression. I can sing in it because no one hears me. Your children, you imagine, when do they feel at home? When they sing. They might not dare to do it somewhere else.

A home is a place of freedom, to do and express yourself as you wish, a familiar place. On the other hand, a house becomes a conflict front, a hell when you are in tension with the person you live with. When I visit a different country, I can't recognize people's motives, so I get in tension. Then I come home, where I understand what they want, where the risks are. Terror is the act of undermining your sense of home. To make you tense everywhere. You can't be relaxed in any place because it is dangerous".

Me: "Do you think that when people say that the whole world is their home, it's a statement that doesn't have any grounds or some kind of a self-comforting because they haven't found a home?"

The professor: "I think he is either an extrovert or creates a cosmo-political illusion. I never experienced strangeness. For example, the language - you get to a place where you can't speak the local language and understand the nuances. It's a linguistic foreignness. You can't be at home there - in this sense - being able to read nuances is a home."

Me: "Recently, I have been thinking about the home question in a broader sense, and as someone who lived in different countries, I discovered how relevant it is today. In Europe, for example, the whole immigration challenge raises the home question again, not of those who changed their roots and came into a new land, but those who already live in Europe and have received the new culture in its environment. In that new tension, the home question rises while it was dormant until that moment.

Do you think a home can exist in the absence of a place? You live with a person and become your home, and it's enough as a home experience regardless of geography?"

The professor: "I don't think so. I am sure this couple will

look for a home, a place of their own. In the book of Samuel, it was written about him that he used to come back to the place where his wife was. That was his home."

The meeting ended in motion. We walked along on one of the central Jerusalem Streets. At the same time, inside me, I kept a constant movement between different horizons we created in our conversation. On the ride home, my thoughts still wandered all over.

Personally, as a nomad myself, the home question was always there, open and tense, demanding an answer in every period of my life. It's not a chance that life has brought me to be an architect - as a "homeless" myself, and looking for it till this day, I became someone who dreams and plans homes and living spaces for others.

Once you reach the point where you say - at this point, I can't explain, maybe God knows it, you are then in the abstract dimension, and you know you finally came back home! The abstraction of the home concept is an infinite well of inspiration and the creation of original home concepts and designs.

In that sense, the world will be more creative and exciting in its solutions. The world will need, now more than ever, people whose life's purpose and habits are - creativity, so they can teach us how to live with the unknown and uncertain and the unexpected changes life will bring us. The world requests creative solutions for survival, especially to train our awareness to be more flexible and dynamic. The man who will survive eventually will be the most creative one, the most flexible and adaptable to changes, the observer and sensitive, and the one who can use his

instincts professionally as a skilled artist.

I see my work as more than just a profession. For me, creativity is a survival tool. I wish to improve all the time and teach others so they can change their reality and others for the best.

The beginning from which it all starts is the home question! It will rise and shake the security we thought to have as a part of our identity and roots. Things will begin to change, to develop in fantastic new directions. It's just a matter of time. Actually...has already started.

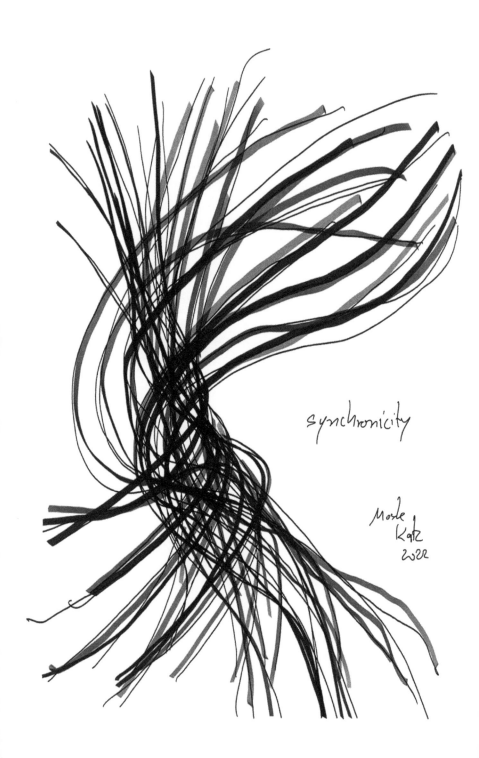

synchronicity

Merle
Katz
2022

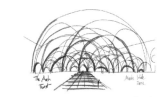

Chapter 18 - Creativity &
The Interior Poet

Reiner Rilke, in his letters to a young poet, shows us an approach that is an aware changing tool toward higher creativity:

"If your daily life seems poor, do not blame it; blame yourself, tell yourself that you are not poet enough to call forth its riches; for to the creator there is no poverty and no poor indifferent place."

This powerful verse reveals a critical thing: the fundamental belief that beauty lies in everything and each detail or situation, everywhere, all the time. It is there, and it's our responsibility to find it, make an effort, and develop sensitivities and new observational - attention skills so we can recognize the immense quality and beauty that exists even in the depths of hell (Dante, The Divine Comedy). Our inner poet sees beyond the apparent reality and recognizes a different story and new meanings. As an example - Nathan Alterman, in his poem "An Urban Evening," writes: "Lights as the city flowers, blooming in fragrant light...a rosy sunset between the rooftops, and a street as a river flowing in its blues, whoever will arrive at its ending, would want to cry of hope and muse."

Urban poets such as Alterman (Baudelaire or Walter Benja-

min) recognize in the city a celestial reality that brings a spiritual uplifting. As I read them in my student years, I immediately recognized the potential of the changing relationships, symbols, and roles of my close environment. A change that has the power to surprise us with new inspirations and new potentials of all that surrounds us. For example - "A city covered with metallic sunset, trees which arise from the morning dew, shine as glass...I won't seize to observe, I won't seize to breathe, I won't seize nor die and keep on walking...". In this manner, the interior poet needs to "die and be reborn" so he can discover the beauty. He loses a connection to its everyday reality. He is reborn in it to find that everything he knew is now different, curious, and inspiring.

In his poems, Alterman represents the city as a beautiful woman, cheeky and mysterious, and constantly sought after. I remember my wanderings in the streets of Florence. I used to imagine her- the city, as a beautiful old woman filled with mystery, how spectacular and impressive she must have been in her youth, and today we see some signs and wrinkles on her "skin," her streets, and buildings- memories of her greatness as she ruled the world. Each detail receives a new meaning, as if the main boulevard is the private street of God. The poet sees through reality into its different possibilities, the new unforeseen relations it is creating, which are imaginative, maybe senseless until they show some "divine" secrete manifested in each detail.

The poet is a hunter of inspiration. He walks in the world "hungry" for it and seeks the new for survival. He looks for a sign or a clue that he could expand and turn into a whole world. Sometimes a tiny particle becomes a concept and the meaning of all. He understands that creative potential exists in each detail. Thus he is full of attention to little details that can tell the whole story, the entire world, the whole universe. In that sense, he is not different from all the scientists who look for the divine

particle that exists in the atoms that build the entire structure of existence.

In addition to details, the poet tries to expose new relations between the different parts and hidden connections. Through that, he discovers the creative sign that serves him as a working tool by the hand of the artist.

As an architect, I visit a site where a project is planned. The poet in me tries to see a clue in detail, like a tiny flower that becomes a whole principle through which the entire building receives its shape and structure. A delicate, flexible flower becomes a theater on a rock in Portugal.

LIVING THEATRE

The site for an open space theatre on the rock in the Baleal, Portugal; Top left: A local plant growing on the rock and was the inspiration for the whole project; Top right logo for the project derived from the shapes of the plant

Fabric 3D Elements Fabric 3D Elements

Sketches - The Dynamics of a Changing Space

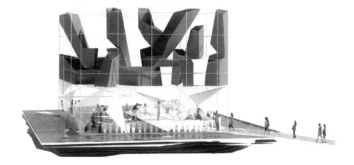

*Rendering of the Theatre Structure - Open Space Theatre Project
on the rock in the Baleal, Portugal*

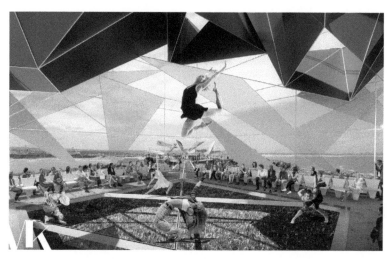

Render of the Interior - Open Space Theatre Project, Baleal Portgual

Nevertheless, I might recognize magic, a sign in the light that enters the site and points out a small stone or a tree, the shape of the stone, the carvings on the tree might be similar to the mountain silhouette in the background, the mountains fuse with the clouds and so it goes on until a whole language is formed in front of us, a language of shapes, textures, colors and their relations, all serving as inspirations and building stones of the concept and design. All that's left is to value it, enhance the quality I have discovered, and give it a presence.

The poet experiences and translates his insights constantly. He observes with passion and turns his dynamic attention toward all that presents to him. Sometimes it's directed inwards and the spaces within him. Then he becomes the source of research, analysis, and discovery of hidden beauty or secrets. The poet in us can bring himself into total identification with our environment and become it. He can be a sad girl sitting on a bench or the child who dropped an ice cream feeling that pain in his heart, or the insecure old man who chases clarity, and a dog enjoying the friendship of a butterfly. He can be live, experience, and identify with each of them separately or all of them together in their connective relations.

The tools with which he succeeds in passing from one awareness to another and seeing the world as new are love and identification with the subject of his observation and attention. The higher his identification, the deeper he can assimilate. The more he loves them, the more beauty he recognizes and values the different relations they are all subjects to and influenced by. The poet-creator strives for the poetic as the highest form of expression of his creativity. That expression is the one that makes the spirit sing and dance and produces within others a sense of uplifting, amazement, excitement, and love. To enhance all those emotions, we wouldn't be able to do unless we experience his

creative work.

This challenging goal requests constant self-analysis and checks. Once I design a building and wish to excite others with it, I ask myself first if the space I have envisioned can surprise and amaze me and how. What are the components with which I achieve that emotional uplifting? What are the triggers? These questions become the basis of my unique research, which eventually brings me to understand which tools I must use in my creative process.

The poet needs a language. There is no poetry without a language, and it's recommended for it to be understood by others. There is a beautiful story about a poet after the World War II who wrote remarkable poems in the Yiddish language. This language seemed to be disappearing, and soon, no one would understand it. Since only a few people remained to comprehend it, a friend asked him: "What would you do now? The number of people who can appreciate your poems turns to zero." The poet answered: "That's the only language I can express my emotions with. I will keep writing until someone understands me".

The poet, the creator, must love his language with passion. The language must be his home. He should feel so comfortable with it, so he can play with it, discover new places in it and try to expand himself in it until he finds his own original authentic private language, no matter what it is (literature, painting, motion and dance, space and architecture, etc.) Be curious of it, be respectively scared of it but still full of lust toward it. Some of the essential writers of this period, who lived or are still living in Israel, had the fortune to invent new words in an ancient language such as Hebrew that dates more than 2000 years. Their invented words made it to the official dictionary. They became a part of the fabric of life and everyday language. One of them

once said - only here, in Israel, only in this dynamic of living Hebrew a man still in his lifetime can sit in a coffee shop, drink the worst black coffee, and hear around him young people use the words he himself created, words that role as sweet dessert on their tongue. The poet is not afraid to invent words (signs), to invent a new language if needed. That's his biggest challenge and purpose in life.

The poet-creator, who strives for a poetic creation, works with symbols and translates emotions and sensations into concrete and tangible things that reach other people and affect them as he wishes. Of course, there is a chance that other people will feel different things, opposite of what he imagined, and he reaches even better success with his work. From his side, the creator must have an authentic intention for an original expression and translation of his world into clear signs, hoping that others could relate and feel something substantial as a reaction.

The poet-creator researches people and places with infinite curiosity because they are his final clients at the end of the process. Even if he puts his attention on himself, still, he becomes his object of research and discovery as a symbol for all people. Creativity demands this type of curiosity, that passionate perspective toward life or death, a perspective of a person who wishes to create a new world with the help of his creative language. The poetic side reveals itself to the creator once he is aware and able to access the state of inspiration and attention. Only then he is able to translate them into concrete reality.

The poet narrates stories. In his process, the creator needs to know how to tell the story of his work - that's the project's concept and spirit. Sometimes all it takes is just one word or sentence revealing all the essence. In this case, the word or the sentence becomes the central principle of creation. Either way,

the poet-creator sees the story as a means to pass the message, the feeling, the secret, and the experience.

The poet, by nature, sees the new. He will always be the perfect partner in "out of the box" processes in searching for the innovative and original. He will always allow a different angle of vision, an angle most people miss. Creativity from the position of a poet allows two critical processes: 1. Abstraction. 2. Concretisation. I will explain- on the one hand, the ability to take the concrete and abstract it, expand it, get it out of clear context and stretch its limits, disconnect it, and see beyond it. On the other hand, take the abstract, the unclear and give it a tangible sign, concentrate it, connect it or place it in matter inside an apparent reality that is immediately perceived and understood.

Those two processes- are essential for all creators and allow the motion of growth and development of each creation into realization. The poet values his intuition as a third eye through which he can recognize a new chord, a secret sound coming to him as if from nowhere, almost by mistake. As the Israeli poet Meir Ariel used to say that words are flying somewhere in the air and looking for a "sucker" to help them reach reality and looking for someone to help them make the way. Then, they pass through him and reach us as a song.

Conceptual sketch for a Sandstone Resort project, Cyprus.
Living stones in front of the sea.

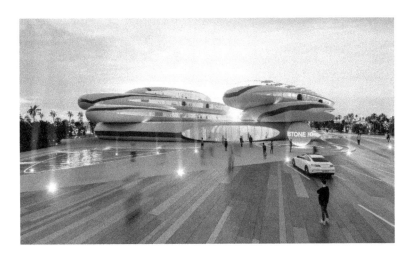

Render - Sandstone Resort, design and plan - View of the entrance

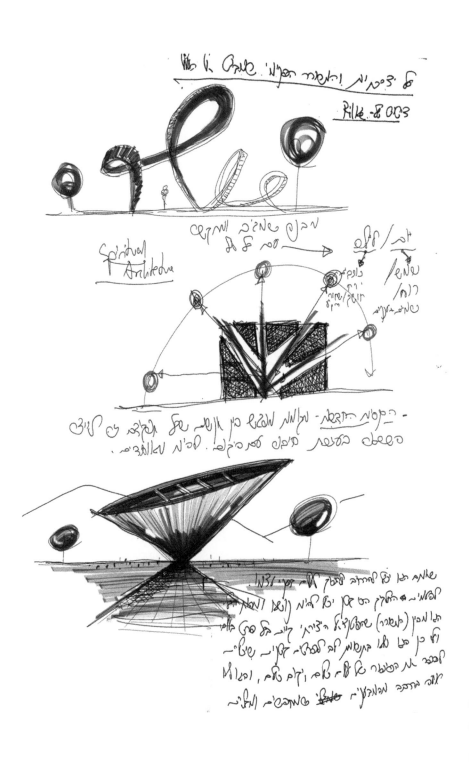

Chapter 19 - Creativity & The Absurd

The absurd is one of the creative dimensions. It enlightens the edges and limits of the concepts we examine. At those boundaries, reality stops working by common and known rules. At the edge of the safe and secure existence, we will find the beginning of the senseless and the inconsistent, where all things can turn upside down from their known behavior.

The creator uses the absurd to examine his ideas, to reinforce the principles they are built upon and the logic of his creation. Sometimes, his work shows how reality is being manifested through its absurd facets. It is then when absurdity becomes the purpose of the whole creation and expresses that dimension only.

The absurd is a laboratory for creative experiments where the subjects are being taken apart, changing their order, or reassembled senselessly and unexpectedly. The absurd world allows a glimpse into alternative realities where laws are taken to their unforeseen consequences. Imagine a place where no one walks on legs but their hands or people who stand on their heads to talk to each other. With this example, we discover a new relationship between the language, thought, and physical motion required to express its nuances, the same as moving our hands

as we speak. What will happen if all our body has to "dance" to the words? Maybe the classical role of a chair is now useless? Or what types of furniture can come out of these new reality rules? What will we learn about our standard furniture through this absurd assumption?

An alternative evolution can be achieved through absurdism as a part of our creative process and is now increased because we are very close to the boundaries of the different and new. The absurd creator allows us to enter a world where everything is possible, a world with new roles and purposes, new rules that answer to a hallucinating life. It is then when our imagination works at its peak, we are forced to use intuition to produce new solutions in this new world of senseless activity, and we are requested to create a new order, a new sense so that new world we created, seems natural and fitting with its interior logic or reason (within the non reason).

The absurd forces our imagination to doubt the world we have lived in so far and ask (maybe for the first time in our lives) "What if?" Could this be different? The creator seeks to break his limits, and he does that through the path of extreme, playful imagination. Creators love the absurd because it gives them access to a new limitless dimension in which they are omnipotent, get sept away by the weirdest thoughts, and here- everything is allowed!

The absurd brings a great deal of humor and ridicule at all that's safe, logical, and accepted by others. It brings fun, a sense of childish playfulness every creator is craving for, a positive, joyful experience that makes them go back or escape over and over again to that dimension, as a joke that develops and becomes funnier each time and the more we expand our limits and let ourselves go in it. It's a "joke" that shows the mistakes and,

simultaneously, the new alternatives for an extraordinary project that might grow out of it. The absurd balances the common "over-rationality" and heaviness that comes with the responsibility of each project. It's a balance that brings us back to our childish awareness, free of judgment or fear of consequences. It increases the flow of new ideas. In brainstorming processes, the absurd does wonders for the dynamics of the group by loosening the mood and showing that it's not a place of too serious discussion but a free space for playful experimentation. Everyone can contribute and bring their maximum potential to manifestation.

A further condition to absurdism in a creative process is temporality. We are entering that parallel world and let ourselves be exposed to new ideas and concepts, weird new signs, just for a limited time as a temporary journey. At a certain point, it is necessary to return to the process, bring all our interesting findings and check their influence on our reality and concrete project.

In each group of creators who gather for a mutual process, there is always one that has the higher skill to stay inside the absurd dimension for a more extended period, collects unique ideas, and returns them to the process. These unique ideas meet another person with a high skill in confronting the absurd with the concrete needs of reality. And so it goes. Each one performs the natural instinctive skill and takes the ideas on a journey through feedback and experimentation by each member. At the same time, there are no judgments, with mutual respect and the recognition of each other's strengths and contribution to the final innovative solution that might grow out of it. This is what a creative, supportive environment should look like. Once the fear of being judged and ego is put aside through absurdity and humor, the potential of creativity grows for the group and the individual.

The absurd brings the child in us into stronger light. It requests a more dominant presence to connect to its instant playfulness, which we use as a tool to perform that journey inside the spaces of senselessness.

In one of those days in front of the sea, as I enjoyed the Israeli sun, getting filled and wrapped by its love and light, a thought crossed my mind- there are places in the northern part of the world that don't have the privilege of light for longer periods. They miss the sun as someone who misses and waits for his distant lover. As a part of my interior absurd "game," I asked myself, how could I take the sun or small parts of it and bring it to the northern world? Well... maybe not the whole sun, but at least some drops you can move from one place to another and get some sunlight to the darkness.

At that moment, the Lightdrops project was born in me. An urban space, a structure in a drop shape, which can contain up to 30 people who sit inside and are filled with strong lights, comes from special lamps that radiate sunlight spectrum and bring that healing, mental sensation. In reaction to that light, a dynamic sound frequency is also introduced within that drop space, frequencies of 432 Hz, known as calming and affecting our muscles.

These Drops are portable and can be moved from one city to another, from square to square, and bring the message of the sun's love to all. Light and sound in constant interaction will influence the space all day and night for people to visit on their way home or to work and charge themselves with new energy. This is how an absurd thought becomes real.

When logic stops, the dream begins.

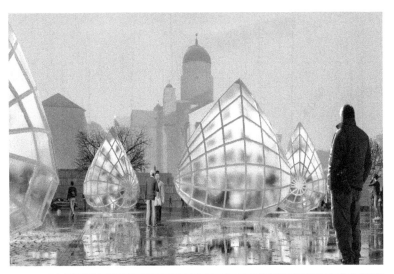

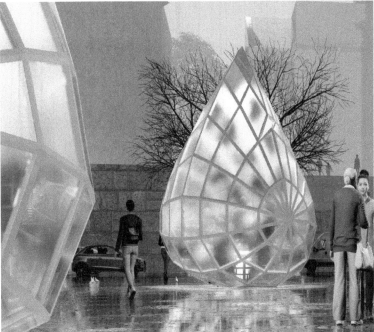

Rendering - Light Drops Project, Helsinki, Finland

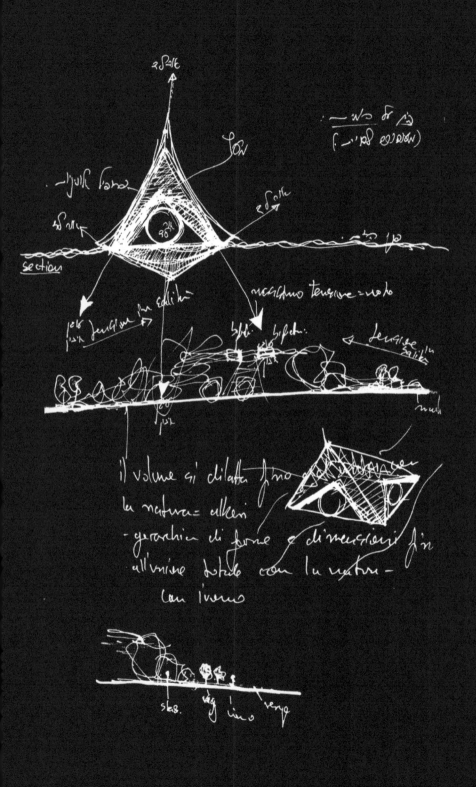

Chapter 20 - Creativity & Improvisation
The Courage to Dare

Creativity grows out of all the places where reason and logical thinking are not the main characters in the play. It's a place of high sensitivity and constant flow. The improvisation, at its peak, is a fast action without any methodology or thoughtful process. Because of the lack of time in the disposal for research and analysis, the creator depends on immediate knowledge, showing us the secrets we couldn't let out with the gradual control of reason.

The improvisation joins a need for an expression, a solution for a problem, and a lack of means at that moment. We use what we have at our disposal, connected to the "now," and instead of our mind, we let our spirit lead the way.

The improvisation relies on the intuition that works in its highest performance since there is no secure ground and no certainty of where it might lead. The element of surprise is essential and valued, thanks to the freedom we allow ourselves to live in that moment. That ensures an unexpected outcome that brings innovative insights with it. These are the best conditions for creativity. Improvisation teaches the creator to listen and trust

his inner voice and how to work in unity and synchronicity with all our existential layers, within a constant motion of our body, with as few thoughts as possible nor a deep rational understanding. To feel and react. To devote ourselves to the moment with confidence that everything is right and **there are no mistakes**.

The immediate reaction while improvising reveals potentials, beginnings of ideas, or expressions we couldn't reach with hours of reason trying to establish a proofed conclusion. Improvising goes through freedom, in a dimension of infinite possibilities where there is no judgment, fear, or ego in play.

We devote ourselves to the action flow of the moment with the attention to finding a sign, a motion, a sound, and some initial start for further development. Once the creator finishes his research phase and is asked for some concrete signs to express his synthesis, the best space to start with, is the improvisation (which works as a filtering process from all the knowledge he has gathered) to show what's most important for his soul to express on an intuitive level.

In the moment of improvisation, there is a fusion, a meditation-like state where we disconnect from reality and stop paying attention to noises or useless thoughts until a pure experience is introduced to us with a constant sensitive motion. Our unity at that moment creates a whole experience, an original one, without filters or fears, leading to our most authentic and creative place.

Each problem demands a solution. Most solutions are reached through a process of elaboration of data, experiment thought, change and proof. There are situations in life where time is scarce, and we must answer immediately with the few means we have in our surroundings- a quick, creative solution is needed. The higher our level of freedom, the more creative and

innovative we are in that improvisation act.

Years ago, due to a multidisciplinary research project I have been working on, I invited some improvisational dancers to dance to a sound, to music they had never heard or prepared for. That music was the heart of my project as the inspiration and leading abstract sign that needed a physical translation.

I told them: "I would like you to stop thinking and let the music guide you to express itself through your motions and choose its right sign, movement in the world through your body."

We shot this experiment at the crowded beach of Tel Aviv, heard the music, and saw it becoming a motion through the dancers who improvised by attention to the sounds.

It was an extraordinary experience! We saw the devotion to the moment and to the sound that was translated to a motion, translated into space.

Dancing improvisations - Research for the project "Architecture is a Living Music" DNA of a Home

It all happened in a flow, and its results grew into an artistic-architectural project where the structure moves, improvises to the sound of music and reacts to the playing artist at that moment. An architecture that dances to the sound of music played live, changing its compositions as the spirit of the music demands it. It gives us a glimpse of an ever-changing creative space that depends on the sound's intensity, depth, and power. It looks different each time.

Improvisation is a meditative action and highly creative by giving in to our interior freedom. It takes courage to let ourselves reach that state of letting go, and through sensitivity, the most accurate expression that needs to flow out of us comes out into the world. That is the sign we, as creators, are looking for. To mediate the signs, we discover in our work. For those who practice improvisation every day, intuition and creativity come easy and naturally until that motion becomes a part of who we are.

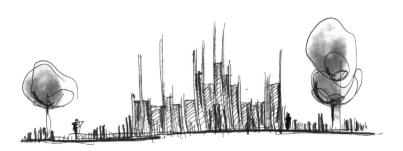

Conceptual sketch - Music as architecture -
tension, rhythm, and sequence as structure

MUSICA DELL'ARCHITETTURA:

SENTIRE DI FAR PARTE DEL CORRENTE, DI PARTECIPAZIONE, FLUIRE.

DI ESSERE, IN OGNI ATTIMO, LA PARTE CHE COMPLETA, AGGIUNGE, O UNISCE. - DI ESSERE IL LEGAME.

L'ARCHITETTURA È UNA MUSICA CHE HA PRESO FORMA PER VIVERE ED ESISTERE FRA DI NOI.

È UN'ANIMA CHE HA TROVATO IL SUO CORPO.

- QUAL È LA MUSICA DEL ABITARE?
- CHE CORPO STA CERCANDO?

QUANDO SI AMA LA GENTE, SI CREANO LE SENSIBILITÀ AI BISOGNI ESIGENZE ED EMOZIONI DELL'ALTRO.

L'ARCHITETTO È QUELLO CHE AMA.

(SEMBRA CHE LA GENTE INTELLIGENTE tende ad essere più pessimisti che positivi - forse per la complessità, la visione dall'alto.)

~ concettuale

Chapter 21 - Creativity & Teaching and Learning

Everyone can learn how to be more creative. It's not as hard as we might think. Each one is creative by its human nature from birth, and we contain all characteristics and qualities to be creative creatures.

It was all-natural as a child, and when we meet him (the child) again after many years, it feels right without effort. All our system works holistically, in flow. It's a sensation of wholeness and deep connection to ourselves. I use that creative consideration system whenever I choose nonmatching socks in the morning.

Creativity is required almost in each solution for any problem in life; each time, we need to answer quickly, and there is no room for a long, intelligent, conclusion-building process. Everyone can reach a high level of creativity. It's also a skill to strengthen to a level of a master. Contrary to mathematicians or Olympic athletes, creators can reach the highest levels, regardless of age. It's an inner call, demanding the dedication of everyday effort, with a lot of curiosity and courage.

The learning of creativity goes through some necessary phases:

Phase 1- Awareness change. The creator's awareness is the understanding and belief that reality is flexible and can show itself to us in new, different ways. Reality is just a recommendation- that's the child's awareness, to which we should go back and adapt in our creative process. The change of our awareness is the first fundamental step, and for that, we use different exercises to train our minds.

On the other hand, we accept certain new truths about our reality and ourselves, and out of that new faith- to act as a creator in the world. After we covered ourselves with endless layers of roles in life, securities, and certainties, it is vital to peel those layers off until we meet that child in us again, that has waited for a long time until someone sets him free to play and discover the world with curiosity.

Phase 2- The identification of signs. Signs and clues in the experiences we go through, we try to understand the DNA of things or the guiding principles of the things we observe. Once the awareness was changed and led us to observe reality differently, we started recognizing different signs around us. Eventually, those signs will become the building stones of our work. We learn how to go through inspirational research, build a story, or find the concept that describes the relationships and principles of our creation- and that's the spirit and soul we will see through each detail of our work and process.

In this phase, we are also required to learn how to develop abstract notions, ask questions that help us go deeper into the core of the meanings, and reach the DNA, their origin. Once we have that knowledge, we translate it step after step into the real concrete world, from a word to a sign, to a shape, to a space to a place and a structure. In a different case- from a word to a sign to a sound to a chord, to music to a song. Or in another field-

from the word to a sign to a movement to a field of motions to choreography to a dance. And so it goes in each area, passing from the abstract into a complex and concrete reality with its manifestation in matter.

To learn to be creative, you need guidance and a mentor. It's a partnership process, where the person that guides us knows our complexities, our needs, and limitations and knows in each step how to untie the problem knots, help us release them, and strengthen our security in staying in that unknown place of the process so we can discover ourselves as new and grow.

With creativity, it is crucial to learn how to break any dependency and be free to act as our artists. Such mentorship guidance helps us find our language, original expression, and the purpose we seek to fulfill but do not always know what is. Such advice strengthens our intuition by learning how to listen to our inner voice, inner source, which is always right. It's about learning a method that creates a straightforward creative process and controls each step. The most crucial thing in that process is the apparent certainty that we will always reach a unique solution.

I teach creativity for many years in different places and institutions. I teach architecture and design students, young professionals, and people from various fields of interest - culinary chefs, pastry chefs, and hi-tech professionals, teachers, all from different countries and backgrounds, different cultures, languages, and interests. Each is different, yet each one learned the method for a personalized creative process I have taught them. Once you are exposed to it, to the principles of creativity, it is necessary to practice it daily and strengthen that skill, which gets more robust and better each day until it becomes an integral part of who we are. We feel that creativity flows naturally through us.

In the mentoring and teaching process, I build customized exercises for each individual depending on the challenge and the needs and character of the person. Even though some principles touch and influence all of us, one-on-one work is inevitable if we wish to learn creativity. There is just no other way.

By learning, we are exposed to our "ignorance," our weaknesses and sensitivities, and the place that needs reinforcements. Each such encounter with ourselves can bring fears, insecurity, and self-judgment. Part of the mentoring process is to soften and relieve that feeling and be there as a partner, a friend that holds your hand or pushes you toward the sky until you can fly by yourself.

In teaching, there must be empathy and true love. As a teacher and a mentor, you need to see the people for who they are, but also for who they can be in their strongest, full potentials, to see their beauty and strengths believe in them, and want their best. We all needed teachers who believed in us as children, who could see our complexities, push us toward our limits, and give us the courage to cross them. A teacher that puts all judgments aside, along with the need for grades or outcomes. Someone to remind us how fun it is to be in the creative work process and the love and passion of being a creator. A teacher that builds motivation within his students through inspiration!

The learning process of my students is full of moments of discovery, moments of satisfaction, amazement, and joy. I see the wonders inspiration can achieve in their growth and understanding of the process without fear of failing. That's the role of the teacher as I see it- create motivation through inspiring and identifying the great potential that lies in the student- showing it to them. They move faster forward than ever as they recognize it and see it in his work. The enthusiasm grows as a student

sees his talent visually, how unique it is, and how much it can develop. Once a student feels he is on to some original idea, like holding a treasure, he applies harder and faster to prove and manifest all the beauty he can bring out of his work, which is so close at hand. They want to feel the world's feedback on their contribution; thus, inspiration is the source of motivation and development. It keeps them going and passes through even in hard times because they see the potential beauty in reaching distance. It helps them be more courageous and overcome difficulties. It can't be an external motivation like limitations by the school system, punishments, grades, or any other voices from the outside. It can only grow naturally out of them and the deep sense of inspiration.

Different companies or organizations have difficulty creating a creative, challenging environment for their workers to improve and innovate. With time and the repetitive everyday work, the routine is affecting the productivity of the individual, changing his mood and the whole energy of the workplace, then diminishing the growth, and causing the lack of motivation blocked by the every-day inertia.

Once they introduce new content, workshops, and knowledge to the system and encourage all their members, from the head to the bottom, to freshen their creative thinking, everything changes drastically and surprisingly fast. Creativity has the power to heal, improve, to strengthen people between each other and themselves, and their interior world.

For that to happen, there is a need for a person who lives as a creator, who can analyze the organization deeply and introduce new innovative approaches, inspiring climate, and show to each individual or group how creativity is a skill and a way of life, can be easily achieved.

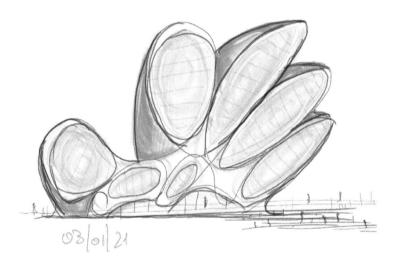

03/01/21

Conceptual sketch- "The Architect's Eye", A Design Faculty Building

Sketch - Conceptual development of a dynamic space developing inside a park based on different senses and sensitivity

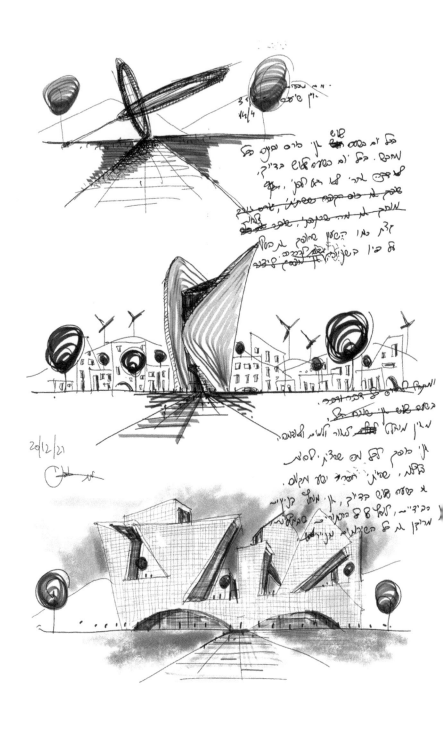

20/12/21

Chapter 22 - Creativity & Multidisciplinary Approaches

One day in my student years, I woke up in my tiny apartment in Florence, in Via Cavour, and had a moment of enlightenment, an intuition - how could I call myself an architect or an artist without knowing different fields and aspects of the world, to lean more about people and myself and control that knowledge as my working tool. As a conclusion, without studying philosophy, psychology, sociology, biology, music and arts, literature, and poetry, without all those, I wouldn't be able to create a worthy project for people and their well-being.

At that moment, I made a drastic decision. I stopped everything, against all common sense, stopped my architecture studies, left Italy, left a woman I loved and went back to Israel to the University of Tel Aviv with a sense of destiny and passion for knowledge. From mornings to evenings, I visited, as a free student, all the classes I chose for myself, with the conviction that the knowledge I would gain in them was vital for my future.

For a whole year, I studied all those different fields, bought books, went to classes, and learned with passion with a strong sense of devotion, almost survival, and thirst for knowledge as it

expressed the (hungry) artist within me and his survival in the future. As a free student, I didn't go to any exams because the grades or diplomas were not the goals. It was a learning for the

Graphic experiments - "Daydreams" silhouettes. The visions of the human combined with the animal nature within us mixing, crossing, connecting Light Drops Project, Helsinki, Finland

pure love for knowledge where the pressure of exams is just unnecessary. I learned how to ask questions and observe. I learned to recognize the relations between things and their main principles. I learned to work with abstract notions and bring them back to reality, researching and analyzing the root and truth of things deeply. I learned to value and love the curiosity that bursts out of me. With each sentence or new information, I always obsessively asked the question: **How is this connected to architecture?** That question opened my mind to trying different forms of connections and discoveries as if I had new Lego blocks to play with and enjoy the new toys I could build with them.

After that year, I went back to Italy, to the University of Florence to continue my architectural studies from the point I left it, but this time, with immense baggage of insights, doubts, interrelations, and a multidisciplinary approach to each thing experimenting them in my projects and felt on a clear path to discover the artist within me and wished so much to be. To this day, the multidisciplinary approach is a part of my creative process and life. I understand and value the connection and contribution of each field to my personal and professional life. It is one of the primary sources of creativity and innovation.

Multidiscipline is the ability to get actively curious about different fields of practice or knowledge that don't seem to be organically connected to what we do and the language we use. Still, they are crucial for us. Creativity starts when we look for those hidden connections when we ask and discover the new relations between everything—a direct association with a direct influence and contribution.

As architecture recognizes a direct link to dance, we witness the birth of an innovative, creative place: A dynamic architecture in motion! A choreography of spaces that allows a new experi-

ence of a place. Multidiscipline enriches us with knowledge and experiences if it goes beyond the simple reading or bibliographical research and goes to experience-based research where we are a part of the whole process and learn from the direct interaction with it and the understanding of its principles through the life it creates in our reality. Creativity becomes powerful and innovative once we can fuse all worlds! As some worlds unite, we realize new potentials they couldn't manifest in the singularity. Now, some of their secrets come to the surface through the fusion. Multidisciplinary is necessary for the research process where we allow ourselves the freedom to break the boundaries of what is known already, all that is certain and expected, and experience new combinations. Once that is done, we return with the findings, the signs, and principles, with the knowledge that turns into raw material in the creative process.

Multidisciplinary shows an open mind and demands a deep active curiosity and flexibility in changing and passing through fields. It requires an amount of inner tension once we bring different elements into a dialogue. That tension brings to the new finding. Multidisciplinary creates an intersection and a dynamic motion, the necessary ones to lead us outside the box and standard mental frames, and as a consequence - higher creativity.

East meets West. Cultures and nations with a history of immigration mix, fusing into themselves, bringing new knowledge from different parts of the world. Those cultures were the most creative ones. They were able to develop fascinating solutions and innovations. Human cultures strive from that constant tension between east and west, opposite approaches, with the continuous need to find the intersections and connective points. Once fused, the culture looks into the heart of that storm of all forces pulling in their direction and observes the magic that happens in that dynamic; that's where the secret of creativity is

at, that's where you find the new original sign that expresses its central principle of existence.

Architecture Meets Pastry - Cakes and molds inspired by Architecture

Multidisciplinarity ensures complexity in our work. The creator is searching for such complexity, new levels, and dimensions that build his work. Sometimes the result is "simple," but it's a result of a complex process of combining many elements and forming that pure new thing.

Like a little "war" of different will powers, what's more important? What's more interesting? Each field we examine has a gravitational force, pulling the attention toward it and seeking a manifestation in our creation as it evolves. Each field discipline creates a sign. Once we put those signs together, a synthesis is formed, a field of signs mixing and transforming into something new. The next step would be its translations into a definite beginning of the creation.

In the balance between disciplines and signs, at the end of

the connective process, in the synthesis, lies the creative principle of our creation. Each time we give one field more importance than the other, we will see a different result. The secret lies in the intuitive choice, the understanding of what combination, what balance is the best for our work.

I recommend three levels of analysis each time we face a new discipline. A zoom-in or a zoom-out process into three levels deep to examine each thing's different points of view and relations. Once that is performed, we ask – how is this related? What is the most crucial sign or insight we can take back to our creation? This is when we bring to our table different insights from different places and experiment with intersecting, fusing, connecting, choosing, and changing until we see a new possibility, a potential.

In dealing with multidisciplinary work, we undermine everyday things we are used to doing, seeing, or looking at. We look with different eyes as if we met ten people from various fields and try to look at ours through their eyes.

One of the most common dreams of each creator is to encounter if in his imagination or real life, interesting people and have a discussion or a brainstorming dialogue about his work, so he can understand or look at his creation from infinite perspectives and, as a result, develop it into a unique synthesis of all. That's how we enrich our work and expose its hidden beauty.

Multidiscipline requires a high level of synthetic skills. We take all the infinite puzzle pieces and bring them together into precise, coherent work. Once we examine many disciplines, our table is inevitably full of new pieces to play with. The artist's and creator's magic is in the synthesis and fusion into a new element—the alchemy of fusion of ideas into matter.

Architecture Meets Pastry - Cakes and molds inspired by Architecture

Events of
Life

Chapter 23 - Creativity & The Process
Word-Sign-Shape-Space-Place

The creative process is a gradual process made of clear stages. After many years of research and practice and developing my creative process, and after teaching it to many students and professionals, I can clearly say how effective and powerful it is and how fast people apply it in their world.

Nonetheless, most young creators face the first challenge of translating their thoughts and feelings into concrete expressions. The second challenge lies in developing a whole concept and story that contains the same creative principles. And the last challenge is keeping the same principles throughout each detail of the work, so each part manifests the DNA of the innovative concept.

As I analyzed the process over the years when I designed and planned my projects, I found a precise sequence, a flow, and a secure methodological approach that brings me to an impressive original result each time.

The process is - Word - Sign - Shape - System - Space (place, or an object). Here is the following description of each one:

Word

Everything starts with a word. Even the world has been created through words. After a primary experience, each creation seeks a word, a sentence, a story, or a translation into words that are the basis of our knowledge of the world. The word is a personal, original sign, our mark. The word has the power to create worlds.

Handwriting is the direct connection between the brain-heart-soul-hand into the world. That's why the creator must practice his writing skills. In his first steps, the creator is asked to research and, analyze, understand the theme or the experience he wishes to develop in his project. Out of attentive and sensitive observation, a word comes out, a text, description, impressions, or conclusions. In the beginning, the text is long, written intuitively in a flow without judgment or fear. Just fast writing, through an interior dialogue that tries constantly express what we feel or think.

That long intuitive text is now narrowed down gradually, step by step, until we reach the most refined, fundamental concept or notions our creation deals with. It exposes the most important thing we wanted to say. It's "zero point"; the idea's DNA is summed up in a few words. It's a gradual process I could interpret as the passage from an article to a post to a tweet to a hashtag. Those "hashtags," core concepts and principles as I call them, have the power to become a whole creation.

These concepts go through deep analysis, some layers deep into them to get closer to their moment of birth. The etymology is vital to make us understand the evolution the world has undergone in its development. Furthermore, it's necessary to see which new meanings the word has received through time; I always check in different languages for comparison. In addition, I check the places and examples of further usage of the word.

Sign

Once we get to the bottom of the concepts, we choose the most important meanings for us. Personally, the ones our intuition selected for us that seem the most fascinating.

If there are some words or meanings, we will create a field of different signs to be connected in some way at the end of the process. For each such meaning, we express a sign or other signs that capture its essence, a sketch-like process, quick and straightforward. That Sign can be graphical, a sound, a body motion, or any language we choose so that the word receives a tangible concrete manifestation in the world. An ideogram- is a sign that expresses an idea.

For example, if we choose the concept or a feeling of "sadness." A sign of sadness in music, for example, is manifested as a note, a chord, or a riff. In dance, it can look like a single motion that expresses a deep sense of sadness.

Shape

In a second phase, the previous initial Sign is transformed into a whole field of shapes and forms that show its complexity as it develops. The development of the shape and form is based on the text we wrote- that's where all our instructions and explanations of what "sadness" means to us and how it's related or built, through all the details we gave to it.

This is how a single sign, a quick line becomes a shape with a motion- the motion of the concept (sadness). What would its dance look like if I had to imagine how sorrow moves in space? With the help of our imagination and the envisioning of a movement, it is easier to establish a form, a shape, starting with my initial Sign into a whole sketch. It's as if the Sign received a life of its own. The spirit of the concept speaks through him, influ-

ences its behavior, and changes it into something more complex than it was.

Inside the shape, there are already relations between the different parts. Areas are forming. There is a small world in becoming through us, through our translation of it. This process stage is also intuitive and leads to free experimentation. There is no right or wrong. There are no mistakes. The only focus is- how accurate the shape expresses the spirit of "sadness." It's an artwork of precision, either narrowing things down or abstracting them until we feel it's right and expresses its essence with just a few elements.

Space

The next step in the evolution is when the shape (representing the concept of sadness through its signs in motion) becomes a space. The shape enters a context with its details and moves from the two-dimensional into the three dimensions. It develops in dimensions and considers our work's fundamental limitations, needs, and conditions. In architecture, for example, we start to consider the site's limits, the basic dimensions, heights, depths, and environmental relations.

I noticed that many students have difficulty seeing the two-dimensional shape of their sketch, becoming a three-dimensional project. Therefore, I give them the following intermediate step exercise- they take all the things they developed so far- the Sign and shapes and build a 3D model of it in each material or technique they wish and make a "sculpture" out of those signs. When they are done, I take a small-scale human figure and put it next to their model. These tiny people give us a new perspective and help us imagine ourselves standing in front of it, of what could become a building. An abstract sculpture, free and without restrictions, gives life to its signs in the real world and analyses

its real spatial potential.

Now, as their shapes are considered and looked at as spaces- it is easier for them to choose the strong potentials to work on and develop in their project. This type of translation requires the extreme and free approach to play with it until some "wow" moments happen. Eventually, it brings us to a conceptual model of the shape as a spatial expression.

Place

The last phase in this process is transforming the space into a place. It happens when we introduce to the abstract, infinite space, the categories of human needs, limitations, and technical and functional needs. Hence, the space adapts or fits itself for the life of a human. It is a further transformation of the spatial model to fit their destination as an architectural space, an object, or any other product we wish to design and create.

In each step of the different transformations we do, we must keep the original concept and the idea strongly intact and influence each detail. In each step, I ask myself- is the concept still clear to me now? Do I still see it or feel it? How can I strengthen it? Is it missing? How do I create a gradual experience that leads me to discover it in the project?

Once a place is designed, it already interprets our human experiences. It is now the moment to decide about the dynamics of my experience. Where are the project's key points or the peaks (of sadness)? Or how does it gradually bring me toward the highest sensation of sadness in the place, step after step, as the qualities and materials change toward the culmination of the sadness experienced in the place through architectural elements?

In the process of translation and development of the project,

the DNA, the core idea, remains on all levels. However, we still have the freedom to experiment, analyze, and bring things into precision and clear, coherent expression. It seems easy- word-sign-shape-space-place.

It's a skilled process requiring guidance to pass each step successfully and understand. Sometimes, we need creative exercises to untie some blocks and make it easy for us to pass from one phase to another. It takes only one whole successful process to pass that experience with a positive sensation and see how much potential it has until we crave to go back to it, again and again, with discoveries each time and unique, innovative results.

Every creator needs a method, a straightforward technique, a path where his steps are clear, and he knows how to progress in his work. It requires a technique that has been tested for years, and many people have proved its effective outcomes.

A method gives the creator a lot of security and comfort, allowing him to test his limits more freely. This method provides us with a frame of work to develop a project from its abstract to an actual concrete manifestation in the world. All it takes is practice until we reach a high skill that becomes a natural part of us.

I have taught this method for years and customized it slightly to the people and fields of interest they are coming from. I can confidently say that it's a tool for life, and I am still surprised by how easy and fast it is being adopted and controlled by people with no professional creative experience.

Sketch "A shelter in motion"- Archi-therapy, dynamic healing space

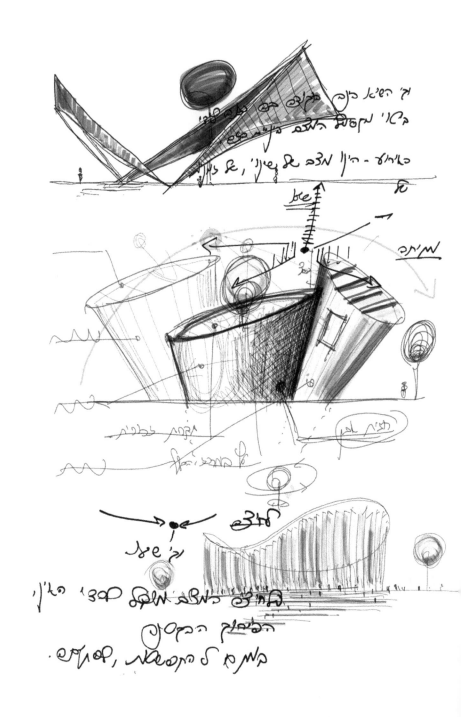

Chapter 24 - Creativity
& The 5 Questions

Throughout my life, and as a part of my research on creativity and the creative process, I met many artists, intellectuals, and creators of different sorts and professions. Through our encounters, I tried to understand the everyday things they have and make their unique work possible. I found out that:

Asking questions is an act of curiosity that seeks to know and understand the world. Through the questions, we move toward knowledge with the hope of finding some secret guiding principle that stands behind things. Their complexity but their simplicity as well. I have found four repetitive questions common to all, and a fifth one, I added myself because that's the question I constantly ask and, in my opinion, is the most important one and has the highest creative potential.

The first question - arises as we encounter something that catches our attention, if through intuition or emotion, and is perceived by us as a beautiful thing. Therefore, the first question is - "Why is it beautiful to me?" What components, qualities, or complexities make that thing beautiful in my experience? It's an important question because, for most people, who are not creators in a profession or everyday life, the beauty experience is a surprising unknown event. In contrast, the creator sees the com-

ponents of beauty as his working tools. Once we understand the elements and features that lead and create beauty, we can easily use them in other places. By asking that question, we learn to control the language, speak and describe creativity, and control our observation and attention to things, increasing our sensitivity that examines all details, same as the broader connections and relations between the object and the rest surrounding it. This question contains an analytical and critical approach, all essential skills to master by every creator.

Throughout the years, I have created my sequence and order of things in that matter- I start with the pure experience. I let myself feel and be in the moment with enough freedom of judgment and be affected and influenced until something within me asks for an expression. Once the intuition shows me the exciting points to examine with additional curiosity, I ask myself the first question- why is it beautiful or engaging in my experience? This is done to point out the elements and components of beauty, which I can then use in my work and projects. Each such insight or answer to the first question is a great secret. It has the power to become the main principle of innovative creation.

The second question - many creators ask is: "How does it make me feel?". This question aims for the emotional-spiritual connection and its effect on us. It's attention toward the inside (of us). It shows the components and elements that affect our emotions and helps us understand what triggers our feelings. It's a powerful understanding because once we recreate it and control it willingly, we can turn toward the human soul and awaken a sense we desire to involve in people's experiences. This question helps us deeply understand ourselves, the emotional system, our memories, the sensitive spots related to our images, the delicate processes operating within us, and how emotions can receive a concrete manifestation in matter. This question makes us

understand that there is an extension and continuation of our interior world toward the environment.

The third question - that many creators and scientists ask is:" how is it built?" (what's it made of?), meaning, what are the components that create the whole structure in all its parts and details. To answer such a question, we examine each piece separately, their connection points and the way they are related. It has a motion of breaking, taking things apart, but then building them together into a whole.

It's an analysis that turns toward the structure, the material, the physical aspect, and all that is tangible. Most of the time, we are asked to find the hidden things as we would look for when we meet a new person and ask what he is made of; is it only the physical body? Or is it also his unseen parts? In that sense, the creator is also a bit of a scientist. He is always ready to dismantle, break everything into its most minor details and then examine the relations and complexities of the whole and how it functions.

The fourth question - common to most creators and inventors is "What if?". This question analyses the hidden potentials of things. It briefly undermines the existence of the subject we examine and tries to find alternative forms of its existence. It's an entry into a parallel reality where different roles can be applied. What if I turn it upside down? What if it would work differently or for another purpose? This question takes us to the limits of the subject and discovers the unexplored potential, same as the creative process where we are constantly playing with limits and boundaries and what exists on the other unexpected side of them.

We see the "what if" approach in children when they play with different objects in their surroundings and apply other use

or roles to them to check if that alternative existence still works and if they can still use it for various purposes of their game. This question continues the belief that reality is just a recommendation (as mentioned in previous chapters) and allows us to examine this approach in practice.

The fifth additional question, which I add to the list and, in my opinion, strengthens creativity within us, forcing us to use our most developed imagination because no logical answer can come out of it from the simple reality, is "What does it dream of being?"—further elaborated in the coming chapter.

Chapter 25 - Creativity & What
All Things Dream To Be

In addition to the absurd dimension that exposes us to an alternative reality where all is possible, there are some questions, once asked inside that dimension, constantly exposed by its nature, creative, unique thought, or solution. One of those questions I regularly ask myself in my creative process is- "what does this thing dream to be?"

The question is so unique that it requires an unorthodox answer because it reaches for the unknown and illogical. When you ask a stone what it dreams of being, you don't ask what it WANTS to be since a will is connected to reason and possible yet limited reality. The dream question makes us imagine a stone with aspirations.

The stone is dense and isolated enclosed material. Years of pressure and exterior forces made all its components connect, unite, and fuse until all its parts and atoms were compressed. Most of the time, the dream exposes all that we can't be and can't realize in the limited reality. Maybe the stone's dream is to be transparent? It can't be in real life in any way. By understating its limits in real life, we can break the boundaries and bring forth its dream.

The principle of being a stone is kept and transferred. Out of that understanding, I started to explore this concept of a stone's

dream to be transparent for the Acco-tech project in Acre, Israel. At the Aqueduct of the ancient city, I started to examine the characteristics of the old stone, its texture, material and layers, and interior motion. I took all these findings and tried translating them into a transparent glass structure that will be treated as stone.

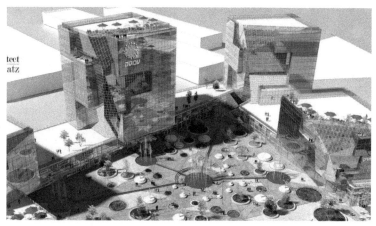

Rendering - Acco-Tech project. Architecture inspired and expressing the dream of the ancient local stone to become transparent

This is how the stone becomes transparent through its DNA and essence that pass to another material while keeping its original quality and value of a rock. This is how a whole complex of buildings was designed as a transparent glass "Stone" structure in front of the sea, the same as the ancient stones in the Acre wall adjacent to the project's site.

At a different time, I met a bridge. An old concrete bridge from the 60s, with cracks and broken parts, looked "sad" and didn't fulfill its highest potential. I asked it: "Bridge, what do you dream of being?" and the bridge answered: "I dream of being an entire city! I don't want to connect its parts and be just a trans-

portation line. I want to be the city in itself that everyone comes to and feels what a city looks like when it's "flying" above the water of the river." That answer to the dream question became an extraordinary project – the city bridge in Florence, Italy. It exposes the new dimensions of what a bridge can be and is an innovative statement for its time.

Rendering- City-Bridge project, Florence, Italy. A mixed use, cultural/social meeting space as a bridge above the Arno river

The dream question enhances creativity because of its nature to extract the innovative and original. As the creator puts himself in a position where he is forced to use his imagination to an extreme extent, that's when he is reaching for innovation. The answer to that question is then translated into a sign. This guiding principle affects the entire project in its parts that express the dream and its new purpose.

I believe everything was once a dream and destined to be a dream. A world that manifests the wildest dreams must be extraordinary and beautiful. Is our life an expression of a dream? If people had more freedom to express their dream, in reality, life would be happier, and people would feel closer to living their purpose.

Chapter 26 - Creativity & Abstraction

Creativity takes its power from the abstract- the notions and concepts, from words and experiences which have different interpretations without a singular or an absolute definition, sometimes perceived from different perspectives or even hidden or beyond the senses. The abstract contains a multitude of potential for understanding. They belong to the souls and spirits. Therefore, in the concept-rich contents lies the rich creative expression.

The process of abstraction is the extraction of the object from its tangible and concrete connection, out of its relationships that define it, and the detachments from the known and obvious. We lead the object toward a flexible place, expanding and dynamic place with free edges, a place that allows it to be many things at once.

As the creator turns toward the abstraction or creates it, he asks to get as close as possible to the infinite soul of the things long before he reaches the precise, defined creation. Time, space, order, chaos, harmony, and love all are simple examples of abstract notions that many projects are made of. The more we feel courageous and free to move inside the abstract and look for its signs, the bigger our creative expression follows it.

The abstract forms the spirit of our creation, the untouchable, the undefined. Once we give it a dominant expression in our process, the more magic and depth we create, and as a result, the more influence and impact it will have on the people it meets, giving them a glimpse of the magic it receives from its connection to infinity. One of the most common challenges of most young creators, especially in their first steps, is the ability to deal with the abstract. What do we do with it? How do we work with it? What questions help us expose the abstract, and how do we translate it into a concrete sign?

Philosophy and psychology give us the tool to ask the right questions and guide us in developing abstract notions. They make us see the conditions of their existence and the creative potential they have.

The key is to decipher which abstract notions stand behind the theme of our project. What was its source, conceptual root, and DNA before it went through its evolution and became the final expression we see today? For instance- a chair. What's behind it? A chair is a helping tool- an object, a place to sit. A place to sit on deals with resting. Resting deals with the tension between motion and halt. That tension deals with the harmony between different forces that lead to zero movements in space. Now, look at what we discovered about the chair from a simple abstraction. A chair is about the harmony of forces that lead to non-motion or balance. Maybe this is the soul of the chair? Perhaps this is the essence and reason, showing us the source from which it was born? Is that enough? No! Once we expose the notion of a chair (sitting act), we must go to its source, its etymology of the word, and understand its origin and birth moment before it took upon itself differently and new meanings or roles. In the total undressing of the word, in its source, lies the most potent creative potential- the divine spark from which we can develop

infinite ideas and projects. The abstract flows from infinity and seeks a substantial presence in the world through us; we are the translators of its secrets using our language.

As a result, the creator works on two main but opposite actions in his creative process: 1. The abstraction of the concrete things seeking for its existential secret by moving toward the infinite. 2. The concretization of the abstract - its translation and expression of infinity to the real world in the matter. It is done by moving from the infinite to the present tangible moment.

Sketch "Emotional sculptures" made of fabric in tesion and motion turning into a dynamic space

Chapter 27 - Creativity & Freedom

In creativity, the concept of freedom is complex and fascinating because it manifests in different ways and phases of the process. The creator can reach his maximal freedom as long as he keeps his habit of daydreaming and imagining new ideas or visions.

Freedom lies in a constant dialogue with limits and boundaries. Sometimes the creator walks gradually toward the edge into a limitless space where he plays with infinite options. People usually fear endless freedom. It seems like a walk in a desert where the man is required to find his orientation and personal sign, understand or create new rules. Since freedom undermines the safe and known to us, the creator uses that quality to reach new worlds with unexplored laws where he is free to experiment.

Inside the realms of freedom, we discover new possibilities. That motion is a free thought that brings to limitless creative work. It's a motion of our creation toward different directions seeking new inspirations or solutions. The free creation seems to move in a limitless environment, or else the boundaries and limitations become its "building blocks" by which the creation is made of and inspired, thus eliminating any negative influence

on the process. Because of its relativity, we can see a constant dialogue of freedom with different boundaries and edges. It exposes different scales of independences we have. In creativity, we notice a direct relation between enabling a higher level of freedom to receiving a high level of creative quality.

Freedom is the ability to control action on one hand, but at the same time, it can release any control or limit to let ourselves get carried away by the flow without any resistance, like a leaf on a water stream. In the creative process, we move between different types of freedom levels, and the interior motion directly influences the work we allow ourselves to do. Any creation seeks the breaking out or checks the limits because on the other side lies the original and innovative, in a place without any clear rules, a space full of secrets and insights. That's why creativity sees in freedom its infrastructure. The creator considers freedom as its existential need, a need he jealously insists on and keeps so he can move without boundaries to his senses or actions as a wild hunter searching for the new.

Freedom is a delicate concept. We are used to containing many limits, rules, and customs in our everyday life. They become a part of us until freedom is perceived as a rare condition or treasure, a hope, a dream for one moment where we don't face any resistance or block and let our inner self be as it wishes. To be authentic, in the pure state of transparency, to express all that is asked to exist within us without any limitations altering our motion in the world. For the creator, freedom and the need for authenticity are his working tools. Without them, he can't connect to his work, as be a part of it without any detachment. For him, the creation is an extension of himself, spreading in the world, and as long as he keeps his authenticity and freedom, he knows and feels that his work is right.

Sketch - From motion to space, City-Bridge project, Florence, Italy

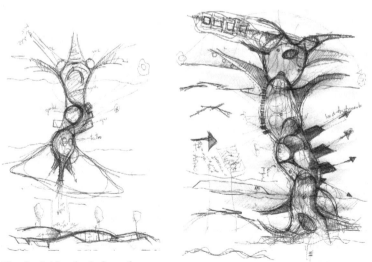

Sketch - Bridge draft above the water
From motion to space, City-Bridge project, Florence, Italy

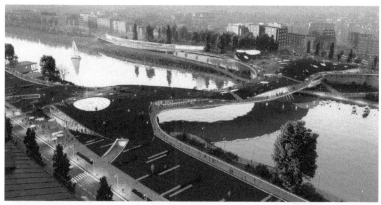

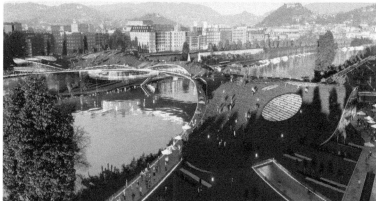

Rendering- City-Bridge project, Florence, Italy. A mixed use, cultural/social meeting space as a bridge above the Arno river, with different functional spaces inside, under and on top an urban park floating above the waters

Nonetheless, freedom can be challenging. It makes us deal with our fears and break the limits of all that was secure and safe in our known environment. Coping with such a process, breaking and understanding the new limitations and spaces we have, putting ourselves in question, crossing to the other side, and seeing ourselves from a different perspective- all lead to growth and the rediscovery of ourselves because through new definitions and understandings of who we are.

As an architect, creative freedom is a necessary condition for me. I create it sometimes through a deliberate "forgetfulness." For a moment, I put aside all my previous knowledge. I reached for the new project as if, for the first time in my life, like a curious child who had never learned or known anything about that matter. Through that childish, active curiosity, I try to find my way and peel all blocks and limitations along the way. I almost imagine myself as an alien who meets for the first time a flower and doesn't know the word or the meaning of it and let my senses enjoy and figure out what it is, what I discover through my new vision of it.

Sometimes, I create freedom by ignoring any concrete limitation of scale, dimensions, budgets, or functionality. I want to experience and create something new through its limitless potential as the creation and the project are fulfilling their wildest dream through me, and everything is possible. The insight and signs we discover in that freedom dimension of things, we collect and bring back "home" to our reality and planning process and use them as the guiding principles for further development. Only this time, it contains the DNA of the building's dream, a memory of his free aspirations manifested in each part of it, reminding us (the visitors or users) of the beautiful freedom it comes from.

Each project has a soul and a spirit. The role of the spirit is to bring and show the memory of its total freedom at its source. I believe it's the same with us, humans with souls and the memory and beauty they bring. Also, architecture strives for the same creation- a project with a soul, expressing its freedom, its perfect condition from times when it had no limits and could dream without boundaries. That divine spark, the particle of freedom, must be expressed in the complex reality, in the matter, in a limited body that reminds us of what to dream of. The higher creation always begins at the freedom dimension of things while looking for a concrete expression of it in the final object.

Freedom is often compared to the divine since God represents the infinite and limitless, which works by its own rules and conditions. Creativity seeks the same divine quality as a memory of every creative process of each existing thing. The creation never seeks to express God but looks for the divinity in things, their hidden infinite freedom.

Creativity grows out of the infinite horizon, and whatever derives from it is already filled with the highest level of creativity than those who came from limited and known sources. It will also have a higher effect and influence on the world. A work that starts from a limit has only fear in its basis, the fear of discovering its truth or higher essence. A limitation can be a starting point for creation only when we need to break it with all our power and decide what's beyond it or what still exists as they are lifted.

The freedom in our research phase acts on our intuition to guide us without any resistance to each direction it chooses, needs, or wants on its path to be surprised with the innovative insight. Free motion is necessary and is given by keeping all exterior forces out of the process with as less friction or distur-

bances as possible. Just flow without control, wander without knowing where it leads, welcomes the unexpected, and put ourselves in a state of readiness to be surprised with secrets.

Freedom sharpens our senses and sensitivity while we act fast and without control. It makes us trust the universe to guide us in our motion. While we are focused on the attention and observation of details, we notice in that new world we suddenly discover, where all is interesting, all is new and can be helpful in our creation.

We came from freedom, and to freedom, we shall return. For many years I have thought that freedom in life means getting rid of all the limits and boundaries we have as living creatures. As I grew up, I understood that freedom is the creation within the limits as you are synchronized with them and work with them as partners. You learn how to dance with freedom instead of eliminating it until it becomes an infinite nothingness.

Man lives in a world of dimensions, time, and space as a physical creature. These are existential limits with which he works and creates his life through a dialogue with them, manipulating and bending them for his creative expression.

Chapter 28 - Creativity
& Daydreaming

Some years ago, a known rock band decided to cancel a concert at the last minute in some small town in Italy. Yet, one deeply disappointed fan decided to convince them to come, no matter what. That one man's dream spread like fire or the wind and influenced 999 people who made this dream into theirs as well, and after six-month planning and work on it, one thousand players synchronized as one for just a few magical divine moments and played their souls out with the sounds of hope, some crying, some in disbelieve but still keeping the motion of their mutual creation. He didn't do it through a reasonable explanation but inspiration! And that's how the 1000 player dream was born - 1000 drummers, guitarists, bassists, and singers meeting in one place and playing and singing together just one song of the band, to show them the devotion of their fans and make them change their mind.

In a small Italian town called Cesena, one thousand people showed the world that everything is possible. You can create reality through your dream. And that is how it was - "Learning to Fly" by the Foo Fighters, a song that became a hymn of hope through the dream of one. That video, documenting the whole creative process and the final song, became viral and made it to the other part of the world. The band decided to give their "crazy"

fans the same love and inspiration by coming after all and playing for them. The project was called "Rocking 1000."

The whole creation exists already in the daydream. Dreaming is already a realization of our creation even before it's realized in matter and space. For the dreamer, his dream already happened. That's his reality. Now it's in becoming, in development. The happiness and satisfaction we feel from the daydream are similar to its realization in practice, sometimes much more.

The creator dreams all the time with each chance he has and turns his attention toward the becoming of that dream in his imagination. In that process, reality becomes a constant trigger for the dream. The reality exists only to guide the dreamer toward his exact dream spot. Reality is just a recommendation. It is only one of many infinite options of existence. As such, it awakens and encourages dreaming. Hence, the creator uses that as a tool to discover the secrets of still unvisited worlds.

The architect, as a dreamer, stands before an empty site, sometimes a destroyed site, and imagines, dreams about all that could exist there soon. Until the moment of construction, which can begin years after, the architect is constantly daydreaming, fixing, changing his dream, fighting for its realization without compromises (in the best case), with the hope that the final space, buildings will be as close as possible to its original dream. All that is being done to avoid the disappointment that follows every realization of any dream that failed along the way, with compromises and leaving behind the core principles of the project's spirit - the concept.

The architect I swore to be, does not compromise. I want the daydream to be identical to the fantastic thing I have envisioned in my imagination as the promise for the well-being of those to live there. The difference between imagining and daydreaming

is that the dream strives for a realization. An absolute dream asks to be experienced and shared in real life. Imagining does not need any sharing. It happens in a private dimension without any aspirations to be realized. Only when imagination turns into a dream- that's where a motion starts toward its birth in the real world.

Daydreaming is the most important act made by the creator in its first stages. He must exercise it constantly, on an everyday basis, like a muscle or a skill to connect to the dream world and receive his answers and potential for his creation. The daydream is his playground, where he experiments with absurdity like a laboratory. He is ready at all costs to mix, turn, and blow up each particle at his disposal to find the innovative and unique in him.

In the daydream, there are no known rules. It is connected to a divine dimension with the close feeling of the "heavenly creator" who creates something from nothingness and formulates his own rules on space. The human received such powers and dreaming abilities to feel some of the forces of the source of which all receive their existence and, through this- fulfill his true destiny in life- to be a deliberate creator and create out of a daydream.

Creativity examines limits and exposes secrets through the daydream and the motion of questions within it. The "crazier" are the questions or assumptions with their absurdity or extremism, the more a dream can reach its peak. The creator daydreams without fear or judgment, or any self-doubt. He enters the daydream with freedom and walks comfortably inside his dream space, free to examine it and invent himself there. The daydreamer works as a mediator to the world, as he receives that position with a humble yet ego-less attitude and understands

that he is not the end or the beginning of things. He is not the owner of the creation. At that moment, synchronicity is happening between him and the generous universe that takes care of a constant flow of signs of inspiration and unique knowledge.

Whenever I watch the "Rockin' 1000" movie again, I can't but cry with the excitement of that pure childish dream. It's precisely the child in us that wants impossible things. It successfully recruits everyone and all the children inside of them, so their mutual dream can be realized together. Sometimes it's just the effort of realization which makes our soul identify and remind us that this is our essence in life- to dream and try to realize it.

The daydream needs the innocent child in us, who can believe and imagine that anything is possible, no matter how complex and limited life can be. The dream always feels stronger than life. We are ready to do anything for the right to daydream. I remember a story about a poet who used to go for a midday nap and put on a sign: "Do not disturb - artist at work."

The dreaming child is the essence of happiness and the purpose of the actual creator. The dreaming child is, in fact, "Learning to Fly."

The Child Dreams - A Play by Henoch Levin

Scene description:

Parents whispering as they observe their sleeping child

"Let time stop now at the peak of joy,

Since it cannot be any better than this,

Three of us as still life,

'Parents looking at a dreaming child'..."

Chapter 29 - Creativity & Inspiration

Inspiration is everywhere. In every moment, every object, every detail of an experience. Everything that we go through within us is a potential source of inspiration. Creativity is driven by inspirational moments in which we discover new knowledge, relationships, and unique understandings we haven't had yet, which become the building blocks of our creation and artistic expression.

Inspiration requires us to be open, ready to be surprised, and excited about discoveries and revelations. In that process, our senses become sharpened; the observation is at its peak. Once we release control from reality and let it be as it is without a doubt, allowing the world to show its unseen sides, we open the door to inspiration. When things stop fulfilling their original role or meaning, they reveal a secret that becomes a source of inspiration.

In inspiration, we find moments of amazement and wonder. As the hidden beauty is exposed, we are lifted spiritually and emotionally. We are filled with lightness, and happiness spreads throughout our bodies. Inspiration begins in our acceptance of the different and the unknown. Once we put our ego aside and the overconfidence in our reality's rules diminishes, we – the creators can ask for inspiration. In that state, he wanders around

while in his mind, raising many questions that lead and bring him closer to the revelation of a "secret" or a sign. As such, we give things a different meaning than their origin. For instance, when we look at a rock or a stone and say, "This is not a rock. It's a cake! It's a dessert!" From that perspective, from the reversing of roles or meanings, what does a rock reveal to us as being a cake? Its texture, broken shape, colors, the gentle connection between its different layers, the fraction, the interior geometry of rock, and so on immediately become a source of inspiration for the pastry chef. The observation does not seek imitation; it doesn't mean we have to create a rock-shaped cake or take the rock as it is and copy it, but rather that we can use our newly found observation to learn and gain new insight about the original, unique being that the rock is and allow that to become a new object in this world, to be of use to me as the creator in a different way than I took it for in the beginning. To translate my new knowledge of the rock's DNA into my latest creation.

Inspiration is fundamental to an architect. Without it, the project lacks its spirit and soul. It also lacks the content that turns the whole work into an exciting, moving experience. For that to happen, I start with inspirational research, a type of research and analysis that takes place with the mindful aware-ness of absorbing each detail and its potential inspiration. I research the local culture and history of a site where a new proj-ect is about to be planned, not for the mere purpose of gaining general knowledge or writing a doctorate thesis about it, but for the magical moment where each piece of information I discover provokes a feeling of inspiration. This then becomes the starting point or the conceptual development of my project. Each piece of information creates a new relationship, a new shape or ma-terial use, and reveals a moment from which I can build a new, alternative evolution so that the project manifests itself as an

innovative solution. Simultaneously, I ensure that the project I'm working on is still deeply rooted in the local culture.

Everyone who asks for inspiration will receive it only if they are willing to change their perception of reality and allow different, alternative forms of existence to emerge. It begins with simple questions like, "How could this thing be connected to architecture?" Or it could come from the translation to architecture, for example, a fish. We ask, "How can a fish, with its skin shapes, texture, and so on, be connected to architecture, to a building? To a façade of a building?" Or we look at the fish and imagine it already is a building.

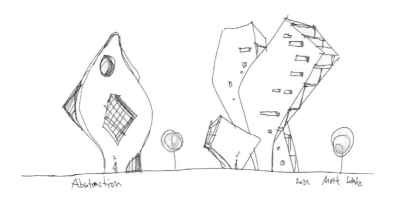

Sketch - Between Abstraction and Imitation

At that moment, the fish seizes to be a fish and becomes architecture. At that point, we stop looking at the fish as a source of direct imitation to copy-paste. Instead, we try to discover the secret or the new insight about the fish's character, way of being, with all its parts and details, unique qualities and characteristics. All these are the sources of inspiration, the pieces of the puzzle that allow us to begin the process of creating a new story

and developing a concept for our creation.

There is a significant difference between inspiration and imitation. Imitation maintains a direct relationship with the source object and turns it into a manifestation of the original in an identical way: similar to its original looks or characteristic. You could say the two images look alike. Inspiration, on the other hand, needs interpretation. It takes the original principles (of the fish). One of them is the DNA – the elements that allow you to create infinite ways of expression and interpretations using the same principle throughout. Using the example of the fish, the imitation will be a building in the form and shape of a fish, identical to the original image. It will be a building with eyes, texture, color, and the skin of the fish I had seen before. A mere enlargement in scale of the small fish to a real-size building. This is not creative architecture. It's an act of direct imitation.

On the other hand, taking inspiration from a fish in architecture means understanding the curved motion that allows it to swim in the water, the dialogue of the body and its geometry with external elements that affect it as wind or rocks or waves and their connection to the flexibility of its skin. Inspiration translates these insights, these motions, geometries, or textures, for example: understanding the different forces operating on the building in its surrounding as rocks. These will determine the flexible shape of the new building allowing it to 'swim' in this urban landscape. This action of interpretation, based on inspiration, assures us that the result, the final shape or structure of the building (or any other object), and the original fish will not have a direct connection to each other than the inherent principle: a clue to the same DNA that once created a living fish and that is now creating a building.

A creator who doesn't open himself up toward inspiration

as an integral part of his creative process condemns himself to a mere technical, practical, mechanical act only and assures a work without any sense of life that will never inspire others. Today, computer software is allowing for more efficient and functional technical solutions. Soon, man will be become useless if he doesn't add another essential value – creativity. Luckily, the computer cannot bring inspiration to life or define a soul that lies within things.

A project that is a direct result of inspiration can inspire all end - users and spectators. What comes from inspiration ends up being inspirational. In music, we feel it strongly. Inspiration from a feeling, a memory, becomes a note, a chord, a riff, then develops into a whole song. This complete, complex work keeps the original inspiration as a leading visible principle in the process and the result, creating a lasting impact on the listeners. Inspiration leads to action, expression, and the need to see the signs represented in reality. This is one of the most significant motivational forces that allows any creator to experiment and persist in their process.

On a different note, creativity and inspiration have been perceived by many artists in history as a dimension in itself, as a separate realm full of potential. It's a dimension that exists independently of us, where all the creation and human creativity erupt like an active volcano. In his creative discovery process, the artist is a mediator. They need to connect to that dimension, find a bond, a direct contact through which they allow the flow of that creation and inspiration into reality through him. The artist becomes a bridge. That's because that dimension's tendency or the "will" is realizing its potential in the material world. It's the infinite dimension of all possibilities and potentials seeking a bridge through which it can channel itself. It does that by using the language of inspiration that appears to come out of nowhere

but is the manifestation of that dimension in us, hinting at what needs to be translated to the world with our help. In this sense, there are no artists really; there are only mediators of the creative dimension. The creation does not begin or end with us. We are not its owners. When the ego steps aside, when we give up on that precedence and control of the creation, on the exclusive ownership, that's precisely when the connection is created. Once we are connected, the inspirational flow starts - the flow of knowledge, motivation and excitement that move it from the creative dimension into reality.

Some years ago, I was overwhelmed and fascinated by the idea that creativity is a separate dimension from us: "the creative dimension." With the help of philosophers, artists, writers, and musicians, I tried to fully understand that approach and discover more about how to connect to our creative dimension. I wanted to expose it, make it more tangible and easier to understand, and determine how its relationship with us is built. I also looked for clues in history and literature to come closer to a complete perception. Some of the artists do try to expose themselves to the creative dimension. Some of them are brought here only to examine. Through this work, a road was paved towards an absolute beginning, the beginning of art and creativity and its authentic expression that may have never been experienced.

Being and the Creative Dimension

Heidegger: the basic concept of being and time allows us to take the next radical step toward understanding a pre-existence of creativity as something that was already there before us. I seek to take the Heideggerian principle to the extreme: to the beginning of being, yet at the same time, I wish to undermine the whole concept of art (by Heidegger), to be detached from it,

without any connection to society, state or a person, in complete opposite to what he described in his writings. Nonetheless, creativity and art that incorporates all forces of existence and its rules are obliged to be the "zero point," the origin and beginning, and cancel the central role of man and its precedence in the creative process. Innovative ideas and principles are rising out of this concept. We can understand and interpret creativity and art, for example, that the human being is not creating art; but that the art or creativity existed long before him. Man has no power to make art, just as he can't create the sun or the stars. Creativity and art are not conceived within the man; they pass through him. So, whenever we consider ourselves the center and the process owner, we already block the existence of the creative dimension. From ancient Greek times until today, most humans haven't been exposed to the creative extent regularly because of the continuous process of making man the center of the creation. This is why we can't consider the last 2000-year activity of a man as creative or an artistic expression. Blanchot — the role of the creator is to try and give the work of art an appearance separate from its unique expression. We can understand in his statement the need to distinguish the art dimension from the centrality of man in the whole creative process. It's not about the skill or the technical ability of the artist; it's more an issue of an intuitive vision of the exposing forces and the potentials which seek manifestations. Mozart stated in his writings: "I seek the notes which love the music...." During the surreal experimentations, Andre Breton spoke about automatic writing and luck. "The words make love on a piece of paper." In this view, an artist surrenders to the force of the text, music, or a brushstroke. This separate force is rising and increasing; he embraces it and uses it for its benefit. In this sense, the fundamental origin of art and creativity does not lie within the individual, just as we are not the ones to create the "unhiding" of all that exists.

Heidegger's theory is, therefore, a theory of creativity, not by the artist as a creator, but from the void and nothingness. It is unique because "she" alone plans its motion and how she will receive expression and manifestation. Thus, she is detached from any given frame or limit. Heidegger keeps transforming the man, as a singular or as a collective, into a mediator. I consciously choose Heidegger's notions because they allow new ideas to come. Heidegger never spoke or wrote about art or creativity as a dimension and never saw in them a pre-existence to all. In the first writings of Blanchot and Heidegger, I see the roots for the development of the creative dimension, a principle that brings a man a new extreme sense of being, not only through the neutral state of man to creativity but with the complete detachment and separation from this dimension. The result is freedom from the centrality and precedence of its reality. In my opinion, this is the ultimate way to freedom through which man will understand its true, whole meaning in his existence and the connection he can create to a new dimension that brings him the most robust and beautiful principles of eternal creation. Here are some fundamental principles of the creative dimension:

1. The creative dimension is based on truth.

2. The creative dimension affects how reality is exposed to us in the first place, before even being manifested (in its concrete, materialistic, natural way).

3. The creative dimension is changing the space it is brought into.

4. The real power of the creative dimension is the formation of worlds.

5. The creative dimension is the force of art.

6. The true origin of the creative dimension is not human.

7. Creativity alone is planning the ways and principles in which it is received; thus, it is unequivocally detached from each human frame.

8. In reference to creativity and art, man is just a mediator.

9. Creativity as a dimension is pre-existence.

Surrealism

Through surrealism, the creative dimension is exposed intuitively, same as in a metaphysical painting. This time it uses its intuitive ideology, searching for creativity in the subconscious, in the place where man has no control (meaning, art is detached from human control and its primary role is in the creation). The subconscious is a dark dimension that needs to be exposed and enlightened. It is where I lose the power of control; there lies the connection to the dimension of creativity. Breton defines surrealism: as "not an expression of a dream, but the dream itself." The dream expresses the creativity dimension's "desires." In the most uncontrolled and unaware place, all the rules and principles are revealed, and we become mediators of the dream. The creativity dimension chooses the elements within us and expresses a new reality through them.

It can only happen by understanding and experiencing losing control and giving up on the idea of our centrality in the process. Surrealism exposes the weakness and negation of all human artistic activity that has man's centrality and conscious act in its fundamental process. It strengthens the approach of separating the dimension to men. Through the dream, it renews the relations toward it through unconsciousness. Surrealism rejects the importance of technique and representation. Still, it

sanctifies and centralizes its force in creating a new tool that assists our reconnection to the creative dimension. The purpose of a man is to find the connection to what he is unaware of, to what seems to be uncontrolled, the dream, to embrace the lack of self-concentration toward the interior freedom that eludes all previous definitions.

In the definition of the dream, daydream, we discover what remains inside us and recognize the intervention of the creative dimension in us, its expression released through us. The daydream works as the mental canvas where the creative dimension draws its principles and sends messages to us.

Nathan Alterman, The nomadism of man is an inherent quality and has existed for thousands of years. For him, it's cultural and artistic nomadism in which man neglects his "playing and music" and disregards its bond to creativity and the artistic dimension. In his poems, Alterman represents the yearning to be reconnected, re-exposed to that dimension after losing it for so long. He imagines that moment and experience precisely and vividly: "And the wind will rise, and the thunder will pass upon you." Thunders — as I interpret it through the Bible, in the "Book of Shemot," chapter 19 — symbolize the angels who play and call forth the arrival of God (as a metaphor for the creator or a creativity dimension) through music and thunders.

With this statement, we understand the importance of music as an awakening tool, a tool that exposes the different dimensions that God or creativity use, revealing their natural quality to us. Music becomes an angel, a messenger to connect with man with the role of awakening him from his dream or a coma.

Half-human angels, half-divine characters, act as mediators to both ends. This is the only place in the Bible and all religious writings where God appears in front of the people. This wouldn't

be possible before the appearance of music and sound as mediation instruments. By using a mediator as such (music), we understand and accept the conclusion of the separation of both parties: man and the creativity dimension (God). Music becomes the primary tool for exposing us to other dimensions.

Alterman points out the existence of the creative dimension and its fundamental relation to man, his human "mistake" by neglecting the sound and playing. Since then, man has been searching for a connection with the creativity dimension.

Sketch - Conceptual plan for a Archi-Therapy space,
inspired by the changing dynamics of emotions of patients.
Emotion becomes space.

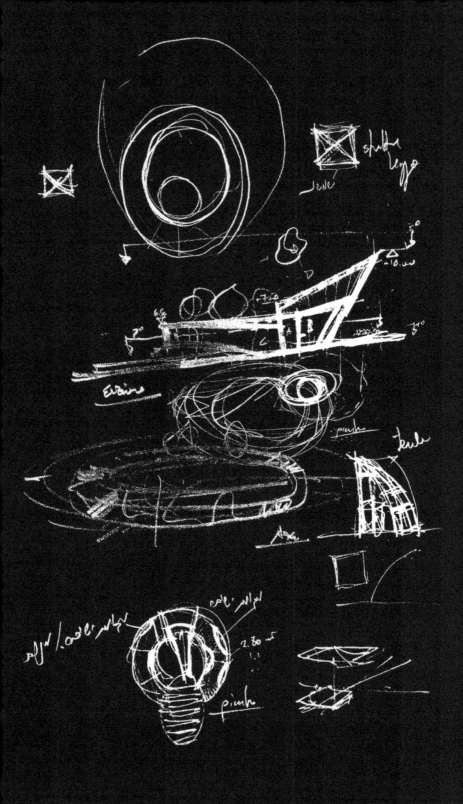

Chapter 30 - Creativity & Reality
As a Recommendation

Every one of us is creative. We contain that existential principle of creativity, a principle that allows us to realize our life's potential every day. Creativity is a human quality, a combination of the human in us and the dimension that helps us solve problems in life, not only through a rational or mechanical way. Look at children and how they behave, play, and invent in each moment, with the help of their imagination and creativity, infinite creative expressions.

As a student in Florence, I used to take the bus home at midday. Most people didn't like to take the bus at these hours because of the density and the crowd, but I was excited about it. I used to wait with a high curiosity for the station where all elementary school children used to enter. Within seconds, the whole bus was filled with them. Through the children, magic happened within seconds. I discovered infinite seating places and new functions that even the designers of the bus couldn't imagine how they could be alternatively used. You will immediately learn the hidden unused potential in each place when children are free to do as they please.

For the children, creativity is a dimension they are constantly connected to by nature. They act through it freely and reach

unique creative expressions each time. To be more precise- creativity is everywhere. Any place, ready to be used by anyone who wishes to connect to it, all that is necessary is to know how to connect to that source and let ourselves be in the flow of it, without any judgment or logical thinking.

Every time we encounter a problem or a need for an unorthodox solution, from the most complex to the simplest everyday things, we require creativity. It comes easy when we believe that originality lies everywhere and is ready to be used at any time. Reality as we know it does not necessarily apply to us. It is all just a recommendation and can be changed in any way. It is the same as mathematics and science - which are not an expression of nature, but only what we can say about nature. The same works with reality and what we choose to accept as absolute and final. Once we change that awareness, we enter into the realms of creativity, where our world shows its new and unseen perspectives or secrets.

A flower is not just a flower. Maybe it is something else? Perhaps it's a light creature, taking the sun's rays and creating colored textures as shading for bugs? Once we experience the flower without its common notion and observe it without a fixed knowledge, we are ready to let creativity in and discover new ways of being in the world. These discoveries are the working tools for the creator in his work and eventually become his creative principles. Not a copy or imitation, but as a translation or interpretation of the new principles we have learned from the fresh observed flower, which has become an inspirational source.

Reality as a recommendation is accepting that behind each existing thing lies a secret or a beauty we still haven't discovered, and we have the responsibility to search for it. We walk

around the world as detectives or hunters for inspiration and secrets- an action that requires high sensitivity and attention, some childishness that allows us to be playful with our imagination and leave all judgments and cynicism behind. Once we find that discovery, we reach its soul, its spirit that lies behind the functional or technical, it's the higher essence and purpose of things and the vision that seeks a continuation in life- to find new expression through us. Creators know the secret of the flexibility of reality and how they can alternate and transform it by controlling their emotions.

Each person with hope or a belief lives with the feeling that reality is a recommendation and flexible; otherwise, there is no sense in hoping for a change. They would live with a sense of fixation where all things are already determined. Life is just a train ride with known stations picked by some external source, and there is nothing we can do about it to change its course. In an exposed world like ours, where social networks, the Internet, public platforms bring people from all places in the world together to share their actions, dreams, and thoughts, and creations every second, we can only enjoy the fact that wherever we look at, we see some form of creativity and how much it wants to burst out to reality, almost as a survival need.

To live our lives as a result of creativity that crosses us is absolute bliss and ensures a life full of everyday inspiration. Each detail is experienced through its magic and unexpected beauty. Each thing can be our starting point for our creation in the world. Life is a creation! Once we understand the relations and leading principles of our lives, it is then that we can start playing with them and become deliberate creators.

The Octopus Project for premature babies

This project started with a father of a premature child in Denmark in 2013. The premature baby was in a critical condition, trying to survive each day as new. The father, who saw his baby through a glass bubble, couldn't stand that his baby was lying alone inside and insisted on not accepting that reality as it is. It was just a recommendation, and he chose to treat his baby as an average child and put inside the incubator a small puppet of an octopus made of soft fabric. The baby reacted to the new presence of a puppet that shared his space, and they noticed an extreme change in his status.

The baby became calmer, his indexes were better each day, and he developed faster than other babies. That dream of a father spread throughout the world and made other parents not accept their reality as it is. That octopus project became a worldwide venture with thousands of volunteers of all ages, who dedicated their time to nit octopus puppets for premature babies and sent them to all hospitals worldwide. That's how a daydream of a new reality influences our body and soul, saves, and heals people all over.

That's the power of creativity.

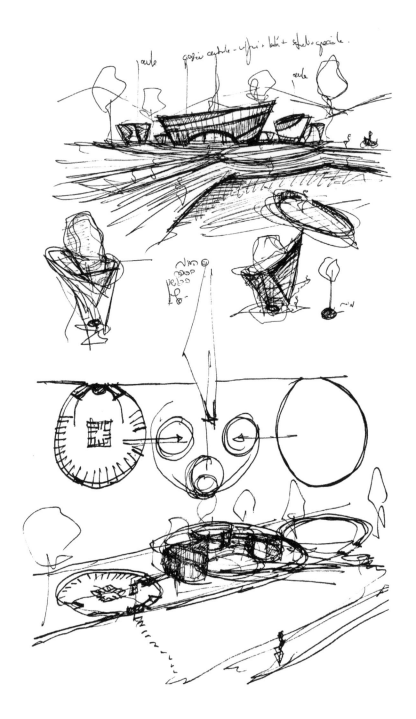

Chapter 31 - Creativity & HUTZPA
The Rebel, The Anarchist

Hutzpa is an Israeli Hebrew term. It was invented here and has no exact parallel in any other language. It incorporates a deep cultural root of people who had to find the guts to undermine their own God. As a result, they became opinionated, talkative, and argumentative. They tried to devise an innovative thought or solution without enjoying the last one they invented. A culture of minorities in their surroundings yet wanting to contribute to the world with a creative idea. Hutzpa is - me, the small grain of sand who wants to teach the ocean how to move its waves better. And the funny thing is- he might also be right at the end of the day.

Creativity is self-confidence, the belief- that we can bring a new voice to the world. After millions of light years, evolutions, and millions of years of man on earth, the creator still wishes to wake up in the morning and shout:" Eureka - here is a new dream!".

Such action is called - Hutzpa! It's the boldness, the nerve, the childish defiance against the world. As a young professor once told me, "Mr. Katz, everything has been already said and done before you. You can't say anything new! In the best case, you can recreate the past." So, I answered, and I was just a 23-year-old at the time: "Such a statement can be said only by someone who never knew or experienced creativity in his whole life! And I am sad for you. I pity you, professor, for living an empty

life." We both laughed, each one for his reason. He was sure I was a dreamer, soon proven false by the harsh reality. I laughed in "Hutzpa" because I was just a student in my first year. Already it was the moment I chose to start researching deeply for the creative process I wished to teach my future students. Today, I live that dream and smile at the end of each class as my students' eyes sparkle from inspiration and enlightenment to creativity.

Hutzpa is the bold, courageous act of crossing the known limits, without any shame, with inner confidence and zero obedience to norms or authorities. Creativity asks for active Hutzpa in us, to question and contradict the past until its safe ground is shaken. Creativity has the same belief that I, the small me, can change the whole universe and make a fantastic place out of it.

A rebellious lack of obedience is needed for the creator to reach new discoveries. Me personally, I never "trusted" any teacher or professor. I always listened to my inner voice telling me to go against the current and prove them otherwise. This part stayed in my personality since childhood, but to maintain it, I had to work harder than anyone, because the known proofed way, the "cooked" knowledge was too simple to adapt to and never felt exciting nor with any potential. The Hutzpa leads you to work harder, to research deeper, to find the logic and proofs that your statements actually work, and are even more effective than anything that already exists. As a result you become visionary and revolutionary.

Every creator rebels against reality by their actions and works that state - that reality is not enough. His "pretense," that basic human need that exists within us, will always be stronger from him than walking the safe and sure path as everyone else. It needs a different thing, more beautiful, more suited to people's

needs, stronger or better.

Through human history, we find out in ancient writings the true purpose of man. A man was always a rebel against authority and God himself. The same source created him, against his family and parents who brought him to the world, and against every limiting frame of culture or knowledge. Adam and Eve, Abraham, Moses, the prophets, and many other characters refused to accept the word of God precisely as they were. They had the Hutzpa to contradict him, argue with him, and even bargain with him as if he were a fruit vendor in the market to achieve his goal or wishes.

That lesson we received in heritage form history teaches us something powerful regarding creative life. This requires crossing limits and never fully accepting truth or knowledge but questioning and arguing instead. In front of reality, the creator is a rebel, an anarchist who acts and walks his opposed path and seeks in his free nomadism the personal, authentic signs which lead him to the innovative ideas he experiments with in his creative process and work.

Suppose we wish to work with a creative person. In that case, we must accept that we will probably face someone who seeks to break the rules and boundaries, the change of norms of the company, he might walk against the current by nature. It takes the risk of "jeopardizing" the known order and rules that keep the frame tight- that's the "price" to pay for enjoying the creative qualities that come with him. The creator owns the anarchist character, always ready in different stages of the process, as he refuses to take anything for granted or adopt any frame since the Hutzpa and the rebel are active in him. He sees in them a high value to his work. Sometimes, in best cases, it's an anarchist motion within precise limits and very temporary to a specific

moment in the process. Nonetheless, to reach the highest levels of creativity, one must strive to undermine the grounds of things and examine them as they break apart, fly freely or parish into nothingness, and by that, expose the innovative insight of their new existence or potential.

When Heidegger broke the grounds under the concept of time, which was built carefully for thousands of years, and took it back to its origin, he examined if time as we know it (past to present to future) is nothing but just a simple derivation out of infinite other options time has. It was his Hutzpa that led to new possibilities of time awarenesses.

The right kind of Hutzpa is the one that has no defiance or disrespect for others. As we activate that approach in research or experimentation phases, even in translating our concepts into the matter, we allow ourselves to expand in different directions and reach new worlds. Thus, creativity can't grow out of someone who accepts one truth to things without questioning the boundaries or accepts past solutions without any doubt or belief in a possible change or improvement.

Hutzpa comes from awareness. Children who rebel against their parents and don't accept the rules or put them to the test don't have a Hutzpa in them until they are grown up and aware of their will or process. That's why they still have defiance in their approach. They do what their purpose tells them- check limits, explore what is temporary and stable, and where the flexibilities are. It's a game of forces as the child examines his life's creative limitations.

The creator who uses Hutzpa puts himself for a moment, in an absolute position, like a God or a genius, in an equal position that brings a strong temporary motivation to cross boundaries and say something new, bring alternatives to his reality. He is

filled with the need to change the world because he feels he can! When a loving, empathic feeling is involved in his process, the creator walks even further because of the sense of responsibility for other people's well-being. He will walk all the way, even back to his God, and demand answers.

I remember an old legend about a small Jewish village in the eighteens century, where some of the wise elderly, after a long debate about – why is human life so difficult, decided to summon God up as a witness in a trail they put for him, in a particular day and hour, to come forth and explain to all and answer with the responsibility to his creation. He never showed up. But the Hutzpa, to demand a specific explanation from your God, and call him for a trial, is the pure expression of a man who puts himself at the same eye level as his creator.

The first human rebel of Adam and Eve against a specific order- not to eat from the forbidden fruit, a rebel that showed the will to stand in the same position and level of your creator, to know what he knows, to understand the secrets of his work, break the limits of knowledge, all that is the first sign for the complex relationship between man and higher authority. A relation of Hutzpa.

Creative anarchy is the one that seeks to take the system apart but in a creative way. Meaning, even in the act of dismantling, there must be creativity involved for the sake of finding the innovative within the void that's coming after all turns into its genesis, to its pre-existing phase, to its chaos, to its complete nothingness before the first word or sign of its being is said. The creator wishes to reinvent himself and grow out of his own experience, and that is why he is required to be a rebel against himself as well, against all that is safe and stable within him and question his grounds, which brings him eventually to personal

and creative growth. Everything he used to turn toward the world now turns inside until he feels that inner tension.

The motion of the anarchist has the search for the void. It's a motion of forming a crack into the void, which has the potential of a rebirth of a new sign, a new original, authentic representation. His moral duty as a creator is to be bold and fresh against reality and its laws. It's a quality and a habit he keeps active in his everyday life. That doubt is his practice to reach limits and cross them. His creation lies on the other side of the norms, out of the chaos and emptiness.

That's where things seek their original existence. Out of the dream into the world, in a motion that has the power to move worlds and stars. That's the purpose of creativity - Love!

About the Author

Moshe Katz, Architect

www.moshekatz.net
moshekatzarch@gmail.com

"I am a **visionary artist, educator and designer** engaged in research and teaching about creativity. This book is a result of my quest to bring creativity closer to my fellow humans through the world that merges **architecture, freedom, and inspiration.**

Being an **architect, urban designer and an interdisciplinary artist** allowed me to wander all my life between Europe and Israel. After I graduated in Architecture studies at Bezalel and the University of Florence, Italy, I practiced architecture internationally and created many award-winning projects that have been featured in numerous international competitions, exhibitions and published in international books and magazines.

Over the years, I have been a devoted teacher of architectural design and creativity mentoring university students, and giving **talks and lectures around the world about creativity, curiosity and interdsciplinary approaches.** These allowed me to become an authority in teaching of creativity, specifically for my ability to inspire students and empower them to turn any exercise into a life-changing creative and inspirational experience. The results are astonishing, and my thoughts from these processes are collected in this book, aimed to help others extend their imagination and re-design their life.

I believe in thinking **outside the box, testing boundaries, and creating inspiration in spaces** to produce a surprise or an amazement experience. My constant preoccupation is with experiencing ideas, shapes, and materials while I search for different feelings of space based on the connection between man, the city, and infinity."

-Moshe Katz

The philosophy of Architecture
by Moshe Katz

Creative Architecture

is based on the process of inspiration and creative thinking, remaining present throughout the project from the beginning until the end. It aims to elevate the quality of the space to a spiritual and poetic level and make your soul dance with joy.

Empathic Architecture

is based on a constant feeling of love towards the place and the human. It seeks to understand the complexity of life, sees the potential in every problem, and envisions a solution for social and environmental issues. As architects, we have the responsibility to dream for others out of love for them.

Dynamic Architecture

is a result of questions and tensions created within the architect's inner world, such as physical, spiritual, mental, emotional, and intellectual, that must be translated into reality. It is a multidisciplinary approach that takes all forms of human creative expression and strives to create a physical motion of the structure - a reactive space to outside conditions. It's a mirror of its time, seeking to find solutions through innovative, visionary thinking to provoke tension and emotional dynamics within the user of the space.

Teaching & Lectures

Lecturer and mentor for architecture students / young architects at various educational institutions

Lectures at colleges and universities across Europe on creativity and dynamic architecture:

- **International Forum of Architecture**, Bucharest, Romania, Dynamic Mind-Dynamic Architecture

- **University of Suffolk**, London, UK, Lecture Discover the Da-Vinci in You

- **Bishulim Pastry School**, Courses and Private Workshops, Pastry Meets Architecture

- **University of Southern California**, Los Angeles, Starting and Thriving in an Interdisciplinary & Visionary Practice

Partial publication file and recognition

- **Biennale di Venezia** (Metamorph), Space for Art - Dynamic Architecture

- **40/40 Exhibition**, Israel / One of the 40 promising architects under 40 in 2018, Award winner / 2018, Design Award Final Nominee

- Publications in international books and various magazines.

Special Thanks

To Professor Moshe Halbertal
To Artist and Creator David Broza

Project credits

Architecture is a Living Music
Music and inspiration: Artist and Musician David Broza
Dancer: Micha Amos
Photo: Efrat Mazor
Illustrations: LINE CREATIVE LTD

Light Drops, Helsinki, Finland
Illustrations: Brooke Creative Ltd.

Acco-Tech, Acre, Israel
Illustrations: Niv Koren

Nathan Alterman, "Stars Out There"
United Kibbutz, 1995, Tel Aviv
Theodor Herzl, "Altneuland" Babel Publishing
2004, Tel Aviv Hanoch Levin,
"Plays 4", Kibbutz Hameuchad, 199
Tel Aviv Walter Benjamin,
"The Wanderer", Hakibbutz Hameuchad
2003, Tel Aviv

Dante Alighieri, "La divina commedia",
 Luigi reverdito editore, 1995, Italia
Rainer Rilke, "Briefe an einen jungen Dichter",
 Anaconda Verlag, 2009, Germany
Martin Heidegger, "Sein und Zeit", Max Niemeyer Verlag
 GmbH & Co KG, 2006, Tubingen, Germany
Giovanni Michelucci, L'ultima lezione,
 Biblioteca del cenide, 2001, Italia

Lightning Source UK Ltd.
Milton Keynes UK
UKHW021521100223
416667UK00012B/605